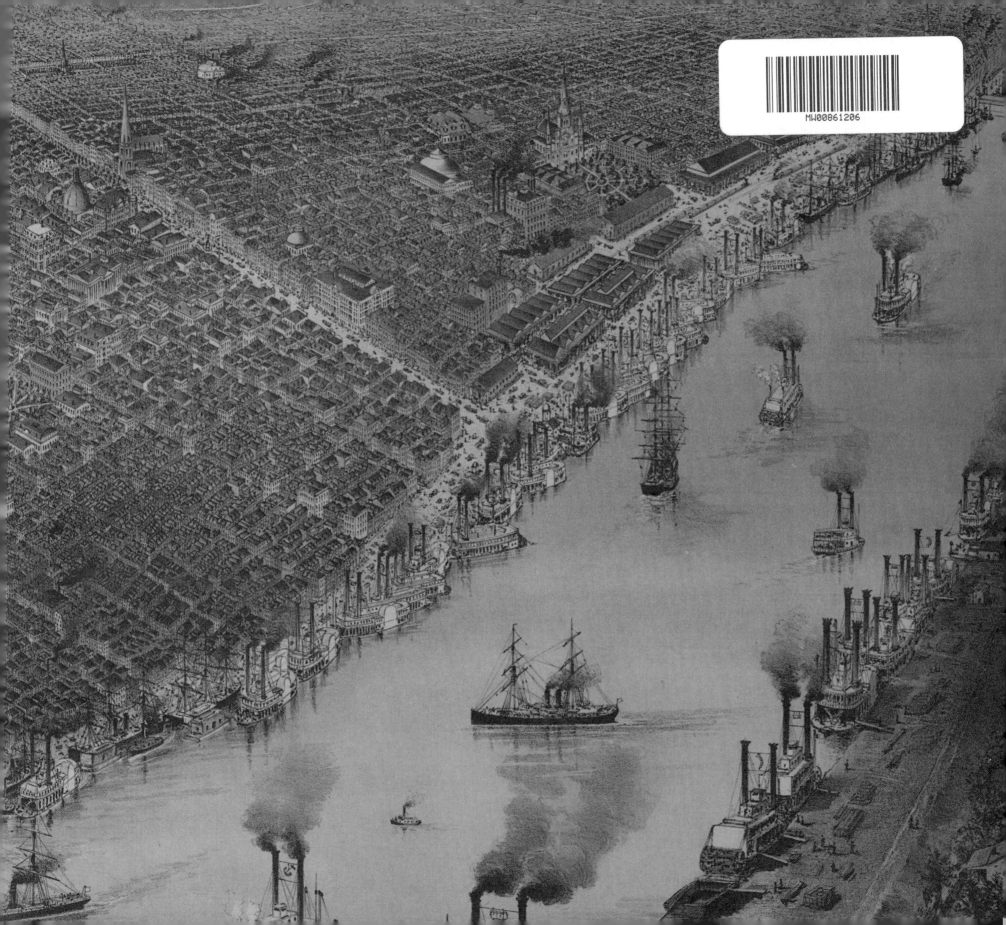

LOST NEW ORLEANS

Dedication

To Marina and Jason

Acknowledgments

I am indebted to Tulane University Provost Michael A. Bernstein; Dean Kenneth A. Schwartz and my colleagues at the Tulane School of Architecture; historian Prof. Lawrence N. Powell; Prof. Joel Dinerstein of the New Orleans Center for the Gulf South, where I am a Monroe Fellow; and archivist Keli Rylance of Tulane's Southeastern Architectural Archive; as well as the following local institutions: the Louisiana Division of the New Orleans Public Library; The Historic New Orleans Collection; Howard-Tilton Library and Special Collections at Tulane University; Louisiana State Museum; *New Orleans Times-Picayune*; and the Louisiana Collection and Special Collections of the Earl K. Long Library at the University of New Orleans.

Bibliography

American Institute of Architects, New Orleans Chapter. *A Guide to New Orleans Architecture*. New Orleans, Louisiana: American Institute of Architects, 1974.

Bridaham, Lester Burbank. *New Orleans and the Bayou Country: Photographs (1880–1910) by George François Mugnier*. Barre, Massachusetts: Barre Publishers, 1972.

Cable, Mary. *Lost New Orleans*. Boston, Massachusetts: Houghton Mifflin Company, 1980.

Campanella, Richard. *Bourbon Street: A History*. Baton Rouge: Louisiana State University Press, 2014.

Campanella, Richard. *Bienville's Dilemma: A Historical Geography of New Orleans*. Lafayette: University of Louisiana Press, 2008.

Campanella, Richard. *Geographies of New Orleans: Urban Fabrics before the Storm*. Lafayette: Center for Louisiana Studies, 2006.

Campanella, Richard. *Time and Place in New Orleans: Past Geographies in the Present Day*. Gretna, Louisiana: Pelican Publishing Company, 2002.

Campanella, Richard and Marina Campanella. *New Orleans Then and Now*. Gretna, Louisiana: Pelican Publishing Company, 1999.

Chase, John Churchill. *Frenchman, Desire, Good Children and Other Streets of New Orleans*. New York, and London: Collier Macmillan Publishers, 1979.

Chase, John Churchill, Hermann B. Deutsch, Charles L. Dufour, and Leonard V. Huber. *Citoyens, Progrès et Politique de la Nouvelle Orléans 1889–1964*. New Orleans, Louisiana: E.S. Upton Printing Company, 1964.

City Planning and Zoning Commission. *Major Street Report*. New Orleans, Louisiana, 1927.

Ellis, Scott S. *Madame Vieux Carré: The French Quarter in the Twentieth Century*. Jackson: University of Mississippi Press, 2010.

Engelhardt, George W. *New Orleans, Louisiana, the Crescent City: The Book of the Picayune*. New Orleans, 1903–1904.

Federal Writers' Project of the Works Progress Administration. *New Orleans City Guide*. 1938; rev. ed., Boston: Houghton Mifflin, 1952.

Friends of the Cabildo. *New Orleans Architecture, Volumes I–IIX*. Gretna, La.: Pelican Publishing, 1972–1997.

Gallier, James. *Autobiography of James Gallier, Architect*. New York: Da Capo Press, Inc., 1973.

Gorin, Abbye Alexander. *Conversations with Samuel Wilson, Jr., Dean of Architectural Preservation in New Orleans*. The Samuel Wilson, Jr. Publications Fund of the Louisiana Landmarks Society, 1991.

Gorin, Abbye Alexander. *Samuel Wilson, Jr.: A Contribution to the Preservation of Architecture in New Orleans and the Gulf South*. Doctoral Dissertation in Environmental Design and Planning, Virginia Polytechnic Institute and State University, Blacksburg, Virginia, 1989.

Hankins, Jonn Ethan and Steven Maklansky, editors. *Raised to the Trade: Creole Building Arts of New Orleans*. New Orleans: New Orleans Museum of Art, 2002.

Heard, Malcolm. *French Quarter Manual: An Architectural Guide to New Orleans' Vieux Carré*. New Orleans: School of Architecture, Tulane University, 1997.

Hennick, Louis C., and E. Harper Charlton. *The Streetcars of New Orleans*. 1965; rpr. Gretna, La.: Pelican Publishing, 2000.

Huber, Leonard V. *Creole Collage: Reflections on the Customs of Latter-Day New Orleans Creoles*. Lafayette, Louisiana: Center for Louisiana Studies, University of Southwestern Louisiana, 1980.

Huber, Leonard V. *Landmarks of New Orleans*. New Orleans, Louisiana: Louisiana Landmarks Society and Orleans Parish Landmark Commission, 1984.

Huber, Leonard V. *New Orleans: A Pictorial History*. Gretna, Louisiana: Pelican Publishing Company, 1971.

Ingraham, Joseph Holt. *The South-West by a Yankee*, 2 vols. New York: Harper and Brothers, 1835.

Janssen, James S. *Building New Orleans: The Engineer's Role*. New Orleans, Louisiana: Waldemar S. Nelson and Company, Inc., 1987.

Jewell, Edwin L. (editor). *Jewell's Crescent City, Illustrated*. New Orleans, Louisiana, 1873.

Latrobe, Benjamin Henry Boneval. *Impressions Respecting New Orleans: Diary & Sketches 1818–1820*, ed. Samuel Wilson Jr. New York: Columbia University Press, 1951.

Latrobe, John H. B. *Southern Travels: Journal of John H. B. Latrobe, 1834*, ed. Samuel Wilson, Jr. New Orleans: The Historic New Orleans Collection, 1986.

Laussat, Pierre Clément de. *Memoirs of My Life*. 1831; trans., Baton Rouge: LSU Press and The Historic New Orleans Collection, 1978.

Le Page Du Pratz, Antoine. *The History of Louisiana*, ed. Joseph G. Tregle, Jr. 1774; rpr. Baton Rouge: LSU Press, 1976.

Lemmon, Alfred E., John T. Magill, and Jason R. Wiese, eds. *Charting Louisiana: Five Hundred Years of Maps*. New Orleans: The Historic New Orleans Collection, 2003.

Long, Alecia P. *The Great Southern Babylon: Sex, Race, and Respectability in New Orleans, 1865–1920*. Baton Rouge: LSU Press, 2004.

Macaluso, Joseph N. *Italian Immigrant Families: Grocers, Proprietors, and Entrepreneurs: The Story of the Italian/Sicilian Corner Grocers and Markets of Algiers*, LA. Pittsburgh: RoseDog Books, 2004.

New Orleans Bureau of Governmental Research. *Plan and Program for the Preservation of the Vieux Carré*. City of New Orleans, Louisiana, 1968.

New Orleans Bureau of Governmental Research. *Vieux Carré Historic District Demonstration Study, Volumes 1–6*. New Orleans, Louisiana, 1968.

New Orleans Chess, Checkers and Whist Club. *New Orleans Chess, Checkers and Whist Club Yearbook*. New Orleans, Louisiana, 1903.

New Orleans Times-Picayune, archived editions, 1835–present.

Powell, Lawrence N. *The Accidental City: Improvising New Orleans*. Cambridge, Mass.: Harvard University Press, 2011.

Preservation Resource Center of New Orleans: numerous articles in *Preservation in Print*, 1995–2014.

Souther, J. Mark. *New Orleans on Parade: Tourism and the Transformation of the Crescent City*. Baton Rouge: LSU Press, 2006.

Starr, S. Frederick. *Inventing New Orleans: Writings of Lafcadio Hearn*. Jackson: University Press of Mississippi, 2001.

Strahan, Jerry E. *Andrew Jackson Higgins and the Boats That Won World War II*. Baton Rouge: LSU Press, 1994.

Tulane University School of Architecture. *The New Orleans Guide*. London, England: International Architect Publishing Limited, 1984.

Tulane University School of Architecture. *New Orleans and the River*. New Orleans, Louisiana, 1974.

Tulane University School of Architecture. *Study of the Vieux Carré Waterfront in the City of New Orleans*. New Orleans, Louisiana, 1969.

Tulane University School of Architecture. *The Vieux Carré Survey: A Pictorial Record and a Study of the Land and Buildings in the Vieux Carré*. New Orleans, Louisiana, 1960.

Wilson, Jr., Samuel. *The Vieux Carré, New Orleans: Its Plan, Its Growth, Its Architecture. Historic District Demonstration Study*. City of New Orleans, Louisiana, 1968.

Works Progress Administration. *Some Data in Regard to Foundations in New Orleans and Vicinity*. Works Progress Administration of Louisiana and Board of State Engineers of Louisiana, 1937.

Works Progress Administration. *The WPA Guide to New Orleans*. Houghton Mifflin, Boston, Massachusetts, 1938.

Zacharie, James S. *New Orleans Guide*. F.F. Hansell & Bros., Ltd., New Orleans, Louisiana, 1902.

Endpapers

Front: "The City of New Orleans," 1885 (Currier & Ives, courtesy of Library of Congress).
Back: "The Levee – New Orleans," 1884 (Currier & Ives, courtesy of Library of Congress).

First published in the United Kingdom in 2015 by PAVILION BOOKS,
an imprint of Pavilion Books Company Ltd., 1 Gower Street, London WC1E 6HD, UK

© Pavilion Books Group, 2015

ISBN: 978-1-90981-5605

A CIP catalogue record for this book is available from the British Library.

10 9 8 7 6 5 4 3 2 1

Repro by Colourdepth
Printed by 1010 Printing International Ltd, China

LOST NEW ORLEANS

Richard Campanella

PAVILION

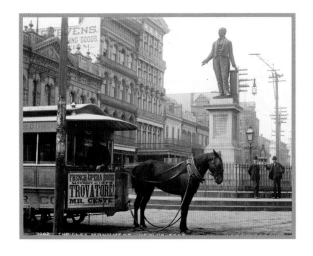

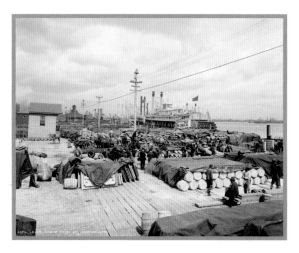

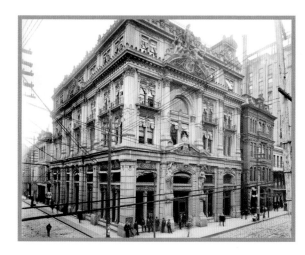

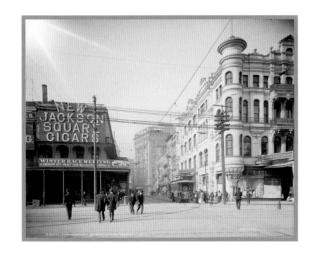

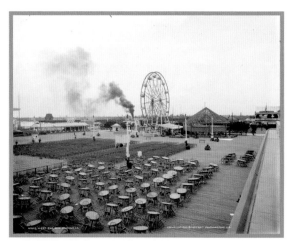

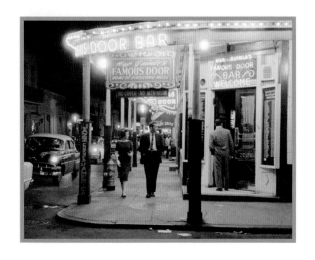

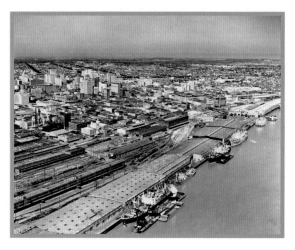

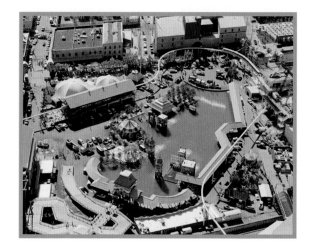

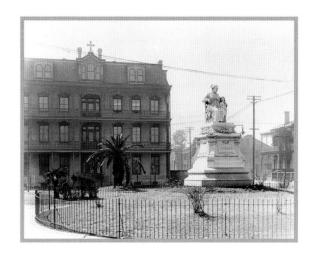
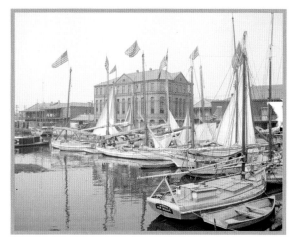

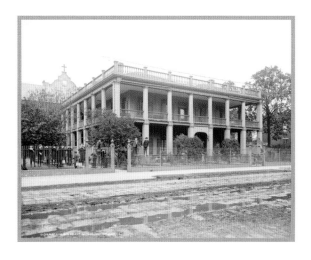
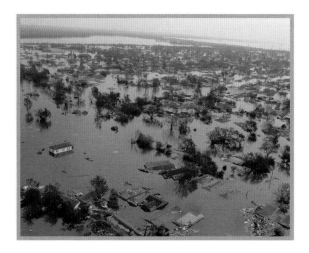

LOST IN THE...

Introduction	**page 6**
1900s	**page 8**
1910s	**page 12**
1920s	**page 24**
1930s	**page 34**
1940s	**page 54**
1950s	**page 68**
1960s	**page 92**
1970s	**page 110**
1980s	**page 128**
1990s	**page 132**
2000s	**page 138**
2010s	**page 142**
Index	**page 144**

INTRODUCTION

Few are the world's cities that are positioned on true deltas, much less those of the young, dynamic variety which protrude precariously into the sea. Fewer still are the American cities founded by the French (1718) and passed to the Spanish (1762), whose cultural source regions derived not from Anglo-Saxon northern Europe but the Mediterranean and Afro-Caribbean world of the South Atlantic.

American dominion turned what had previously been something of a roguish colonial orphan into the largest city in the South and the nation's second busiest port. The reason was fundamentally geographical: positioned astride the Mississippi and nearest to its mouth, New Orleans monopolized trade coming in and out of what would become the richest valley on earth. Photographs throughout this volume show the bustle of the city's cotton and sugar wharves, the oyster and fisheries trade at Lugger Landing, lumber and bricks arriving at the Old Basin Canal, and the operations of the banana and tropical fruit sheds.

A sector of savvy middlemen—shipping agents, bankers, factors, merchants, lawyers, insurers—grew affluent and funded the development of a strikingly opulent cityscape, as evidenced by the magnificent cotton and sugar exchanges and other commercial and residential buildings in this book.

Below this Franco-Anglo-Saxon patrician class was an upwardly mobile white middle class; a working-class white population of mostly immigrants; an influential *gens de couleur libre* (free people of color) caste which dominated much of the city's artisan and building trades; and finally an enslaved caste of African Americans, whose labor rendered most of the region's agricultural wealth.

People within these classes and castes allied themselves with two overriding cultures: an older and more provincial Francophone and Catholic community known as the Creoles, and a mostly Anglophone Protestant population recently arrived from points north who the Creoles called, with mounting resentment, *les Américains*. Much of the city's antebellum age (1803–1861) witnessed an acrimonious struggle for power between these two ethnicities, which played out politically, economically, linguistically, religiously, geographically (Creoles generally lived in the lower, downriver half of the city; Americans, uptown), legally (Creoles practiced Roman civil law with Napoleonic influences; Americans, English common law), and even architecturally. The St. Louis and St. Charles hotels, which appear in this volume, served the Creole and American populations, and were located in their respective neighborhoods. All five buildings known by these names have since been destroyed by fire or the wrecking ball.

On one issue, however, all were united, and that was the challenge of urbanizing a soft, swampy deltaic plain. Development had no choice but to remain upon the upraised "natural levees" closest to the Mississippi, leaving the backswamp largely wild. Seasonal floods threatened even these highest lands—all of two to four meters above sea level—thus authorities erected artificial levees at the crest of the natural levees to keep the river from overflowing. Efforts were also made to drain the backswamp, which was erroneously suspected to cause yellow fever and other deadly epidemics, one of which (1853) wiped out 10 percent of the city's population. In fact, mosquitoes were the culprits, and cisterns and poor sanitation gave them habitat; New Orleanians unknowingly benefited from the backswamp, in that it stored excess water that otherwise would have flooded the city and buffered them from hurricane storm surges.

The American Civil War (1861–1865) and the ensuing emancipation of enslaved African Americans after the defeat of the Confederacy radically reshuffled the social, economic, and political order. By the late 1870s, however, former Confederates, having lost the war, effectively won the peace, as they installed a white supremacist government and the apparatus of racial subjugation that would remain in place into the 1960s.

Economically, the antebellum "Golden Age" would never return, and New Orleans gradually declined relative to other American cities. The Civil War's impact upon the plantation system and the city's failure to diversify its economy through industrialization were in part to blame, but more so, the decline followed the development of Northern canals and railroads which gave Western produce direct routes to Eastern markets.

Victorian times were nonetheless fairly prosperous, at least for most white New Orleanians, and the municipal improvements and social reforms of the Progressive Era (1880s–1920s) gave rise to a robust cultural and built environment. Most of the photographs in *Lost New Orleans* depict architectural treasures from this era, including the two elegant Maison Blanche department stores on Canal Street, the soaring Old Masonic Temple on St. Charles Avenue, and a host of stately benevolent institutions. One particular loss, the burning of the Old French Opera House on Bourbon Street in 1919, marked the decline of the Creole community in the French Quarter, and coupled with the demolition of the St. Louis Hotel three years earlier, sparked the foundation of the city's preservation movement.

A premier municipal improvement in this era was the installation of a world-class drainage system, which by the 1910s had drained the backswamp and allowed urbanization to spread toward the low-lying shores of Lake Pontchartrain. Parallel efforts led to the full-scale control of the Mississippi River as well as the excavation of canals throughout southeastern Louisiana for the purposes of navigation, drainage, and oil and gas extraction. These projects produced great wealth and enabled modernized living, but they also caused soil subsidence and coastal erosion, as less and less sediment-laden river water replenished the deltaic plain and more and more wave action from rising seas gnawed away at the marshy coast. New Orleans in the 20th century dropped below sea level and became increasingly dependent on artificial levees for flood protection.

Social changes paralleled the physical changes. The Civil Rights Movement of the 1950s–1960s brought an end to *de jure* segregation in public facilities, but what followed was not so much integration as *de facto* re-segregation, as middle-class whites fled for the suburbs and left the inner city with a diminishing tax base, fewer jobs, and an increasingly poor and predominantly African American population. The auto-fueled suburban exodus brought an end to many city institutions pictured in this book, from municipal markets and train stations, to churches and theaters, to Solari's Delicatessen on Royal Street, to D. H. Holmes and Godchaux's department stores on Canal Street. Aging plantation mansions such as Three Oaks and Seven Oaks were demolished mostly for reasons of mere convenience.

By 2000, New Orleans had dropped to the rank of 31st largest city in the nation amid one of its poorest regions, with a socially vulnerable population and a physically prone landscape. Catastrophe arrived on August 29, 2005 in the form of Hurricane Katrina, which triggered multiple breaches in a scandalously under-engineered levee system. Once predicted to become the most opulent city in the hemisphere, New Orleans drowned in its own filth for weeks, leaving 1,500 people dead and hundreds of thousands scattered in evacuation. The neighborhood hardest hit by the deluge, the Lower Ninth Ward, is featured in this volume, but comparable destruction occurred throughout the eastern half of the metropolis.

The rebuilding of New Orleans got off to a rocky start, with some people questioning whether it was worth the effort and others debating where, how, when, for whom, and with what resources. A number of factors helped accelerate the recovery in the 2010s, including a new $15 billion "risk reduction" levee system plus an influx of well-educated young professionals eager to embrace the city's architectural and cultural charms. Today, the city finds itself in a rather unexpected renaissance, recognized nationally for its entrepreneurism and cultural economy.

Some see the new New Orleans as a gentrified, self-aware version of its old self, and have come to cast the Katrina catastrophe and the inequities of the recovery in a wistful "end of history" narrative. As the photographs in *Lost New Orleans* attest, however, traumatic change has happened before, and stability, if anything, is an illusion. The present era is not the end of New Orleans' history but rather its next chapter, and so long as we figure out a way to reverse coastal erosion and hold back the encroaching sea, we may someday look back on these times and call them a second Golden Age.

RIGHT *Newspaper stand at 103 Royal Street, July 1908. (Courtesy of Library of Congress)*

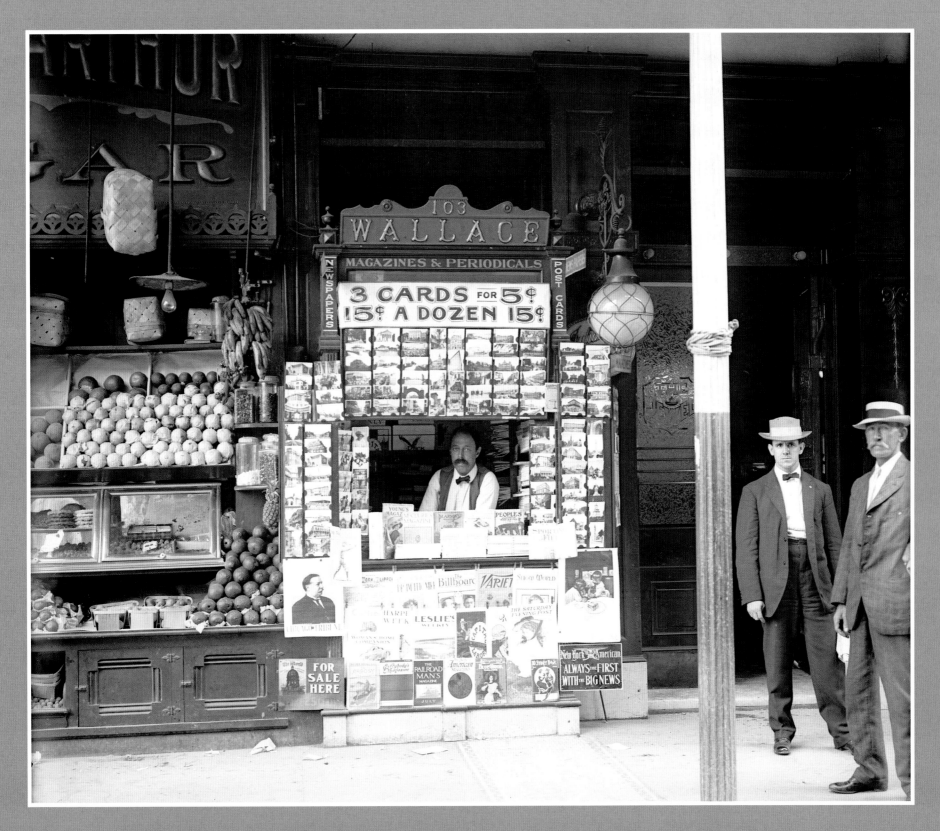

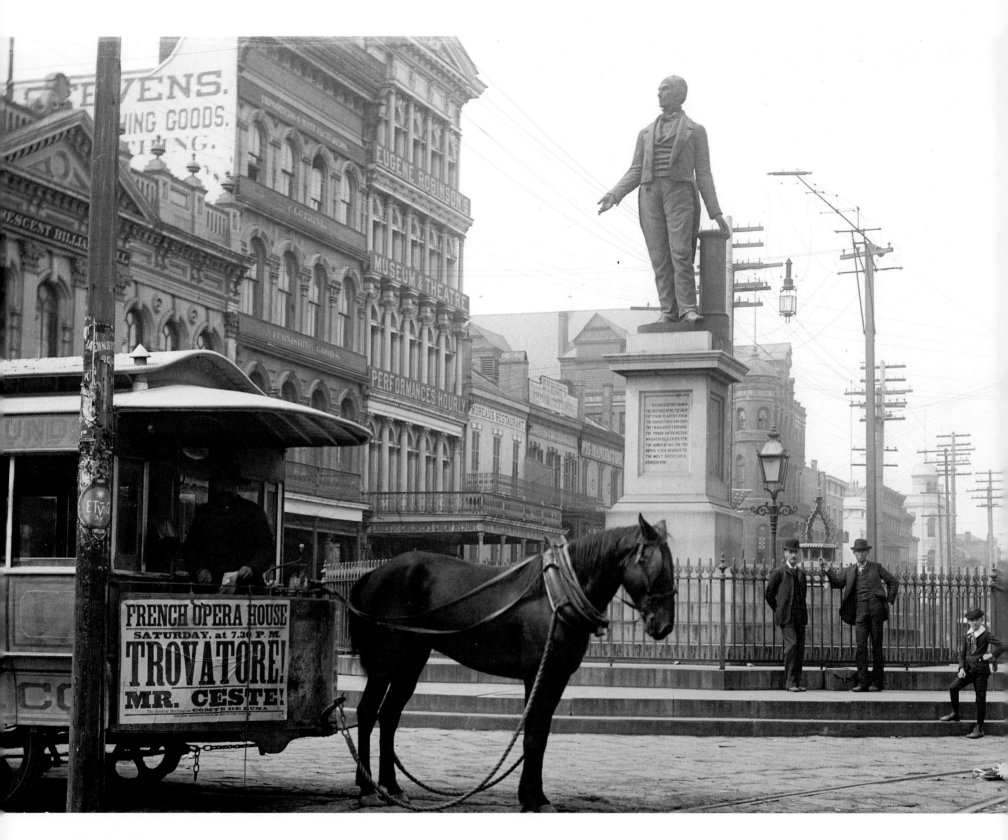

Clay Statue RELOCATED 1901

Despite its breadth and splendor, Canal Street arrived late to the urban geography of New Orleans. During colonial times, the land through which the artery runs had been left undeveloped so that the primitive fortifications surrounding the original city (today's French Quarter, below Iberville Street) would have unimpeded firing lines. Those commons terminated at what is today the eponymous Common Street, above which lay plantations—until 1788, when, shortly after the catastrophic Good Friday Fire, Spanish authorities decided to lay out the city's first suburb, which is now the Central Business District.

The formation of the new suburb, named Santa Maria, left open a triangular commons between it and the Old City. Growth after the Louisiana Purchase in 1803 increased the pressure to make use of this valuable open space, and in 1805, the City Council petitioned the federal government to recognize the city's claim to the commons. By an Act of Congress on March 3, 1807, the claim was accepted with the stipulation that a 60-foot right-of-way be established on both sides of a planned canal to connect the Carondelet Canal with the river. When streets were laid out within the commons in 1810, surveyors left space for the canal and made what came to be known as "Canal Street" especially broad—171 feet, one of the widest inner-city thoroughfares in the nation. Although the canal was never excavated, the name stuck, and because the street joined the city's two most important neighborhoods, it developed in the 1810s–1830s into a fashionable residential boulevard, and starting in the 1840s, the city's premier commercial and retail district.

Canal Street also assumed a kind of town-square role, as a place where citizens assembled in times of both celebration and strife. James S. Zacharie's 1885 city guide not only described Canal Street as the "main avenue" and "chief promenade" of the city, home to its "principal shops, confectioners, stores, and clubs," but also as the "centre of the city"—specifically at the Henry Clay Statue seen here, on Canal at Royal/St. Charles.

That such a monument should be prominently positioned reflects the high regard with which New Orleanians held Kentucky statesman Henry Clay (1777–1852), who during his lengthy service in the Senate and the House of Representatives became known as an advocate of Western interests and an open Mississippi River, from which the local economy profited immensely. A few years after his death, a Clay Monument Association formed and began raising money to erect statues to Clay as well as George Washington. The cornerstone for the pedestal was laid in an elaborate ceremony on Clay's 79th birthday, April 12, 1856, but it took a number of years for the statue to be completed, by Kentucky sculptor Joel Tanner Hart working in Florence, Italy. The 12½-foot bronze figure was finally set upon its pedestal in a second grand ceremony on April 12, 1860, and for the next 40 years, it witnessed the city pass through the turmoil of succession, Civil War, occupation, Reconstruction, and violence, including the 1874 "Battle of Liberty Place" and the 1891 lynching of 11 Sicilians at the Parish Prison, both of which were incited by fiery speeches delivered at the Clay Monument.

The statue also witnessed the emergence of a modern American downtown, with one of the nation's greatest concentration of newly electrified streetcar lines plus newfangled "horseless carriages" swirling around it—so much so that, by 1900, the monument became a traffic obstacle. Wrote the *Picayune* in its 1904 *Guide to New Orleans*, the bustle "made the vicinity dangerous to human life[;] sentiment…finally yielded to reason and the monument was removed by act of the City Council in 1901 to [the middle of] Lafayette Square." To make room for the Westerner, a statue of Benjamin Franklin already in the center of the square was moved to its eastern edge. The likeness of George Washington first envisioned by the same circa-1856 movement behind the Clay statue did not come to fruition until a century later, when the Grand Lodge of the State of Louisiana donated a statute of the first president (and Freemason) sculpted by Donald De Lue and Bryant Baker and placed in the Civic Center near New Orleans Public Library in 1960.

Traffic today flows freely across Canal Street.

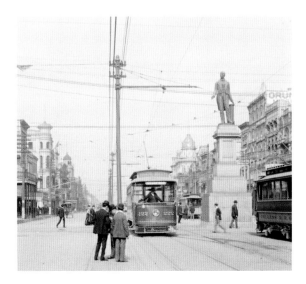

OPPOSITE, FAR LEFT & LEFT *New Orleanians seeking to commemorate Western hero Henry Clay with a prominent monument were perhaps a bit too successful, as the statue created a traffic obstacle evident in these 1890s–1900 photographs. (Courtesy of Library of Congress)*

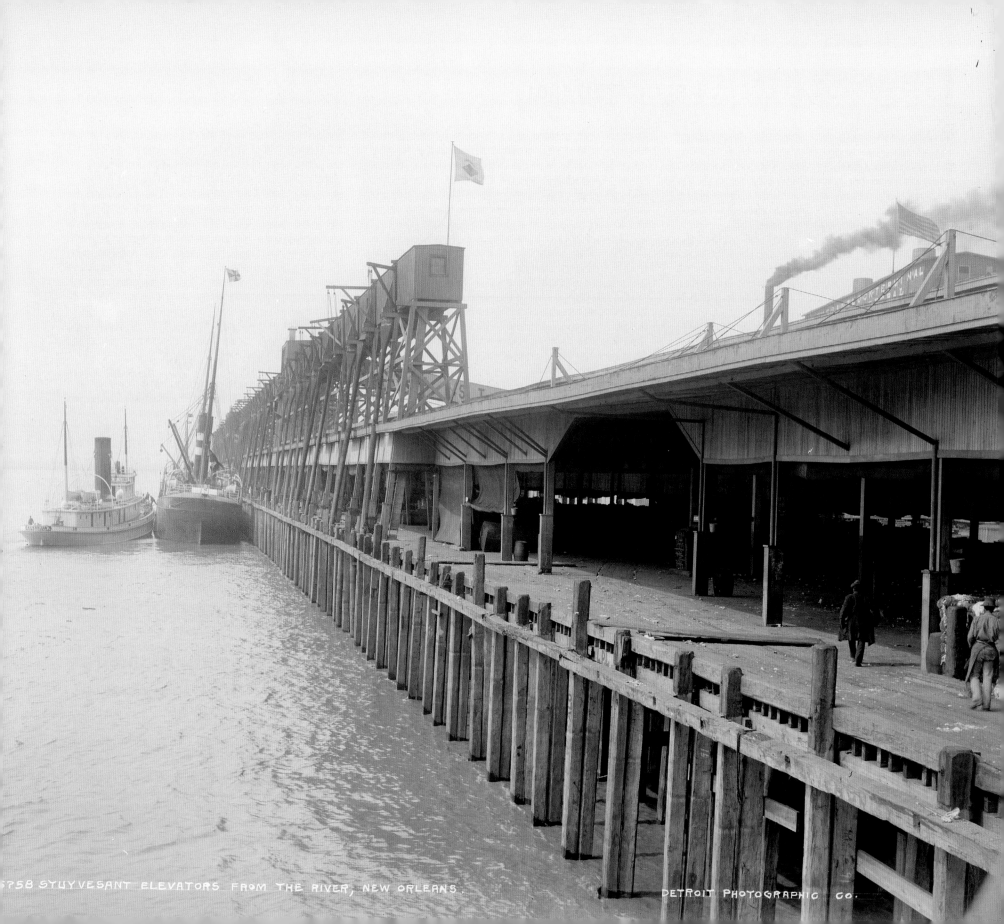

5758 STUYVESANT ELEVATORS FROM THE RIVER, NEW ORLEANS.

DETROIT PHOTOGRAPHIC CO.

Original Stuyvesant Dock and Elevators

BURNED 1905

The Stuyvesant Docks, built in 1896 along the 4,750 feet between Louisiana to Napoleon avenues, were named for Stuyvesant Fish, scion of New York aristocracy and president of the Illinois Central Railroad. They represented an era of change because 1896 was also the year when the Louisiana Legislature created a Board of Commissioners to administer the Port of New Orleans, an entity that had previously been controlled by the city and leased out to operators. The leasing system did not work well: leaseholders had little incentive to maintain the wharves and every incentive to overcharge for their use. The new state-run system empowered the Board of Commissioners, known as the Dock Board, to modernize the port's facilities, and the Stuyvesant Docks as well as the Public Belt Railroad (which aimed to standardize rail service to the wharves) were key parts of its plan to build an intermodal world shipping port.

Two realms comprised the Port of New Orleans in the early 20th century: "public wharves" controlled by the Dock Board, and "terminal stations" controlled by private railroad lines under Board oversight. The Texas and Pacific Railroad, for example, ran its terminal stations at Westwego on the West Bank, while the Illinois Central ran the Stuyvesant Docks on the East Bank.

The Stuyvesant Docks were an integrated complex of piers on pilings extending over the river, consisting of planked or paved bankside wharves crisscrossed with railroad tracks. On the rails ran specialized yard locomotives and freight trains, and along their flanks were sheds, warehouses, water towers, boilers, power generators, offices, and, as seen here, grain elevators arranged in what was called a "marine gallery."

Grain elevators were key to the $10 million operation. The devices lifted grain off incoming conveyances (usually freight trains) and either stored it in towering silos or moved it via mechanical belts to other conveyances (usually vessels). A great improvement over hand-lifting of bagged cargo, steam-powered grain elevators were first introduced here in 1868 by the New Orleans Elevator Company to handle wheat and corn on barges; years later, Illinois Central built a larger grain elevator on the Poydras Street Wharf.

On February 26, 1905, the original Stuyvesant docks and elevators were destroyed in an epic blaze originating from an improperly lubricated elevator shaft. Losses, which topped $3 million, included 3,500 feet of terminals and wharves, two elevators, 625,000 bushels of grain, 22,000 bales of cotton, 300 car-loads of lumber and cotton seed meal, 12,000 barrels of sugar, plus buildings, railroad cars, three fire engines, and six horses—not to mention revenue and jobs. But the facility was insured, and Illinois Central rebuilt the Stuyvesant Docks by 1907. In a typical operation, grain would arrive by rail and get lifted into one of the two elevator sheds, which together could store 2.5 million bushels and deliver it into ships at a rate of 80,000 bushels per hour. Driers, coolers, and other apparatus kept the operation running safely, as wet grain was worthless and dust could ignite and explode.

The Stuyvesant Elevators fell victim to the post-World War I rise of river barge traffic, which shifted Mississippi Valley grain transportation from rails back to the river, and concurrently to the new vertical grain elevators in Westwego and the Inner Harbor Navigation Canal (Industrial Canal) in the Ninth Ward. The old Marine Gallery elevators were removed in the late 1920s and were replaced with a long line of steel sheds. The term "Stuyvesant Docks," however, persisted until 1984, when the Dock Board purchased 22 acres of the old site from the Illinois Central Gulf Railroad for $5 million. Some of the pilings and piers from a hundred years ago still exist, as do the traces of the railroad tracks.

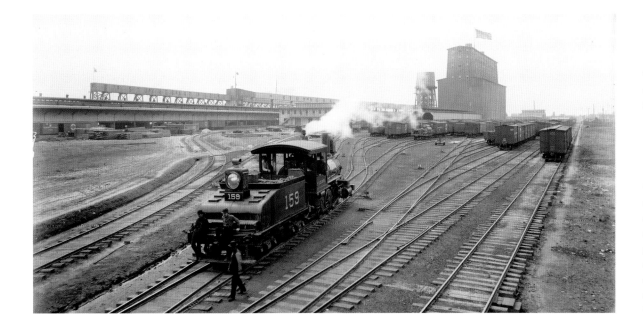

OPPOSITE *The Stuyvesant Dock's "Marine Gallery" of grain elevators formed a distinctive sight along the uptown riverfront. They moved corn, wheat, and other grains between vessels and railroad cars at up to 80,000 bushels per hour.* **LEFT** *Illinois Central Railroad's Stuyvesant Dock, built in 1896, is seen here in 1900 from the foot of Delachaise Street riverside of Tchoupitoulas. Five years later, the entire complex went up in an inferno. (Courtesy of Library of Congress)*

Cisterns DISAPPEARED 1910s

Despite the proximity of the continent's greatest river, potable water proved a challenge for New Orleans for nearly its first two centuries. Residents would typically obtain domestic water, via servant, slave, or peddler, by scooping it from the river or digging small courtyard wells. Homemakers would remove impurities with stone, alum, or charcoal filters and store the water in earthen jars. It was terribly inefficient, and consumers demanded more convenient systems.

A system worthy of Biblical times was attempted in 1810 on the levee at Ursulines Street, in which slaves pumped river water into a raised tank which thence flowed by gravity through hollow cypress logs to subscribers. Famed architect Benjamin H. B. Latrobe designed a better system a few years later, using a steam pump mounted in a three-story pumphouse with cast-iron reservoirs and a network of cypress pipes to residences. Subsequent growth spawned additional private water companies, premier among them the Commercial Bank of New Orleans (1836), whose waterworks system served what is now the Lower Garden District, Garden District, and Irish Channel. The Commercial Bank oversaw operations from 1836 to 1869, after which the city took over until 1878, when it deeded the system over to the New Orleans Water Works Company. Monopoly status, upheld in court, precluded the rise of competing systems. By the 1880s, about 8 million gallons per day were pumped through 71 miles of cast-iron pipe, but only for those few who paid for the special service.

For everyone else, the solution was the cistern—what one writer described in 1893 as,

> the strangest and most distinctive features of New Orleans[:] collecting-tanks for rain-water in almost every door-yard…huge, hooped, green cylinders of wood, [like] enormous watermelons on end and with the tops cut off…. Nine-tenths of the water used for cooking and drinking is this cistern water….

These photographs show how the cisterns, some two stories high, were nestled by rooftops to capture and store as much rainfall as possible. During dry spells, residents of this water-surrounded city actually suffered water shortages, particularly the poor living in the back-of-town. In droughts,

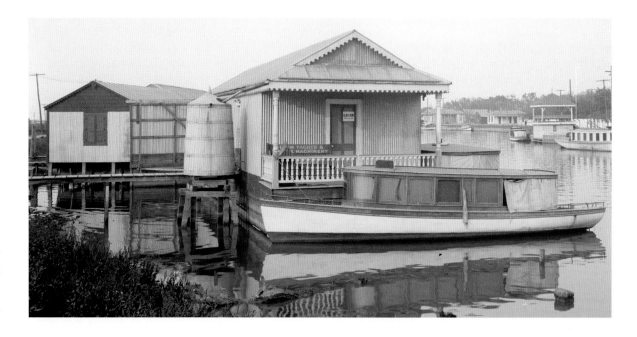

water was sometimes "delivered" simply by pumping it through the open gutters.

The "Progressive Era" of social and municipal advancements (1880s–1920s) finally saw the installation of a full-scale modern water treatment and distribution system, as well as drainage and sewerage apparatus. The Carrollton Water Works Plant, started in 1905 and opened in 1908, drew water from the Mississippi by an intake pipe and pumped it through a series of treatment reservoirs for the removal of impurities and bacteria. Eight pumps then propelled the purified water through distribution mains to city residents everywhere except Algiers, which was served by a similar system. Water mains were laid starting in 1905; by 1910 they extended 512 miles; by 1926, they measured around 700 miles and spanned most of the urban footprint. The number of water meters soared from around 5,000 installed in 1900 (one per 57 people) to 22,600 in 1910; 56,600 in 1920; and nearly 96,000 in 1927—one for every four people, or roughly every household. Cisterns were rendered obsolete for anyone connected to the urban grid, and, depending on the economic class of the household, they all but disappeared from the New Orleans cityscape during the 1910s–1920s.

ABOVE, BELOW & RIGHT *These photographs from the turn of the 20th century show three cistern sizes, designs, and positions. The houseboat scene was taken on Bayou St. John; the courtyard scenes are in the French Quarter. (Courtesy of Library of Congress)*

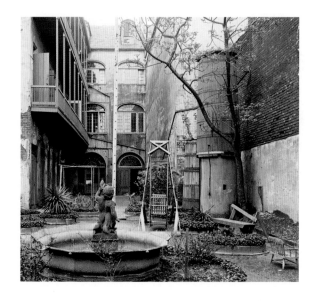

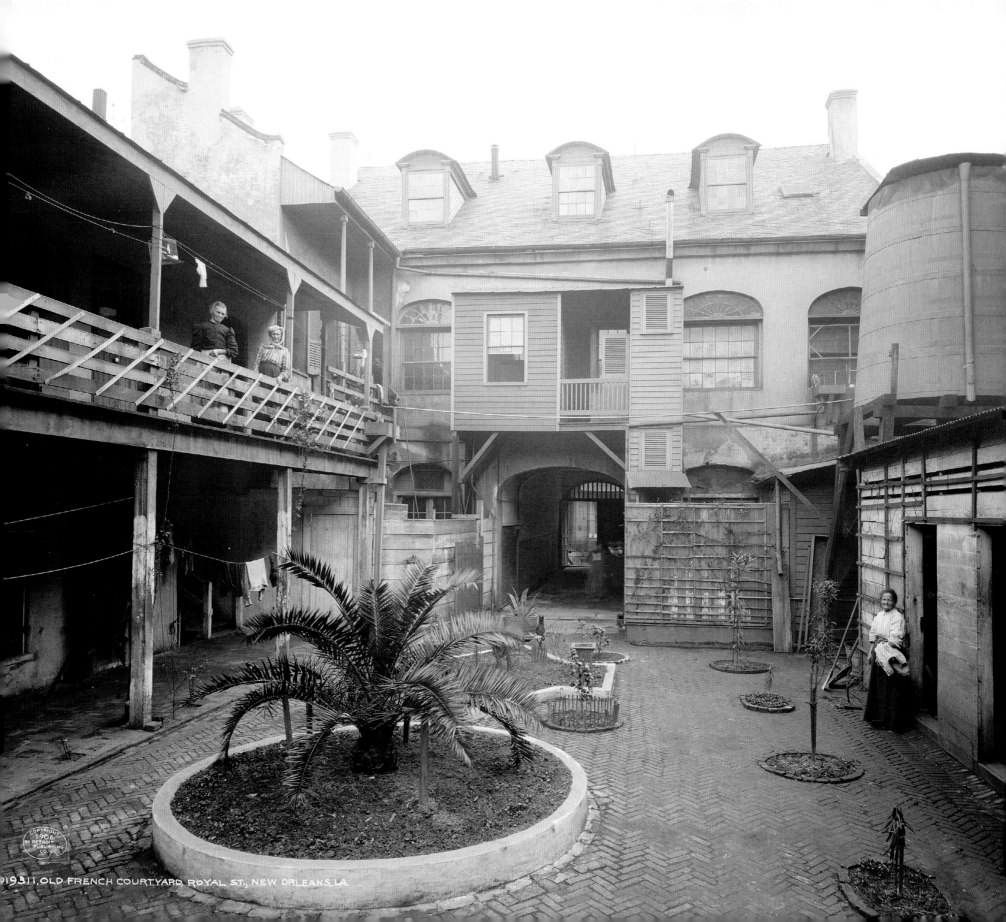

19311. OLD FRENCH COURTYARD, ROYAL ST., NEW ORLEANS, LA.

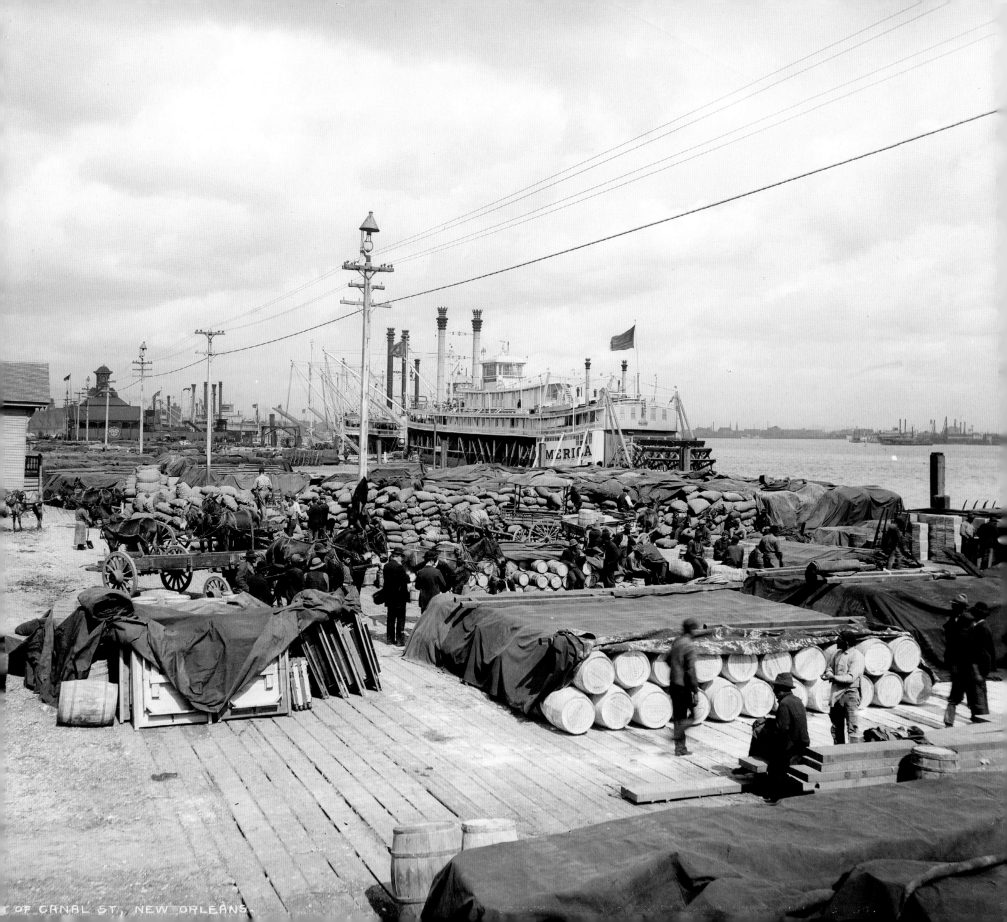

OF CANAL ST., NEW ORLEANS.

Cotton Wharf COVERED 1910s

"New Orleans exists chiefly by reason of the cotton trade," declared the *Times* in 1881. "Without [it] the city would actually have no industries to support its population, no reasons for such a population to live here, and, by consequence, no reason for the existence here of a town very much larger than Galveston or Mobile." The riverfront wharves attested to cotton's dominance, as presses, pickeries, mills, warehouses, and wharves could be found two miles in either direction of downtown well into the 20th century.

The Southern cotton industry emerged in the late 18th century from a series of technical breakthroughs. On the demand side, the steam engine, mechanical spinners, and the power loom reduced production costs and upped the demand for cotton lint. On the supply side, Eli Whitney's cotton engine, or "gin," separated lint from seed and trash 10 times faster than it took human hands.

Keen to rising profitability, settlers migrated to the lower Mississippi Valley and began clearing land for vast cotton plantations, which would benefit from another new invention, the steamboat. The Southern cotton boom also breathed new life into slavery—and gave New Orleans yet another lucrative business: the slave trade. The so-called "Golden Age" had begun, and for decades, New Orleans would serve as a key node in the Cotton Triangle, in which Northern-owned ships would ferry cotton to ports like Liverpool, cross back to New York with cargos of textiles or immigrants, and return with Northern goods or ballast.

The reception, storage, care, sale, and exportation of over a million cotton bales per year required a vast local workforce. At the top of the labor pyramid were cotton *brokers*, *merchants*, and *agents*, who kept records, tracked bales, and decided whether a client's cotton should be sold or warehoused in anticipation of better prices. Cotton *factors* represented planters' interests in the marketplace and aided them in acquiring supplies and financing. Cotton *classers*, meanwhile, graded the lint by color, cleanliness, and fiber length, all of which drove price.

At the bottom of the labor pyramid were the *roustabouts*, who handled bales on the steamships until the vessel docked, at which point *screwmen* took over, unloading the bales for the *longshoremen* on the wharf (seen here) to organize into shipments and pass them on to *draymen*, who hauled them to the cotton presses. There, *rollers* got the bales to *scalemen*, who loaded them onto scales for the *weighers*, who also pulled samples for the *classers*.

While all this took place along the river, the downtown merchants decided the fate of their bales: sell, store, or ship; at what price, to whom, where, when, and how. When the deal was completed, cotton *pressers* compressed the bales down to anywhere from three-quarters to one-third their original size. Then the process was reversed: the draymen hauled the pressed bales to the longshoremen, who in turn passed them to the screwmen, who then perform the more specialized task of "screwing" the bales into place on the ship (using jackscrews) so as to maximize limited space. The roustabouts would then see the bales delivered to the marketplace. Each tier in the labor pyramid had its support echelons, ranging from lawyers to machinists. Thus cotton fueled the New Orleans economy and employed tens of thousands of its citizens. What helped end scenes viewed in these photographs was, in the 1910s, the erection of metal sheds to protect cargo and operations from the elements, and the advent of the forklift (circa 1914), which replaced longshoremen, screwmen, draymen, and rollers.

A series of factors dethroned King Cotton's Crescent City retainers in the early to mid-20th century, chief among them foreign imports, railroad competition with river transportation, government price controls (which negated the roles of factors and merchants), and the shift of cotton cultivation from the humid South to the dry lands of Texas and the Southwest. Floods and the boll weevil also took their toll, and as a result, cotton acreage in Louisiana declined from almost 2,000,000 acres in 1930 to 130,000 acres in 2013. In New Orleans, cotton-related businesses declined by over two-thirds between the 1920s and 1940s. Cotton handling remained an important commodity at the port through the 1950s, but as cultivation shifted westward, so did its pathways to market.

Gradually wharves in New Orleans, once dedicated to bales, were changed to bananas or other cargo. Today, two companies, Staplcotn and Kearney Companies, keep cotton moving through New Orleans, the latter leasing federally licensed cotton warehouses at the Napoleon Avenue Container Terminal for shipments destined for Pakistan, Turkey, and Latin America. But the bales are packaged and hidden from view, and the average New Orleanian under the age of 60 has probably never seen one.

OPPOSITE & LEFT *The advent of forklifts and installation of covered sheds in the 1910s ended the century-old scenes of the open cotton wharf. The building with the distinctive cupola in this circa-1903 photograph is the Ferry House at the foot of Canal Street.* **RIGHT** *Labor on the cotton wharf was stratified by position and segregated by race. "Roustabouts" handled the bales on the steamships, while "screwmen" unloaded them onto the wharf and "longshoremen" (seen here) organized and carted them to "draymen," who trucked them to the cotton presses. These views, taken by William Henry Jackson in the early 1890s, show the bustle around the foot of Poydras Street. (Courtesy of Library of Congress)*

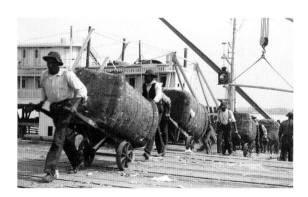

Ursuline Convent Complex DEMOLISHED 1912

On September 7, 1912, 52 veiled women in black robes boarded a streetcar in the Ninth Ward bound for uptown. For some it was their first venture into the city since before the Civil War; for others, it was their first ride on an electric car. They were cloistered Ursuline Nuns, and their home since 1824, seen here, was about to be demolished.

The Ursulines first arrived at New Orleans in 1727 in an attempt to civilize the roguish colony with religion and education. After a few years living in provisional quarters, they moved in 1752 into a new convent on Chartres Street. By the early American years, population pressure made life there untenable, so in 1821, the Ursulines acquired a parcel two miles downriver and had erected, according to the designs of architects Gurlie and Guillot, a graceful convent fronting the Mississippi. They moved in 1824, and for the next 88 years, the Ursulines lived, worshipped, educated girls, welcomed visitors, aged, and died among 15 graceful buildings between the levee and Dauphine, and from Manual to Sister streets.

Among the structures were the distinctive St. Ursula Chapel (1829), the boarding academy for girls, a cloister, a chaplain's residence, an orphanage, dependencies, and even a dairy. The convent itself was renovated in the 1850s with a mansard roof and a distinctive baroque clock. Life inside was structured, simple, and pious: "Rising early for their matins [nighttime liturgies]," described K. K. Blackmar in 1912, "attending early mass, long hours in the classrooms or the sewing-rooms, with brief recreation in the handsome parks or…libraries, with vesper office and long night prayers: [such is] the day of the cloistered Ursuline nun."

Like all other parcels in the lower *banlieu* (downriver outskirts), the Ursuline property extended back to the "Forty Arpent Line" (the French unit *arpent* measuring 192 feet, thus about a mile and half back), where the swamps began. Over time, those neighboring parcels transformed from plantations and farms to street grids, and finally, in the late 1800s, to full urbanization. The Ursulines likely would have sold off the empty land in the rear of their parcel and kept their buildings fronting the river.

But the Mississippi, and the Orleans Parish Levee Board, had other designs. River currents had long scoured these particular banks, and officials decided that the levee had to be realigned. They expropriated the nuns' main convent and annexes but left the

chapel and rear buildings. Resigned to the project and aware that their students mostly lived uptown, the nuns donated part of their land to the city and, selling the rest, erected a new institution on State Street and Claiborne Avenue. On that September morning in 1912, the sisters rode a special streetcar to their new uptown campus, carrying with them ancient sacramental records and religious treasures to their new home.

The demolitions ensued—but they would be the least of the changes. City leaders and the maritime industry had long clamored for an "inner harbor" of deep-draft dock space linking the Mississippi River and Lake Pontchartrain, and in July 1914, the state authorized the excavation of such a canal. Where exactly? Sufficiently wide, perfectly positioned, and largely undeveloped, the Ursuline parcel provided the answer. All remaining buildings were razed, and with the Dock Board in charge and the renowned George W. Goethals Company as consulting engineers, ground was broken on June 6, 1918. Over the next 18 months, the Ursuline land and adjacent properties were literally scraped off the face of the earth, and on May 5, 1923, the Inner Harbor Navigation ("Industrial") Canal was inaugurated.

The Ursulines remain today in their State Street campus, where they run the oldest continually operating girls' school in the nation. Their original 1752 convent still stands on 1100 Chartres Street, the oldest documented structure in the city and region. Of their 1824 riverfront complex, however, only artifacts survive.

ABOVE *Designed by architects Gurlie and Guillot and opened in 1824, the second Ursuline Convent had the look and layout of an Old World nunnery, fronting the Mississippi River in the city's lower banlieu (downriver outskirts). The sisters served New Orleans with a boarding academy for girls, orphanage, and religious services.* **RIGHT** *The tower of St. Ursula Chapel commanded spectacular views of the lower river region. (Courtesy of Library of Congress)*

BELOW *The Ursulines, though cloistered, hosted a steady stream of visitors and were anything but isolated from fellow citizens. This outdoor service was held in the courtyard behind the main convent. (Courtesy of Visual Materials Collection, Southeastern Architectural Archive, Special Collections Division, Tulane University Libraries)*

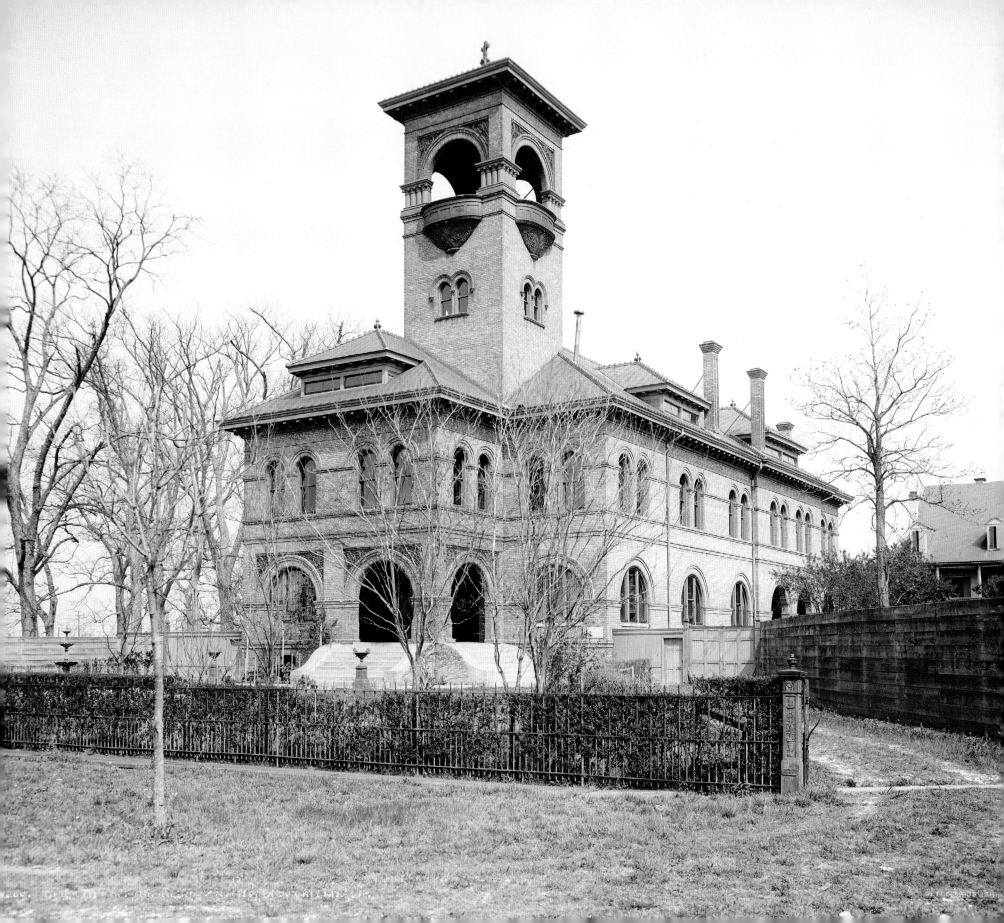

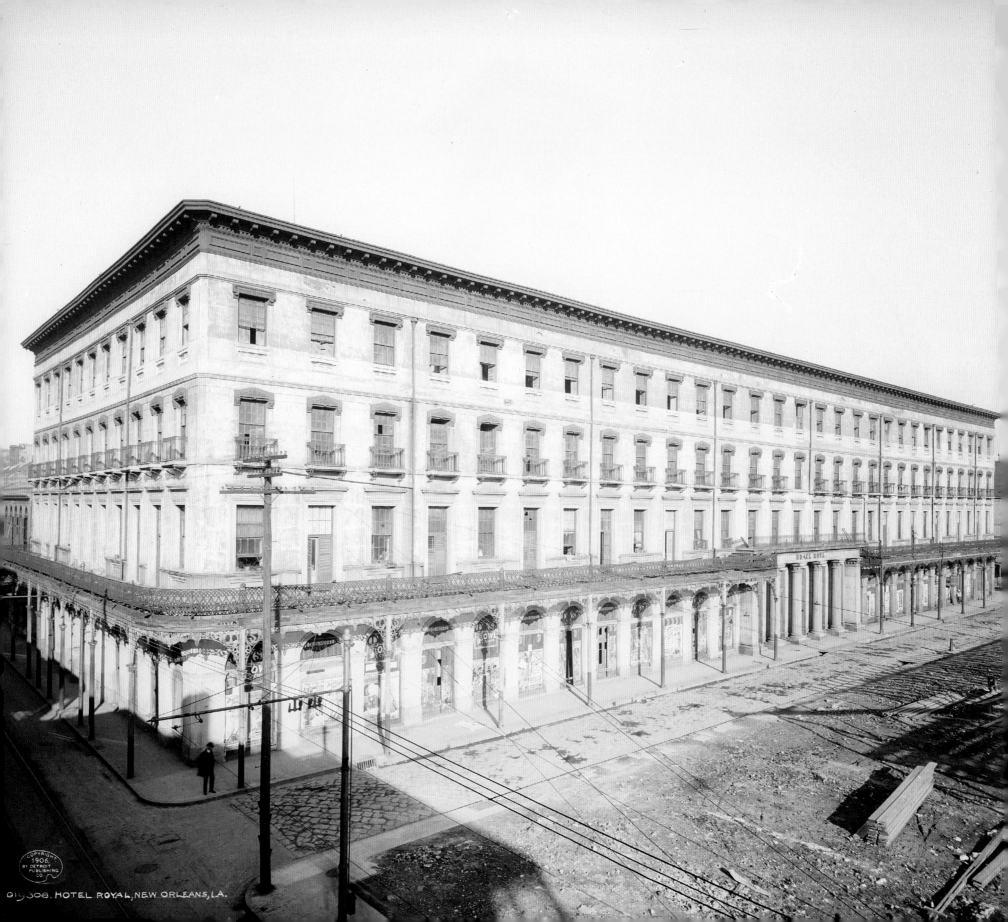

019306. HOTEL ROYAL, NEW ORLEANS, LA.

St. Louis Hotel and Exchange DEMOLISHED 1915–1916

New Orleans was a city of transients, from seamen, flatboatmen, and itinerant laborers; to financiers, lawyers, and engineers. Professional migrants would typically head to the Queen City of the South in mid-autumn and stay until the "business season" ended in late spring, and in response hoteliers erected luxurious full-service complexes to serve moneyed guests with all their needs. They were called "exchange" hotels, and were roughly the antebellum equivalent of today's conference hotels or resorts.

The St. Louis Hotel and Exchange, designed by J. N. B de Pouilly for the Improvement Bank during 1835–1838, aimed to rival competing outfits on the American side of town. De Pouilly and his clients originally envisioned their project to occupy an entire block, but the financial Panic of 1837 forced a scaling-down to slightly more than half that size, with the frontage along the lower side of St. Louis Street between Chartres and Royal.

For its first two years, the St. Louis would form,

according to the *Daily Picayune*, "the pride of New Orleans and of Louisiana, the wonder and admiration of strangers, the most gorgeous edifice in the Union," featuring a "magnificent hall where merchants congregated, the saloon where beauty gathered for the dance, the elegantly furnished hotel, the bar room, the billiard room [and] numerous offices and stores…." The journalist used the past tense in his descriptions because a terrible conflagration the previous morning, February 11, 1840, had completely leveled the building, its timber-supported rotunda collapsing spectacularly to the earth.

So brisk had been the hotel's business that owners speedily rebuilt, this time funded by the adjacent Citizen's Bank at a cost of $600,000 and executed with fire-resistant components such as a lightweight rotunda composed of a honeycomb of hollow clay pots. "We rejoice in seeing its lofty dome soaring again to the sky," beamed the *Daily Picayune* in May 1841, "and we hope to hail it…once more a proud architectural boast of New Orleans."

For the next 20 years, the St. Louis would form the nucleus of Creole business and society. Sales of every conceivable form of property, including enslaved human beings, were conducted daily on the auction block, beneath the 88-foot-high dome surrounded by towering Tuscan columns, like a scene out of ancient times. Slave auctions had a long history at this site; the city's most famous public mart, Hewlett's Exchange and its predecessors Tremoulet's, Maspero's, and Elkin's, were all located on this site, and throughout the 1810s–1830s, visitors would observe the proceedings therein and write either critically or nonchalantly about the spectacle. Hewlett, a co-investor in the proposed hotel, had his exchange razed for the construction of the much larger building seen here, and slave auctions continued up to the Civil War.

The War reversed the destiny of the building. The hotel had closed, its rooms having been used by troops, and in 1874 it came into the hands of the New Orleans National Building Association, which promptly sold it to the State of Louisiana. For the next eight years, the old St. Louis Hotel became the *de facto* Louisiana state capitol building. It returned to private-sector use as a lodge from the 1880s through 1900s, when these photographs were taken. Sanborn Fire Insurance maps from this era indicate the "Hotel Royal" had a ladies' entrance on Royal, a restaurant under the rotunda, a kitchen behind it, and a steam laundry in the Greek Revival edifice of the now-defunct Citizens' Bank.

With widespread divestment in the French Quarter, business at the Hotel Royal was mediocre, and the building found itself, according to a 1906 retrospective penned by Charles Patton Dimitry, in a state of "silence, neglect, emptiness and gloom." Tourists would explore its labyrinthine interior and amid the ruins come across vagrants and, at one time, a horse. After the Great Storm of 1915 further disheveled the landmark, the building was sold to the lowest bidder, the Samuel House Wrecking Company, which proceeded to dismantle it between October 1915 and early 1916. Only a few storefronts along Chartres Street were left standing, and today their façades remain embedded into the wall of the Royal Orleans Hotel, build in 1960 as a replica of the old St. Louis Exchange Hotel.

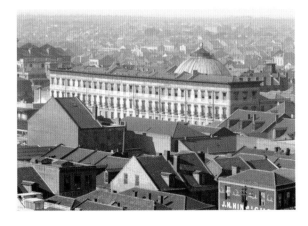

ABOVE *"We rejoice in seeing its lofty dome soaring again to the sky," wrote the* Daily Picayune *in May 1841 as the St. Louis Hotel was rebuilt after a catastrophic fire. This bird's eye view from 1905–1906 shows the dome's salience.* **LEFT** *The former St. Louis Exchange Hotel (1840), is seen here as the Hotel Royal in 1906, 10 years before its destruction. Its landmark dome is blocked from view.* **RIGHT** *The auction block beneath the dome where slaves were displayed for sale. (Courtesy of Library of Congress)*

Horticultural Hall DEMOLISHED 1915–1916

Horticultural Hall was built in 1884 as a flagship attraction in the world's exposition held at present-day Audubon Park throughout 1885. Whereas all other structures were dismantled after the event, Horticulture Hall remained standing into the new century, forming an antecedent of today's Audubon Zoological Gardens.

The idea to host a major exposition in New Orleans originated with the National Cotton Planters' Association in 1882. Advocates sought to drum up regional investment and trade with Central and South America while shining light on the city's incipient modernization and putting to rest rumors of lingering postbellum turmoil. Approved by Congress in early 1883, the event was given the cumbersome name World's Industrial and Cotton Centennial Exposition, ostensibly to commemorate the first American cotton export in 1784. Upper City Park, a fallow uptown plantation that was never subdivided, was selected to host the event because it afforded sufficient space as well as direct boat and streetcar access to downtown. After that savvy decision, however, things went downhill. Behind-schedule construction, sparse funds, erratic national and international participation, and an opening day in late 1884 that even boosters described as "sadly unfinished" got the event off to a rocky start. Attendance throughout 1885 fell short of expectations, and no subsequent boom in regional trade and investment made up for the fair's fiscal hemorrhage. But the event had its share of wonders, and Horticultural Hall topped the list.

Described by one visitor's guide as "the crowning glory of the Exposition," Horticultural Hall was not the largest structure at the fair (the Main Building measured at least 10 times bigger), nor did it hold the most extravagant attractions. But it was likely the most beautiful, a gigantic glass conservatory over 120 feet wide by 600 feet long and 46 feet high with a 105-foot tower, its design reminiscent of the Crystal Palace built for London's Great Exhibition of 1851. With a grove of ancient live oaks surrounding the building, newfangled electrical lights above, and a grand illuminated fountain in the center, the wood-timbered Horticultural Hall cut a splendid sight, particularly at night. Inside, everything from tropical ferns to Sonoran cacti to

"bananas, cocoanuts, palms, coffee trees, pineapple and cotton plants, ginger plants, cinnamon and clove trees, vanilla plants [as well as] apples, oranges and other fruits" were displayed, many for the first time locally. England and France displayed 225 different varieties of apples. Horticulturists from all over the world met in the hall and inspected each other's handiwork for awards for "best variety," "handsomest plate," and "best collection," a sort of scientific conference and gardening competition amid the festivities.

For years afterwards the standard narrative held that the World's Industrial and Cotton Centennial Exposition did more harm than good to New Orleans' interests. But retrospection has since softened this assessment. The Exposition succeeded in showcasing Louisiana arts and culture in a way that resonates to this day. It filled periodicals nationwide with dazzling illustrations of electrified splendor, and increased both the production and consumption of Louisiana literature. It accelerated the finest of residential real estate development in what is now the Uptown/Universities section, and laid the groundwork, in the form of transportation, lodging, restaurants, entertainment, and romanticized historical narratives, for the modern tourism trade.

It also, through Horticultural Hall, inadvertently planted the seeds for the city's first and only major zoo. Because of its specialized programming, beauty, and pricey construction cost of $100,000, Horticultural Hall, unlike the other fair buildings, was designed for long-term use. Organizers struck a deal with the City Council to donate the conservatory to the newly renamed Audubon Park, and for the three decades after the exposition, Horticultural Hall would serve as an indoor botanical garden around which many of the park's new recreational features would cluster.

What doomed Horticultural Hall was three episodes of fierce wind: a storm in 1906, a tornado in 1909, and the Great Storm of 1915, which utterly destroyed it. Some members of the public advocated for its reconstruction, but instead the $10,000 insurance claim went to build a dedicated flight cage for birds. It proved to be a wise investment, because to that initial aviary would be

added larger displays for birds and animals, and from those attractions would emerge today's lovely Audubon Zoological Gardens. The footprint of Horticultural Hall today lies between the Audubon Tea Room and the Sea Lion Exhibit. Nothing remains except for some underground foundations.

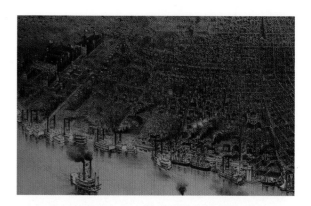

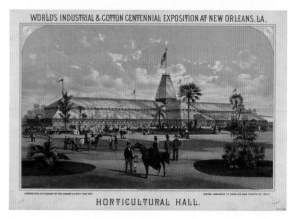

TOP *This detail of an 1885 Currier & Ives lithograph shows the elaborate complex of halls erected on present-day Audubon Park for the year-long exposition. Only Horticultural Hall was left standing afterward.* **ABOVE** *This lithograph by Thomas Hunter illustrates the showcase position held by Horticultural Hall during the 1885 exposition at what is now Audubon Park.*
RIGHT *Horticultural Hall about 10 years before hurricane damage led to its demolition. (Courtesy of Library of Congress)*

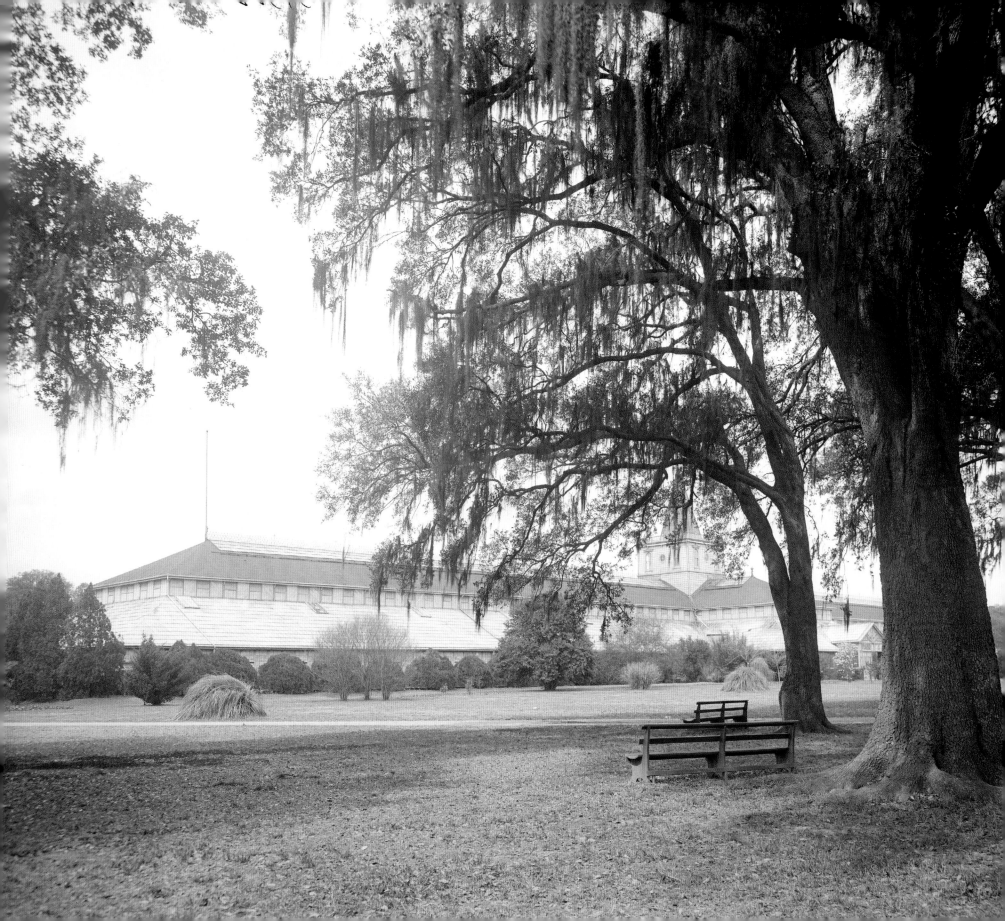

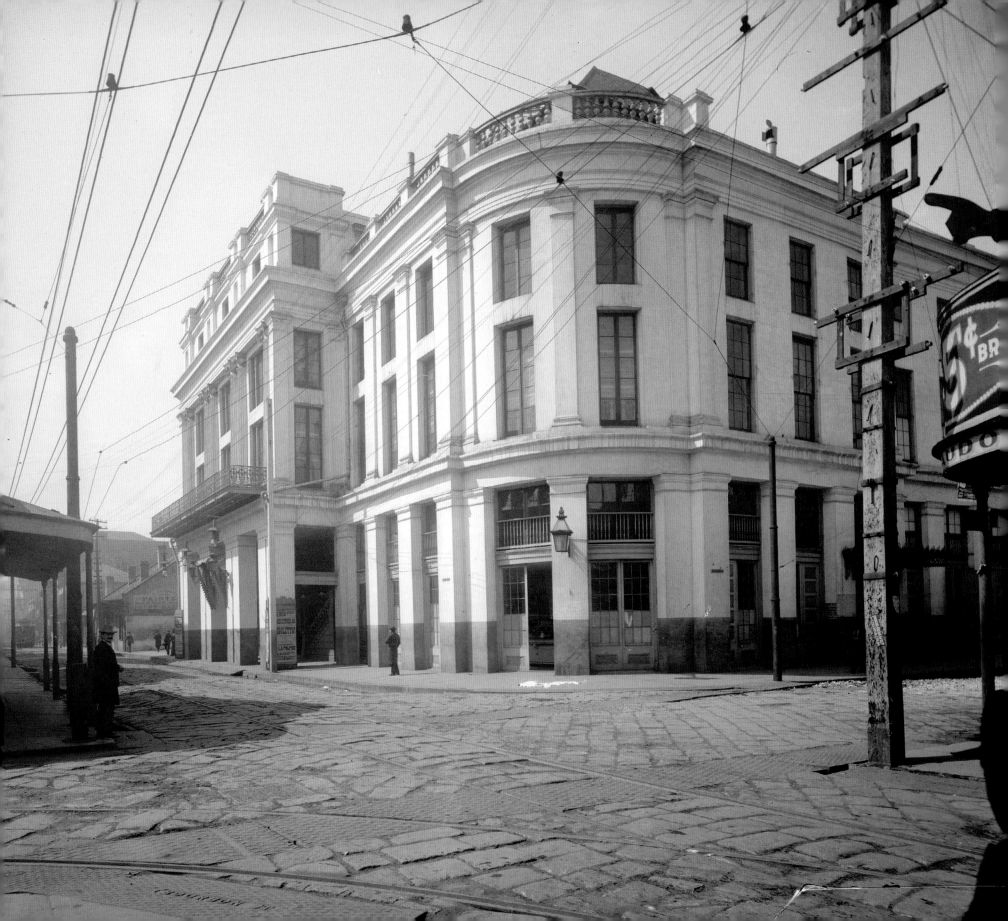

Old French Opera House DESTROYED BY FIRE 1919

In the late 1850s, in this town smitten with performance and dotted with rival theaters, Bourbon Street scored a coup. A new Parisian owner had acquired the nearby Théâtre d'Orléans, a popular venue which was managed by New Orleanian Charles Boudousquié and known for hosting touring European theatrical companies. The Parisian planned to continue that success, but when he failed to agree terms with Boudousquié, the local impresario decided to open his own theater.

In March 1859, Boudousquié formed the New Orleans Opera House Association, raised $100,000, purchased a lot on Bourbon at Toulouse, and contracted architectural firm Gallier and Esterbrook to design "a handsome structure of the Italian order, a Colossus." Work commenced in May and proceeded round-the-clock. The grand opening on December 1, 1859, featuring Rossini's *Guillaume Tell*, was a triumph. "Superb …magnificent…spacious and commodious," raved the *Picayune* of the gleaning white new French Opera House.

For the next 60 years, despite Civil War, occupation, declining fortunes, managerial turnover, and a few missed seasons, what became beloved as the "Old" French Opera House played host to a litany of famous performers as well as carnival balls and society events. It served as a

home away from home for European performers at a time when New Orleans' connection to the Old World grew increasingly tenuous. And magnificent it remained: wrote one observer, "the building, with its fresh coat of whitewash, glimmers like a monster ghost in the moonlight."

Perhaps the greatest role of the Old French Opera House came from its enthusiastic patronage by local Creoles, who simply adored the place. Mildred Masson Costa, born in 1903, described the building as "my second home; I practically lived there, three nights a week, [plus] matinee on Sunday." There was another reason for her loyalty: her grandfather belonged to the *Les Pompiers de L'Opéra*, (firemen of the opera) whose members attended all performances to check for hazards. "When there was a fire to be built upon the stage," explained Masson Costa in 1985, "they were the ones who built it, and they were the ones who put it out…. They used to go over every single seat to see that not a cigarette was left."

Just before midnight on December 3, 1919, the concert master and a friend departed for drinks following a rehearsal of *Carmen*. At 2:30 a.m., they noticed a plume of smoke from the opera house. Flames soon engulfed the upper floors. By dawn, "the high-piled debris, the shattered remnants …the wreathing smoke" reminded an *Item* journalist of "a bombarded cathedral town."

The allusion to the recent fighting in Europe was appropriate. The Great War had weakened the fragile exchange between French cultural institutions and their former colonies. New Orleanians took pride in their French Opera

legacy—"the one institution…which gave to New Orleans a note of distinction and lifted it out of the ranks of merely provincial cities," wrote a *Times-Picayune* editorialist.

Mildred Masson was devastated by the loss, particularly since her own grandfather toiled to ensure this would never happen. "You see, the fire burned the night after a rehearsal, not after a performance," she explained. The *Pompiers* "were *not* responsible for…rehearsals because you weren't supposed to use the rest of the theater; you were supposed to be on the stage, and they thought the actors or the singers would have the sense enough not to smoke. You can't very well smoke and sing anyway!"

The Grand Opera Company had suffered "a severe blow to the artistic and social life of New Orleans," and the aforementioned editorialist pondered whether the fire would "sound the death knell of that entire quarter of the city, with its odd customs…" Newspapers received hundreds of letters pleading the Company to rebuild at the same site. But all too aware of the neighborhood's decay, it demurred. Charred ruins were finally cleared away, and for over 40 years, the parcel was an unsightly wrecking lot, until a hotel was built on it in 1965. Today, only a handful of clues of the old gem remain, chief among them a widened stretch of Bourbon Street designed by Gallier and Esterbrook in 1859 to allow patrons to disembark from carriages, en route to an evening at the opera.

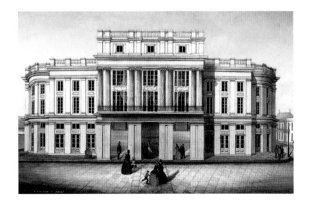

OPPOSITE *The Old French Opera House, seen here circa 1900, was a beloved cultural hearth among the French-speaking Creole community of the lower city. (Courtesy of Library of Congress)*

FAR LEFT *Designers in 1859 indented Bourbon Street along the frontage of the French House to allow patrons to disembark carriages without blocking traffic. The building was destroyed in 1919 but the indentation remains. (Courtesy of Historic New Orleans Collection)*

LEFT *A painting of the newly built opera house by Marie Adrien Persac. (Courtesy of Historic New Orleans Collection)*

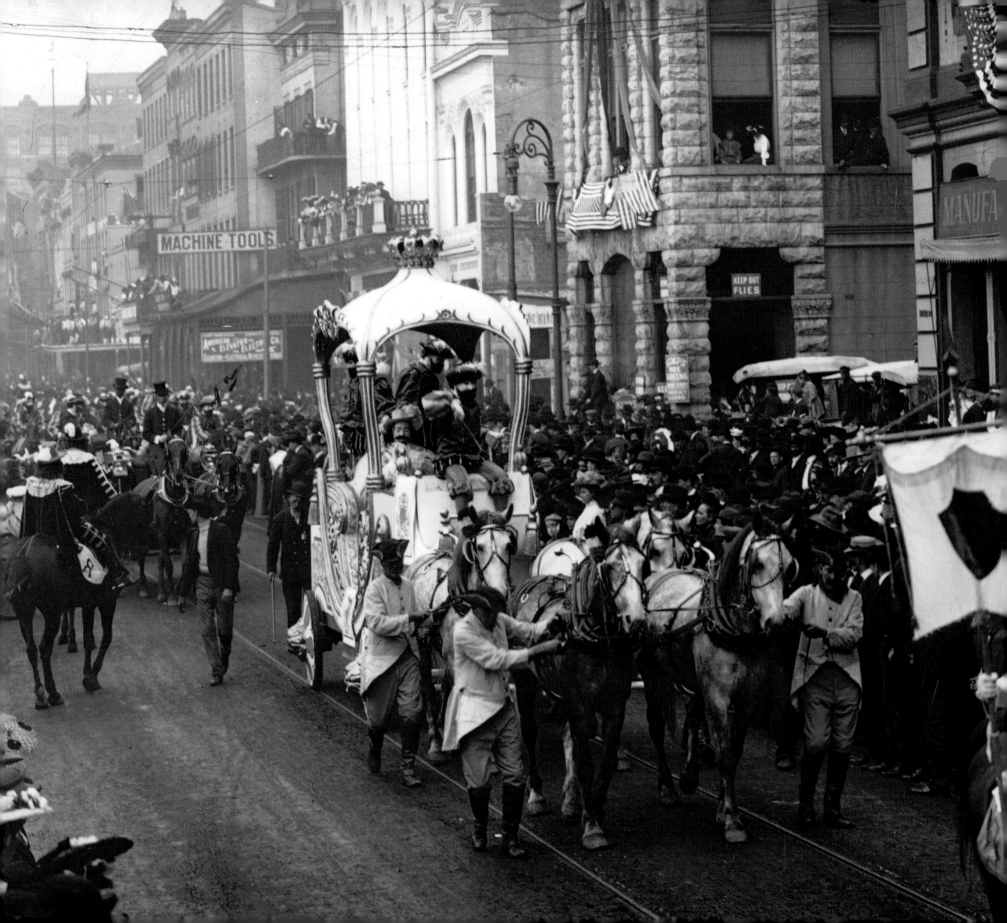

Lower Camp Street's "Newspaper Row"
DISSIPATED 1920s

Lower Camp Street formed the heart of New Orleans' publishing industry from the 1840s to the 1920s. Known as "Newspaper Row," these blocks produced weekly, semi-weekly, daily, and twice-daily newspapers in five different languages, keeping readers informed, entertained, and agitated throughout the region.

Early print media had first set up shop seven blocks downriver, on Chartres Street in the French Quarter. The settlement of Anglophones uptown nudged publishing into Faubourg St. Mary: while all seven of New Orleans' editorial and printing offices were located in the French Quarter in 1809, only four of 10 remained there by 1838. What tipped the balance to Camp Street was the arrival of the *Picayune*, which published its first edition from a Gravier Street office on January 25, 1837. After two

relocations and a fire, in 1850 the *Picayune* erected at present-day 326 Camp a handsome four-story Greek Revival structure designed specifically for newspaper production. Its success drew competitors, and by 1854, four of the city's 15 newspapers and periodicals were located on Camp Street, while another seven operated nearby.

Why Camp? The blocks between Gravier and Poydras were centrally located, neither too close to the bustling riverfront nor to the destitute back-of-town. Major banks, hotels, and offices occupied adjacent blocks, as did City Hall after 1853. There were no compelling reasons not to locate on Camp, and plenty of reasons to locate there, namely the presence of major players in the industry, such as *Times-Democrat*, *Daily States*, *City Item*, *Daily News*, and others. Their success lured rivals for the simple survivalist instinct to be in the heart of it all, especially in a competitive business like journalism. Once a critical mass was reached, support services such as printers and binders also settled in the area, which iterated the trend.

Newspaper Row's heyday peaked in 1890–1910, when it was home to the 20 largest of the city's 50 publishing-related outfits. The concentration of aggressive journalists made for a bustling and colorful atmosphere, and passions sometimes spilled into the streets. Mostly, though, the row buildings were filled with diligent

journalists, editors, typesetters, and workers intent on meeting deadlines.

While the industry remained geographically stable, its constituents opened, closed, changed hands, or merged relentlessly. "From the simple operation it had once been, newspaper publication was [becoming] a highly specialized and tremendously costly manufacturing process," wrote Thomas Dabney in 1944. "Machinery grew larger and more expensive; telegraph tolls increased; the cost of news service rose; paper; ink; and other materials climbed; so did labor." In 1914, the *Picayune* consolidated with the *Times-Democrat* and became the *Times-Picayune*. Now owned by the Nicholson Publishing Company rather than the Nicholson family, "the Old Lady of Camp Street" became a corporate entity. With so many papers swallowed up by rivals or hobbled by wartime costs, the number of offices on Camp Street dwindled from 16 to 10. After the Great War, the *Times-Picayune* relocated to a big new building on Lafayette Square.

The postwar era saw the demise of a number of old downtown industry districts, and publishers were no exception. The concurrent shift of the population to lakeside neighborhoods and outlying parishes motivated the *Times-Picayune* to relocate once again, in 1968, to 3800 Howard Avenue, for its proximity to new transportation arteries. The company subsequently established six outlying bureaus to cover news throughout the metropolis.

The paper's 2012 decision to shift to three print editions per week while expanding online coverage, and the subsequent expansion of the *Baton Rouge Advocate* into the New Orleans market, form the latest chapter in this story of eternal change, but certainly not the last one.

As for Newspaper Row, we are at least fortunate to retain most of its old buildings. They line the 300 riverside block of Camp, the narrow Picayune Place (formerly Bank Place) behind it, and on the adjacent Natchez Alley. Only one clue of the old days remains: faint lettering of THE PICAYUNE etched into the upper façade of 326 Camp.

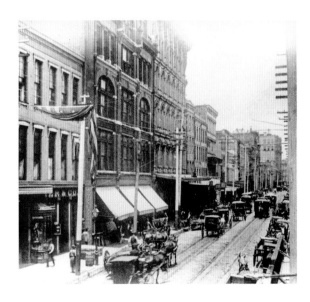

ABOVE & RIGHT *Views up and down the 100 to 400 blocks of Camp Street from the 1890s to 1900s. (Above, courtesy of the author's collection; right, courtesy of Library of Congress)*

LEFT *Although hardly evident in this Rex parade up the 400 block of Camp Street in the 1910s, this area was the heart of the city's journalism and publishing industry. (Courtesy of Library of Congress)*

Lugger Landing REMOVED 1920s

Lugger Landing, located at the foot of Ursuline Street by the French Market, was a specially crafted wooden platform hinged to the wharf such that it floated up and down with the stages of the river, allowing local shallow-draft sailing vessels to dock. Also known as Picayune Pier, the landing formed the transshipment point between lower Louisiana's productive marshes, bays, swamps, and farms, and the kitchen tables of a hundred thousand urban families. Here would arrive from the "lower coast" (St. Bernard and Plaquemine parishes) men of predominantly Sicilian, Slavic, and Spanish Canary Island (Isleño) ancestry—the press called them "Dagoes"—sailing on distinctive round-hulled "luggers," small schooners equipped with antiquated lugsails, which gave them a jaunty charm reminiscent of the old junks of Hong Kong's Victoria Harbor.

After pulling up on the dock, luggermen would lay down gangplanks and roll out barrels or sacks of oysters and other seafood, game, oranges, tomatoes, and other produce to the shade of a wooden pavilion. There, authorities from the Louisiana Oyster Commission would inspect the harvest for infection and collect taxes due to the state, two sensitive issues that put oystermen and authorities at legal loggerheads constantly in this era. Once the paperwork was done, wholesalers in wagons bee-lined for city markets, where the cargo was sold to retailers and thence to consumers, else it was iced and shipped by rail to regional markets. The best catch went directly to the city's storied restaurants and saloons and commanded the highest prices. "Counter oysters," eaten raw at the bar, topped the list, and tended to come from saltier waters; "cooking oysters," usually fried, mostly came from lower-salinity waters of the interior marshes.

Oysters reigned at Lugger Landing. The bivalves in this era came from 80,000 acres of coastal waters leased from the state and selected for having salinity regimes optimal for producing that prized briny flavor. Three-quarters of the acreage comprised natural reefs; the remainder were cultivated by creating cultch (hardened substrate, usually old oyster beds) and seeding them with spats (young oysters), which attach themselves to the cultch to grow in time for the next harvest. Regulators saw to it that oyster farmers dredged rather than tonged for oysters (which damaged the substrate), never in waters shallower than 14 feet, and only between September or October through April. In 1919 Louisiana's oyster industry was valued at \$5,000,000, and while all coastal parishes contributed to the catch, those arriving to Lugger Landing came predominantly from St. Bernard, Plaquemines, and Lafourche. Bivalves deriving from the Lake Pontchartrain region came up Bayou St. John/Old Basin or New Basin canals into their respective lugger landings on the Creole and American sides of town, and the two rival waterways, one privately owned and one state-owned, battled each other in court for years for the right to be the sole lake oyster port. Acrimony and litigation flew among other players of the oyster industry—harvesters, luggers, wholesalers, retailers, restaurateurs—each suspecting that the other was taking home more that his fair share of the profit, or that competing regions or transportation arteries were gaining unfair advantages from the state.

As today, New Orleanians feasted on oysters on Christmas Day like no other—raw, fried, or most popularly, in oyster dressing. In 1915, despite the harrowing hurricane which thrashed the eastern marshes barely a hundred days earlier, 15 lower-coast oyster vessels deposited at Lugger Landing a record 2,010 barrels of choice counter oysters on Christmas Eve morning. While waiting to load some cargo back to the country, the luggermen would, according to one 1904 *Picayune* account, "loiter idly about, smoking cigarettes or cooking their meals over queer little charcoal furnaces. The [Pier] is a picturesque sight."

Picturesque perhaps, but inefficient compared to mechanized transportation. Three factors ended the era of luggers: the advent of commercially available boat motors in the early 1910s; the expansion of the riverfront Public Belt Railroad, which needed the dockspace; and the mounting popularity of trucks, which delivered delicate regional abundance to market faster and cheaper than boats, and when fitted with refrigeration, managed to cut out multiple middle men in the route from field to table. Lugger Landing became obsolete, as did the Old Basin Canal and later the New Basin Canal. The oyster industry somehow thrives today in Louisiana, despite constant ecological and economic crisis, but no longer must it sail its schooners onto Picayune Pier. The landing's footprint is now occupied by the corner of the Gov. Nicholls Street Wharf Shed, and the only floating dock remaining along the French Quarter riverfront serves the Algiers Ferry.

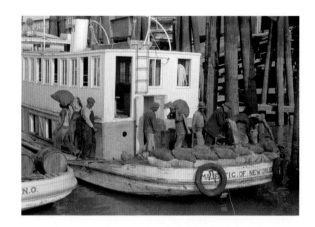

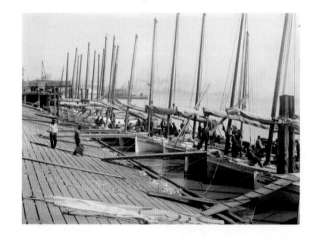

TOP *Workers unload oysters from packet boats in 1938. (Photo by Russell Lee, courtesy of Library of Congress)*

ABOVE & RIGHT *Lugger Landing, at the foot of Ursuline Street by the French Market, was a floating dock designed for small round-hulled schooners to arrive from the coastal marshes with fresh seafood, primarily oysters, and get them to market as swiftly as possible. (Courtesy of Library of Congress)*

LUGGERS AT NEW ORLEANS, LA.

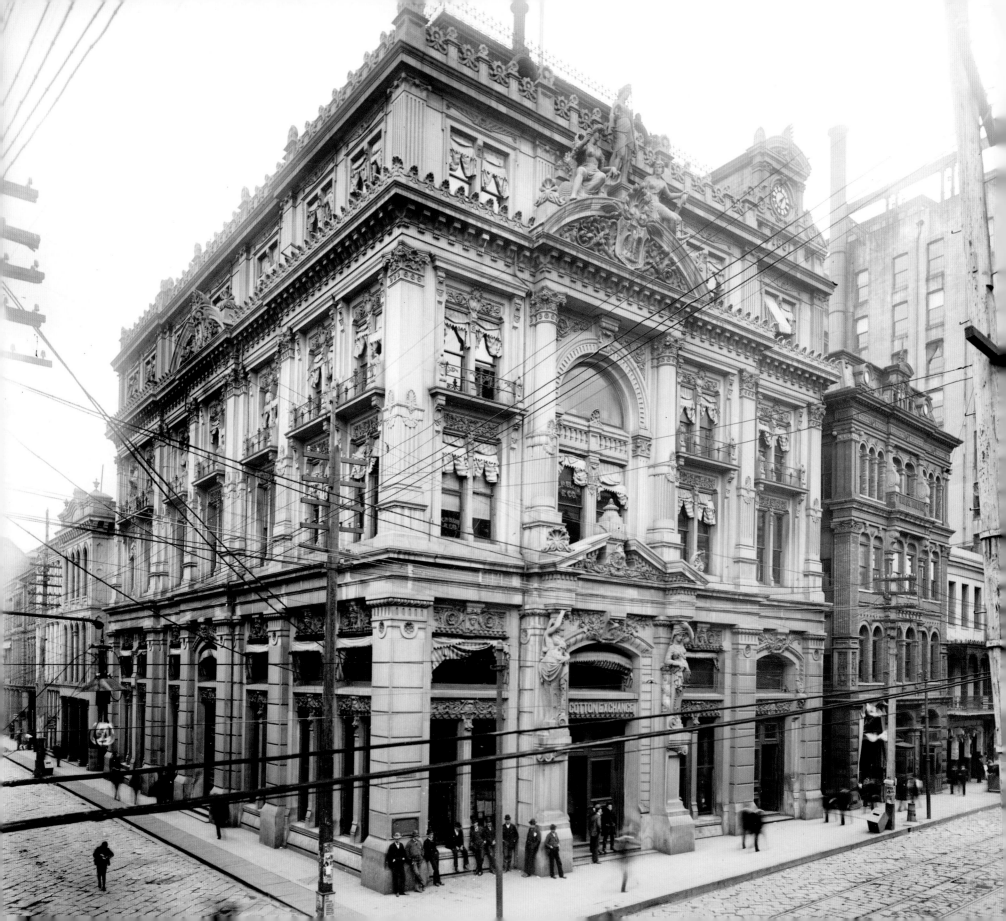

New Orleans Cotton Exchange DEMOLISHED 1920

Top among the high-value exports passing through New Orleans in the 19th century was cotton. Raised predominantly in the lower Mississippi Valley above Baton Rouge, the baled lint was transshipped along downtown wharves from steamboats to ocean-going vessels bound for the fabric mills of Europe and the Northeast. In the streets of downtown New Orleans, a veritable army of "cotton men"—factors, merchants, brokers, agents, lawyers, insurers, graders, classifiers, and affiliated middlemen—stewarded the industry, making princely sums in the process. Most had their offices around the intersection of Carondelet and Gravier streets in the Faubourg St. Mary, nicknamed the "American sector" at the time and now the Central Business District.

"Most of the cotton business was conducted in the open air, up and down Carondelet Street," recalled one elder, or "in saloons, which called themselves 'exchanges....'" What industry players needed was a centralized space with some decorum. Toward this end, in February 1871, a hundred cotton men organized the New Orleans Cotton Exchange and chartered it to provide meeting space; resolve disputes; establish principles, standards, and regulations; analyze and disseminate information; reduce risks; and promote the industry and city's role in it.

At first operating out of rented rooms, the Exchange occupied a three-story building on Gravier off Carondelet. But the organization quickly outgrew this space and erected in 1883 its own magnificent four-story Cotton Exchange Building on the corner of Carondelet and Gravier. Behind the florid façade of the $380,000 structure, variously described as Second Empire, Renaissance, and Italian in architectural style, was a spacious Exchange Room with Corinthian columns, gold ceiling medallions, fresco murals, sculptures, and a fountain. Above were well-appointed offices and meeting rooms on four floors serviced by an elevator. For almost four decades, this building functioned as the "capitol" of New Orleans' Cotton District, just as New Orleans served as the "capital" of Mississippi Valley cotton production.

While the number of local cotton businesses gradually declined by three or four per year from the 1880s to the 1920s, gross receipts continued to rank the crop near the top of the city's moneymakers, and the city at or near the top of the nation's cotton markets. The Great War brought with it uncertainly for American cotton, but it also augmented demand for lint and rejuvenated use of the Mississippi River to deliver it. The South produced its first billion-dollar crop during these years, and doubled it in 1919. Counting on a rosy future, the New Orleans Cotton Exchange in 1920 tore down its building due to structural concerns and replaced it the next year with a modern seven-story structure.

Instead, the new Cotton Exchange oversaw an era of decline. Government regulations, foreign competition, a western shift in domestic production, plus the rise of railroads and the emergence of Dallas, Texas as a business hub, effectively ended New Orleans' status as the nation's premier cotton port. Of the 93 cotton factors in New Orleans in 1880, 15 operated in 1921 and only one remained by 1949. "We went from trading thousands of contracts in the early 1950s to maybe five contracts in all of 1962," recalled Eli Tullis, a retired cotton broker and a member of one of New Orleans' last active cotton families.

The Exchange itself became irrelevant as government price supports smoothed out once-volatile prices and modern communications obviated the need for a trading floor. The building was sold off in 1962—to the Universal Drilling Company, symbolizing the upcoming oil boom—and the Exchange finally closed in 1964, although, according to the last trader, Herman S. Kohlmeyer, Jr., the institution really "just petered out" after the 1962 sale, when the rent was no longer worth paying and "the lights were just turned out."

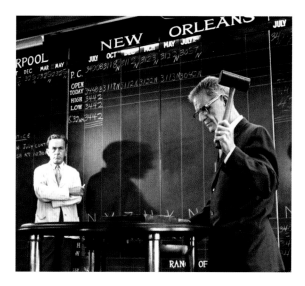

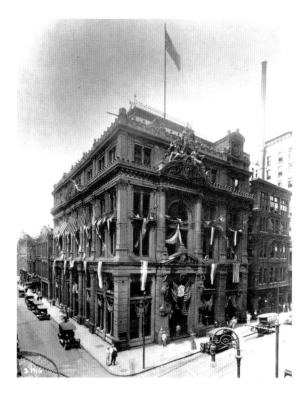

ABOVE *Last gavel at the New Orleans Cotton Exchange, 1964, captured by pioneer television cameraman Del Hall. (Courtesy of Del Hall)*

OPPOSITE & LEFT *The New Orleans Cotton Exchange formed the heart of the city's cotton district, a center of economic power in the city and South. Views here are from 1900 (opposite) and 1916, during World War I (left). (Opposite, courtesy of Library of Congress; left, courtesy of Visual Materials Collection, Southeastern Architectural Archive, Special Collections Division, Tulane University Libraries)*

Old Masonic Temple DEMOLISHED 1921

Freemasonry has been a part of New Orleans society since the Spanish colonial era, when emigrating American masons established a lodge at Camp and Gravier in the new *Suburbio Santa Maria*, away from the disapproving Spanish administrators and Catholic bishops in the old city. After the arrival of American governance and populations after 1803, Freemasons became more common and accepted, and their architecture reflected the change. This corner, 333 St. Charles Avenue at Perdido, has hosted Masonic-affiliated structures since 1845, when the Commercial Exchange was built according to designs by famed local architect James Gallier Sr. Thirteen years later, the Grand Lodge of Free and Accepted Masons acquired the old exchange and made it into their home, adding commercial storefronts on the ground floor, a ballroom on the second floor, and four lodge rooms on the third floor.

The retrofit never quite worked out, and after the Civil War, the Masons eyed the lot of the former Carrollton Railroad Depot near Lee Circle. They acquired it and in 1872 laid the foundation and granite steps for a new Masonic Temple. For some reason, work was interrupted, and with no pressing need to proceed because the old building still sufficed, the Masons eventually abandoned their Lee Circle project. They got a decent deal on the land and decided in 1890 to demolish the circa-1845 building at 333 St. Charles and replace it with a stupendous new temple.

Architect James Freret, who happened to be the son of the president of the old Commercial Exchange, devised for the corner lot something of a cross between a medieval castle and a cathedral— the *Daily Picayune* called it "fourteenth century Gothic"—topped with a statue of Solomon, all symbolic of the Masons' professional legacy and civic-religious aspirations. But the Masons also had their feet on the ground—or rather, their tires: close inspection of the ground floor in the main photograph reveals an early bicycle shop plus three other commercial stores, all of which would have paid rent to the Lodge and help make ends meet. Completed in 1891, the Masonic Lodge became a downtown landmark and a striking fixture of the city skyline, with its peaked roof and pinnacled dormers, intricate friezes, "quadruple Gothic windows," five-story corner turret, and soaring octagonal spire.

Inside were libraries, meeting rooms, the grand lodge, and spaces for chapters, commanderies, and Scottish rites, as well as offices rented to business such as an insurance company (visible here). This being before the era of municipal water service, Freret's design also incorporated artesian wells from which pumps would lift the water to attic tanks, where they were supplemented by rainwater.

The lodge opened in early 1892, but despite its grandiosity, it proved to be high-maintenance and inadequate for 20th-century needs (perhaps the inevitable fate for a building designed as a 14th-century cathedral). After only 30 years, the Masons agreed to replace it with a modernized structure, the second largest lodge in the nation, priced at $3 million. During site preparation in 1922, the circa-1891 square-hewn cypress pilings upon which the old castle rested were extracted and found to be in good condition, but exposure to open air after decades of submersion in watery silt allowed a fungus to form, and they deteriorated in a matter of months.

The new Masonic Lodge Building, designed by the Stone Bros. and built by James Stewart & Co. in a modernized Gothic style, rested on 1,850 yellow pine pilings of various lengths, driven through two layers of ancient cypress stumps, silt, and, in some

places, a sturdy old sandbar. The 18-story high-rise opened in 1926 and served as the state Masonic headquarters until its sale in 1982. A partner building, the Scottish Rite Cathedral, was built at the same time on St. Charles at Calliope, not too far from where the Masons had originally planned their temple in 1872. The 333 St. Charles building today is home to a hotel, while the space where the bicycle shop once operated is now a restaurant. Above are Masonic emblems and a frieze that reads "Erected by the Grand Lodge of Louisiana."

RIGHT *The castle-like Masonic Temple lasted only 30 years before being demolished for a modern building for the same organization. Note the bicycle shop in the corner store. (Courtesy of Library of Congress)*

BELOW *The Masonic Temple's steep pitched roof and spire made it a striking feature of the turn-of-the-century skyline. It is seen here from a rooftop along Carondelet. Note the towering utility poles at right and St. Patrick's and Presbyterian churches at center-left. (Courtesy of Visual Materials Collection, Southeastern Architectural Archive, Special Collections Division, Tulane University Libraries)*

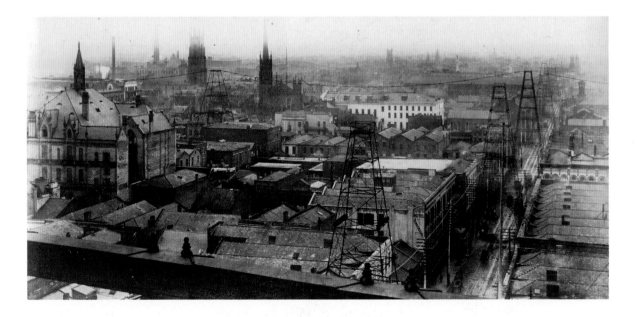

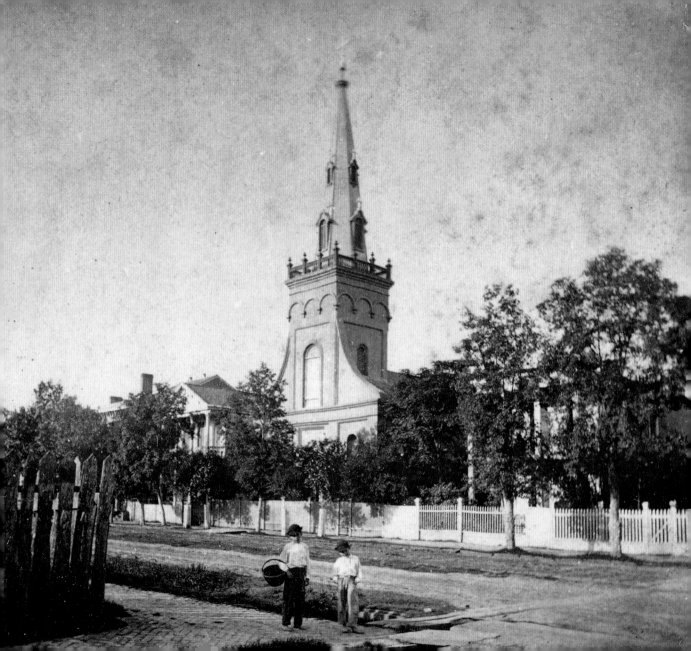

Notre Dame Church DEMOLISHED 1926

Shown here is Notre Dame de Bon Secours Catholic Church, a lost element of historic New Orleans' most remarkable agglomeration of religious institutions—Ecclesiastic Square in uptown's Tenth Ward, better known as the Irish Channel.

Prior to 1852, this area did not fall within New Orleans; rather, it was the City of Lafayette (1832) in the Parish of Jefferson (1825). In its inland area, Lafayette developed into a fashionable garden suburb, aided by the newly established New Orleans and Carrollton Railroad (today's St. Charles Streetcar Line). This is today's Garden District.

Toward its riverside end, however, Lafayette was anything but posh: here, low-density cottage-type housing lined muddy streets, close to the rough-and-tumble flatboat wharves and malodorous industries such as rendering plants and tanneries. These economies kept real estate values low while creating ample low-skilled job opportunities, both of which attracted Irish and German immigrant families.

Among the latter were German Catholics, Protestants, and Jews, and all three groups erected religious institutions on or near Jackson Avenue. Intermixed throughout were various smaller ethnic groups, including French-speaking residents—a bit of an anomaly here, as most people of French ancestry in those days, be they Creoles (New Orleans natives with colonial-era roots) or immigrants (from France or the French Caribbean) tended to live in the lower half of the city. Their presence uptown illustrates that while the city certainly had neighborhoods dominated by one ethnic group, and Anglo and Creole culture did indeed reside separately, ethnic intermixing generally prevailed in the streets of New Orleans. Evidencing this is the fact that the first Catholic church in Lafayette, which opened in 1836, had a mixed French, German, and Irish congregation.

But as the latter two ethnicities saw their numbers increase dramatically in the 1840s–1850s, congregations moved to form "national churches," serving their own people in their own language. Italians, Slavs, Chinese Presbyterians, Hispanics and other groups would do the same later.

Behind the trend were Redemptorist priests from Europe, who arrived at New Orleans in 1837 and founded in 1844 the New German Roman Catholic Church in a little wooden building on Josephine at Laurel. Growth motived the congregants to build the breathtaking German Baroque-style St. Mary's Assumption Church (1858–1860), which still stands on Constance Street. Across from St. Mary's, the Redemptorists had previously erected for the Irish faithful St. Alphonsus Church (1855–1858) in a sort of English Baroque Revival style. Also in 1858, the same fathers built Notre Dame de Bon Secours Church in a Romanesque style designed by architect J. N. B. de Pouilly. Thus, in just a few years, this working-class neighborhood became home to one of the most spectacular collections of religious architecture in the city.

National churches formed because immigrant-dominated congregations usually sought to worship and socialize with members of their own ethnicity or language. But as populations later assimilated into English-speaking American culture, the notion of a "national" (ethnic) congregation became obsolete, and from the perspective of the archdiocese, costly, because it had to staff and fund multiple and redundant churches. In 1920, the congregations of St. Mary's Assumption, St. Alphonsus, and Notre Dame were amalgamated into one parish, with English as its first language. Notre Dame, the smallest of the three churches and a bit removed from the other two, was demolished in 1926.

Today, the two surviving institutions of Ecclesiastic Square operate as St. Alphonsus Parish and St. Mary's Assumption Church. No evidence of Notre Dame church, convent, or orphanage remain, although *Notre-Dame de Bon Secours* (Our Lady of Prompt Succor) remains the Catholic patroness of the City of New Orleans.

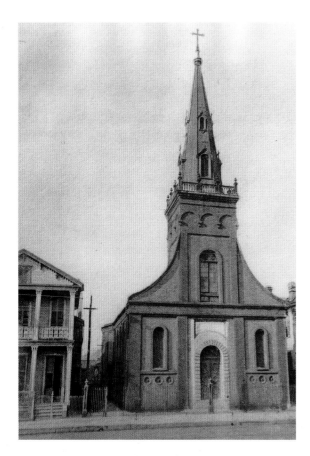

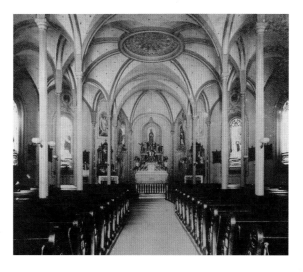

LEFT & ABOVE *Interior and exterior of Notre Dame, designed in a Romanesque style (except for the spire) by architect J. N. B. de Pouilly and photographed by Nina King. (Courtesy of Visual Materials Collection, Southeastern Architectural Archive, Special Collections Division, Tulane University Libraries)*

OPPOSITE *This view of Notre Dame de Bon Secours Church on Jackson Avenue was captured by S. T. Blessing around 1872. (Courtesy of Library of Congress)*

The Sugar District SHIFTED DOWNRIVER 1912; DISAPPEARED 1930s

While cotton came to New Orleans from lands upriver from Baton Rouge, sugar cane arrived from the parishes of southeastern Louisiana, including just outside the city limits. Sugar earnings were truly local, and they derived from planting, processing, refining, packaging, and marketing. For almost a century, all but the first of these activities occurred upon the upper French Quarter *batture* (riverside deposition of sediment) from present-day Iberville to Toulouse and from Decatur to the Mississippi. Here an informal "sugar landing" formed, starting in the 1830s and gradually growing into New Orleans' Sugar District, from the 1870s to the 1930s.

What prompted the growth was a plan by businessman Francis B. Fleitas to rekindle the postbellum economy by building permanent fireproof sheds along the railroad tracks on Wells Street. Fleitas' New Orleans Sugar Shed Company (1870), capitalized at $1,200,000, erected 308-foot-long molasses and sugar sheds with distinctive saw-tooth rooflines, a feature that would visually characterize this industrial landscape for years. Actually open-air pavilions, the sheds had floors "arranged to slope along to gutters which will convey the drippings of the molasses or sugar into [38 80-gallon] tanks places under the floor." A newspaper recorded that "operators in sugar now meet in the sheds instead of on the landing."

The bustle attracted other sugar-related businesses to locate adjacently, notably those behind the Italianate edifice designed by Henry Howard in 1867 known as the Importers Bonded Warehouse (1873) along North Peters between Conti and St. Louis. Many adjacent *batture* lots fell into the hands of sugar interests as well as

RIGHT & BELOW *Lands in the foreground of these circa-1906 bird's eye views were deposited by the Mississippi River after the founding of the original city of New Orleans (extreme left). Called a* batture, *the river-deposited sediment was shored up, protected with a levee, and, starting in the 1830s, used as a landing for the region's sugar industry. Later in the 1800s, it developed into a full-scale industrial sugar processing district. (Courtesy of Library of Congress)*

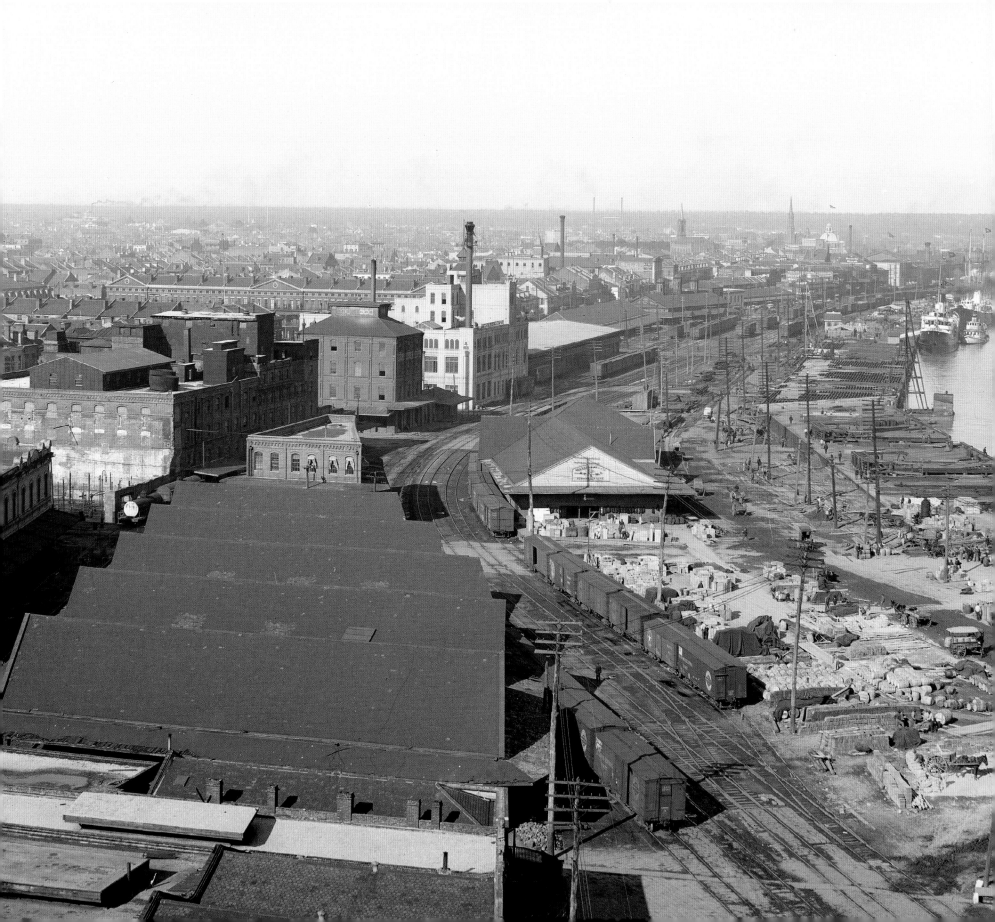

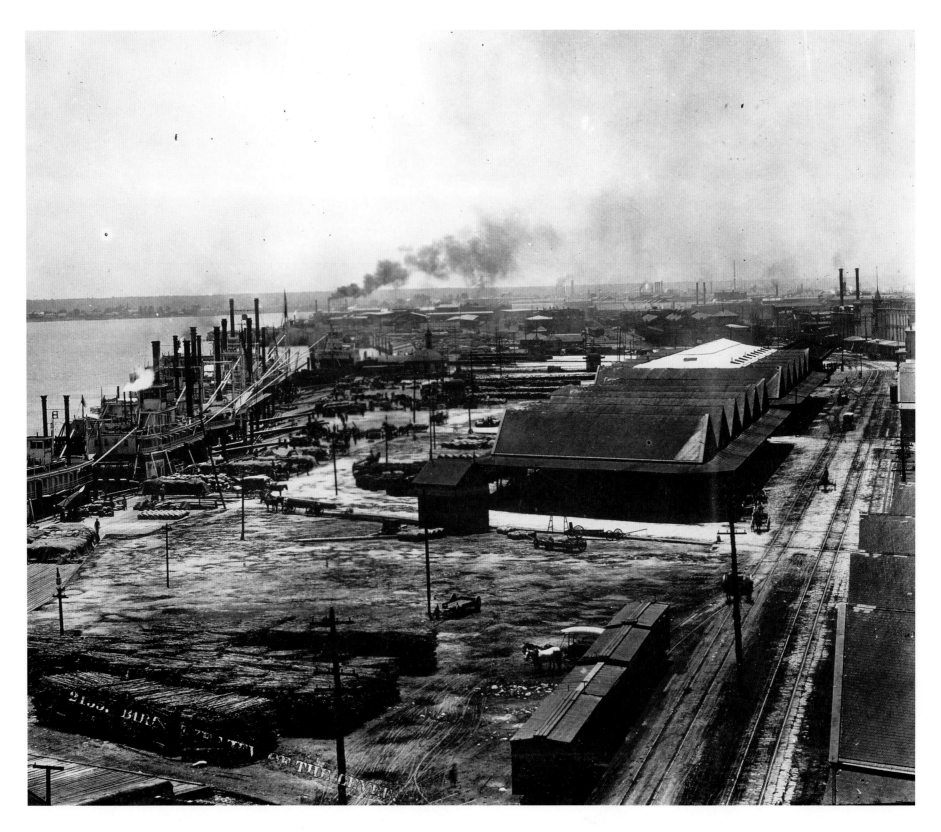

lumbering mills, railroads, and cooperage shops. By 1876, sugar and related businesses occupied 40 percent of upper French Quarter riverfront, not including railroads and wharves.

The 1880s witnessed this area's transformation into a *bona fide* industrial district, where raw sugar flowed in from rural sugarhouses and refined sugar flowed out to consumers nationwide. Three blocks upriver from the Planters Refinery (1881) was the Louisiana Sugar Refinery (1883–1884), described as "the largest and most substantial structure in the city" and "the largest sugar refinery in the South." Built by Alexander Muir for $300,000, the 10-story Filter House rose to 120 feet with a 130-foot smokestack—all just a few blocks from Jackson Square.

The Planters and Louisiana companies competed ferociously until they began colluding in 1886. In 1891 both firms came under the ownership of the newly incorporated American Sugar Refining Company, a trust controlled by America's first family of sugar, the Havemeyers. The ASRC erected another Filter House at North Front and Bienville in 1899–1900, the second-highest structure (over 162 feet) ever to exist within the French Quarter. By 1896, at least 80 percent of this area was dedicated to sugar as well as rice and related industries. Space was increasingly tight, and the ASRC began to cast its eyes elsewhere.

What reversed the fortunes of the Sugar District was the ASRC's decision to shift its operations downriver to semi-rural Arabi in St. Bernard Parish, where it built the state-of-the-industry Chalmette Refinery in 1909–1912. It also did not help that Louisiana sugar cane suffered in this era from blights, frosts, erratic rain, and threats to eliminate import duties. Worse, in 1914 the state filed suit to cancel the ASRC's license to do business in Louisiana on grounds of monopolization, and while grievances were eventually resolved and the suit withdrawn, the controversy instilled further uncertainty. The number of sugar businesses steadily declined and the district shrunk. The antiquated Fleitas sheds were removed, and new warehouses and tracks severed the old landing's direct access to the river. Sugar price collapses in 1920–1921 further exacerbated the post-war decline, and disastrous crops in 1923–1928 led to plantation closures and an exodus of laborers.

By the early 1930s, New Orleans Sugar District was all but extinct, and because its gritty industrial ambiance failed to charm preservationists, most of its solid brick edifices fell to fire, neglect, or the wrecking ball. Today, most of the scenes in these photos are parking lots, and few people recognize that the French Quarter had, for over 60 years, a bustling industrial district.

OPPOSITE *This 1880s view of the riverfront at Bienville Street shows Fleitas' sugar sheds, which, with the sawtooth roofline, became a visual signature of the Sugar District. (Courtesy of Visual Materials Collection, Southeastern Architectural Archive, Special Collections Division, Tulane University Libraries)*

BELOW *Pay day for workers at the Southern Pacific shed near the Sugar District, circa 1903.* **BOTTOM** *Some of the largest edifices ever built within the present-day confines of the French Quarter were the industrial complexes of the American Sugar Refining Company. (Courtesy of Library of Congress)*

Benevolent Institutions CLOSED 1930s

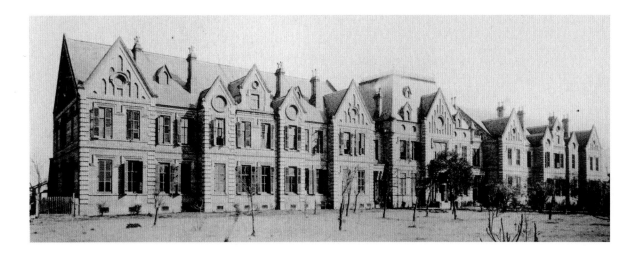

RIGHT *Camp Street Female Orphan Asylum, located behind a statue of the famed Margaret Haughery, "Mother of Orphans." (Courtesy of Library of Congress)*

LEFT *The Touro-Shakespeare Alms House in 1895, built on present-day Daneel between Joseph and Nashville.* **BELOW** *The Children's Home of the Protestant Episcopal Church was located on Jackson Avenue across from the original Jewish Orphan and Widows Home. It later became the Sara Mayo Hospital and was demolished around 1970. (Courtesy of Visual Materials Collection, Southeastern Architectural Archive, Special Collections Division, Tulane University Libraries)*

New Orleans once abounded in orphanages, asylums and other social service facilities sponsored by religious institutions, civic society, and wealthy benefactors. In nearly every district could be found imposing edifices whose formidable countenances matched the type of care to be found within, the kind that did not indulge. Stuffy, stern, and solid, these institutional buildings predominated in outlying neighborhoods in both uptown and downtown, which had lower population densities and cheaper land prices. The charitable giving derived from Americans' deep-rooted instinct to solve problems among themselves, without relying on government. Organized religion filled the gap by coordinating donations of time and money from able-bodied congregants to fellow worshippers in need. Fiscally, a sense of *noblesse oblige* prevailed among the aristocracy (and for good reason, as their wealth often derived from enslaved or exploited labor), and the absence of income taxes left patricians with more money than they could ever spend. Some created endowments or bequeathed funds and appointed boards to oversee charitable institutions, in the hope of giving something back and leaving the world better than they found it.

Benevolent funds proliferated, and typically they flowed to orphans, whose numbers tragically swelled after every epidemic. There was, for example, the Henderson Fund, willed by Steven Henderson in 1837, which went to Charity Hospital,

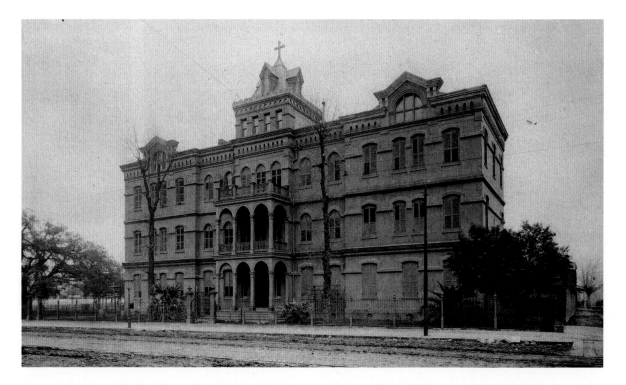

the Asylum for Destitute Boys, the Female Orphans Asylum, and the Firemen's Charitable Association, plus a number of churches and poor houses. There was the Girod Fund, from Nicholas Girod, who willed money to orphans of French heritage. There

was the Milne Fund, which Alexander Milne used to establish the Milne Asylums for destitute boys and girls as well as other social aide institutions, not to mention land holdings that would become today's City Park. There was Judah Touro's fund, which

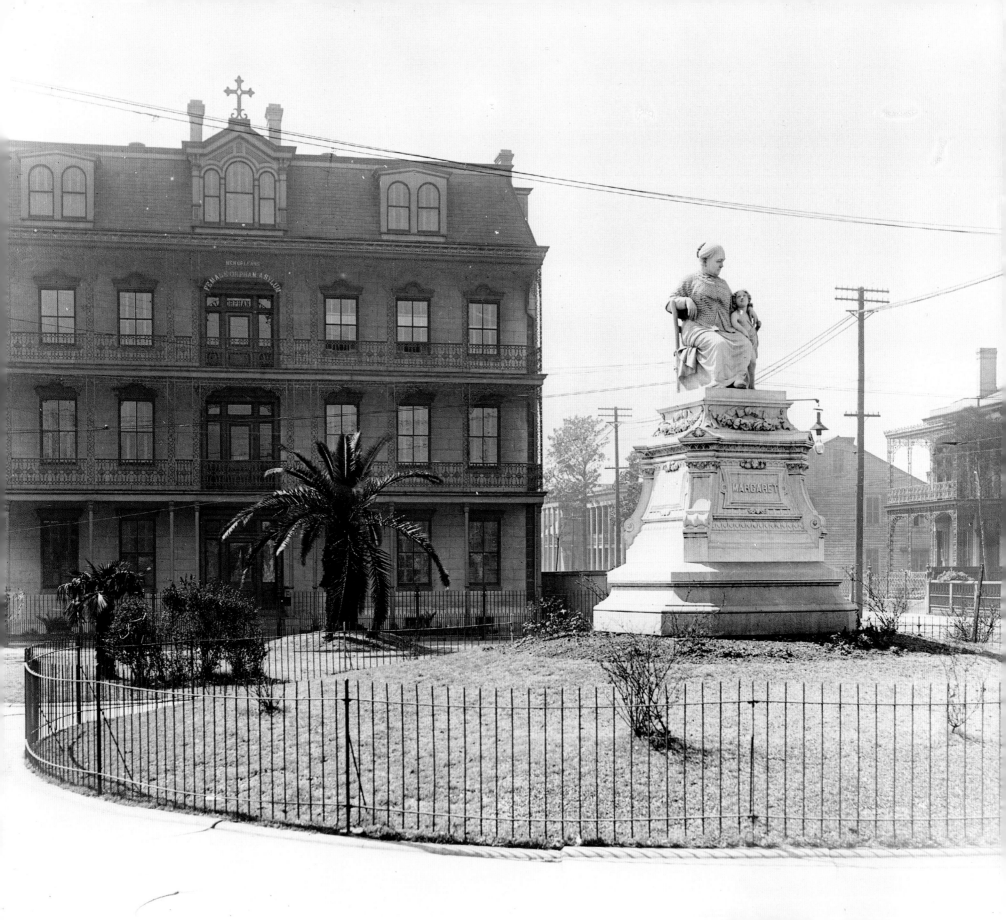

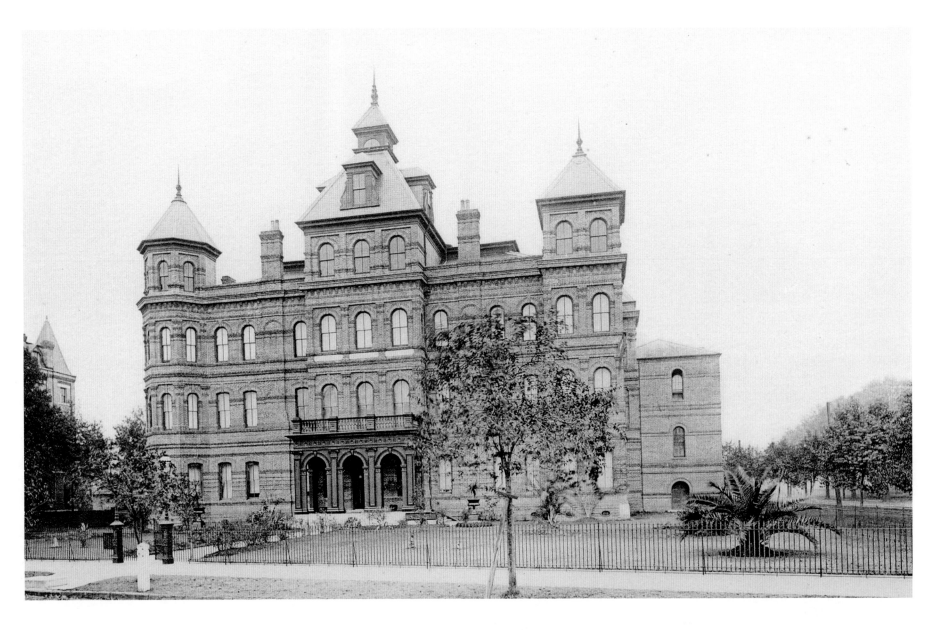

went to alms houses, and John Fink's fund, which paid for a Protestant Widows home and asylums. There was Simon Sickles' Fund for medical equipment for the poor, Julian Poydras' fund for orphans, and Isaac Delgado's bequest for an industrial school and art museum. Most famously, there was John McDonogh, who willed his estate to expand and improve the city's nascent public school system. In most cases, control of these funds was granted to the City of New Orleans, where their administration sometimes became a matter of public controversy. Shown here are some

landmarks representative of New Orleans' unusually generous charitable-giving tradition.

A home for the Association for the Relief of Jewish Widows, Orphans, and Half-Orphans, said to be the first in the nation, opened on Jackson at Chippewa in 1855–1856, across the avenue from the Children's Home of the Protestant Episcopal Church, founded in 1853 by the Christ Church. The building was designed by Thomas Sully and built in 1884. It closed in 1942, becoming Sara Mayo Hospital, and was demolished around 1970.

When German Jews moved uptown in the

ABOVE *The majestic Jewish Orphans and Widows Home on St. Charles Avenue and Peters, now Jefferson Avenue. (Courtesy of the author's collection)*

RIGHT *McDonogh public school #14 was one of over 30 schools funded by the estate of John McDonogh. Most have been closed, repurposed, or renamed. (Courtesy of Visual Materials Collection, Southeastern Architectural Archive, Special Collections Division, Tulane University Libraries)*

FAR RIGHT *A bust of John McDonogh, with figures of grateful children laying a wreath to his memory, stands in Lafayette Square. (Courtesy of Library of Congress)*

1880s, they built a stately new Jewish Orphans' Home (1887) designed in a French Renaissance Revival style also by Thomas Sully on St. Charles Avenue at Peters, now Jefferson. No longer needed by the late 1950s, it was demolished and the site now hosts the Jewish Community Center.

Just a few blocks away was the Touro-Shakespeare Alms House (1895), on present-day Daneel between Joseph and Nashville. Established by Judah Touro, the Touro Alms House was originally located on Louisa Street by the river until Union troops torched it at the end of the Civil War. Trustees eventually rebuilt uptown at the site seen on page 38. In 1901 control of the fund shifted to a city commission and was renamed the Touro-Shakespeare Alms House. Officials in 1927 decided to move the home across the river; the block-long site was sold, cleared, and subdivided for residences, and a new site was established in Algiers in 1933. The Touro-Shakespeare Nursing Home at 2650 General Meyer Avenue remains in operation today, under city management.

The circa-1840s Camp Street Female Orphan Asylum, one of the largest in the city, was founded in 1850 to receive toddlers as they outgrew St. Vincent's Infant Asylum, which still stands on Magazine at Race. The famed Margaret Haughery, whose statue appears in the photograph on page 39, became one of the greatest benefactors of orphanages in the city, including this asylum. An orphan herself, the Irish immigrant started in business as a peddler and made a fortune as a baker. Working with the Sisters of Charity, she founded or aided at least a dozen orphanages citywide and became beloved as the city's Mother of Orphans.

Charitable giving in New Orleans still tends to be generous compared to other metropolises. But the social aid institutions it once financed are now mostly defunct, except for some schools, hospitals and elder-care facilities. What caused their closure was the very government investment whose absence previously called them into existence. The expansion of state-sponsored social services under

the leadership of Louisiana Gov. Huey P. Long in the early 1930s, plus New Deal programs at the federal level, shifted the obligation of social aid from the private to the public realm. To the cheers of liberals and dismay of conservatives, services once underwritten by wealthy citizens, albeit unevenly, now became government services stewarded by taxpayer-funded bureaucracies, albeit inefficiently. Orphanages suffered additionally from a rather Dickensian reputation and fell out of favor after World War II; nearly all closed in favor of state-administered group homes and foster programs.

Whatever the gains or losses from the circa-1930s shift of social services, there is no argument that it eliminated the uses of historical institutional structures and led to the demolition of most.

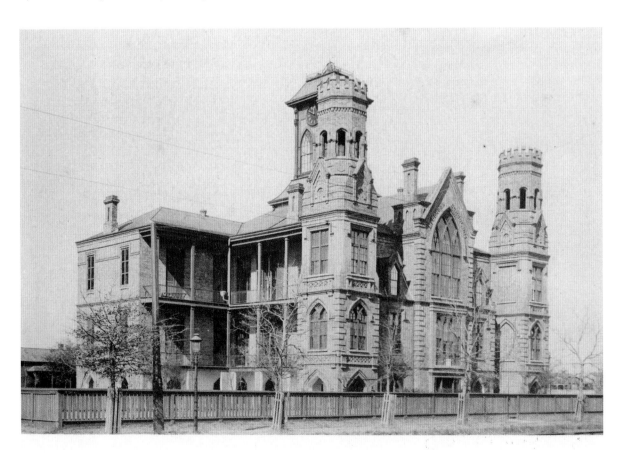

Poydras Market DEMOLISHED 1930–1932

The Poydras Market, established in 1838 during a major expansion of the municipal market system, served residents of Faubourg St. Mary with a two-block long pavilion in the neutral ground of Poydras Street from Penn to South Rampart. The market offered every conceivable foodstuff plus other household goods via hundreds of open stalls united under a pavilion-like roof with a picturesque wooden cupola.

Markets in the antebellum era were owned by the city, controlled by ordinances, and managed by one commissary per market, who oversaw suppliers, stall keepers, deliveries, and the building itself. In the 1850s, the Poydras Market developed a reputation for being, according to the *Daily Picayune* (1858), "intolerably filthy, from the want of facilities for obtaining water," which left the public "disgusted at the uncleanliness," not to mention "so crowded as to be almost impassable." The bustle attracted loiterers and vagrants, some of them coming from Phillippa (Dryades, now O'Keefe) Street, which at the time hosted a remarkable concentration of brothels and saloons. Toward the woods was a sketchy district known appropriately as "the Swamp," a notorious lair where flatboatmen debauched, as well as the putrid New Basin Canal (1832) with its tough workforce. Violence was common in this area, and in 1860 it came to the Poydras Market proper, when an unemployed woman, likely a prostitute, exchanged words with what she described to the *Daily Delta* as "a beautiful looking man with a gold watch around his neck"— and ended up getting shot by him.

Mostly, however, ordinary law-abiding people patronized the Poydras Market for their everyday sustenance, and it prospered to the point that in May 1866 the City purchased the neutral ground of Poydras from South Rampart to Basin for expansion. The new section, known as the Pilie Market, relieved the overcrowding of the original pavilion. A reorganization of the market system in 1868 saw the stands and stalls in the Poydras sold to a new set of owners—market space was sold and not leased by the city in those days—although many stall owners subleased to renters, a source of constant controversies in the late 19th century.

This was the era in which an immigrant population of Orthodox Jews from Russia, Poland, and other parts of Eastern Europe arrived at New Orleans, as they had in much larger numbers at New York. Some found work as peddlers and merchants at the Poydras Market, where vendors of a dozen other ethnicities could also be found. Because Dryades Street ran through the structure and connected it with the 325-stall Dryades Market a mile uptown, both markets became central to the residential settlement and economic ascendency of Orthodox Jews. Into the 1960s, Dryades Street above Howard Avenue and the adjacent blocks toward St. Charles Avenue was known citywide as New Orleans' "Jewish neighborhood," and while this occupancy is mostly on account of the Dryades Market, it originated with the Poydras Market.

In 1911, New Orleans' market system peaked with its 34th unit, placing it among the largest in the nation and certainly the highest per-capita. Shortly afterwards, however, municipal markets grew increasingly ill-suited for 20th-century life. Nearby corner grocery stores continued to draw consumers away from the drafty halls of the quaint old stall markets, and a shift of the population into modern automobile-based subdivisions near Lake Pontchartrain undermined their client base. The Poydras Market and others responded by forming merchants' associations and lobbying the city for improvements.

But City Hall had other designs: in 1927, the recently formed City Planning and Zoning Commission, which prioritized for modernization and saw the public market system as a relic of the past, proposed the removal of the Poydras Market and the railroad tracks farther inland on Poydras for the widening of both Dryades and lower Poydras.

In January 1930, the section of the 92-year-old market between Dryades and Penn was torn down explicitly to make space for vehicles. Two years later, the city officially abandoned the Poydras Market because it "was no longer needed and it constitutes a serious traffic hazard," and the remaining sections were unceremoniously cleared away in June 1932 by men otherwise unemployed during the Depression. Dryades was later renamed O'Keefe, and both it and Poydras were widened in the 1950s–1960s. Poydras Street, after 1966, became the city's showcase corporate boulevard, the address of skyscrapers and petroleum money, to a degree that it is almost hard to believe the scenes on these pages took place there well within one human lifetime.

RIGHT *William Henry Jackson photographed the passageway of Dryades (now O'Keefe) Street beneath the cupola of the Poydras Market in the 1890s.* **BELOW LEFT** *View up Dryades through the Poydras Market in the 1920s.* **BELOW** *An 1898 annex of the Poydras Market seen in the 1920s, when it was increasingly viewed as a traffic obstacle. (Courtesy of Library of Congress)*

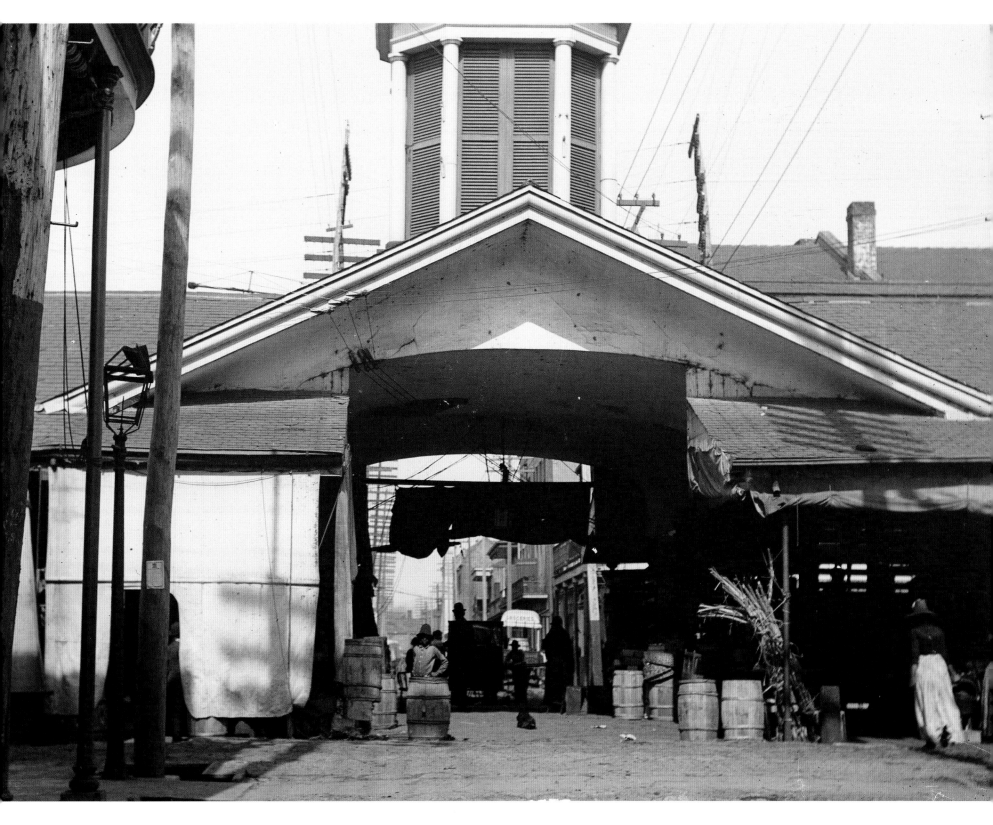

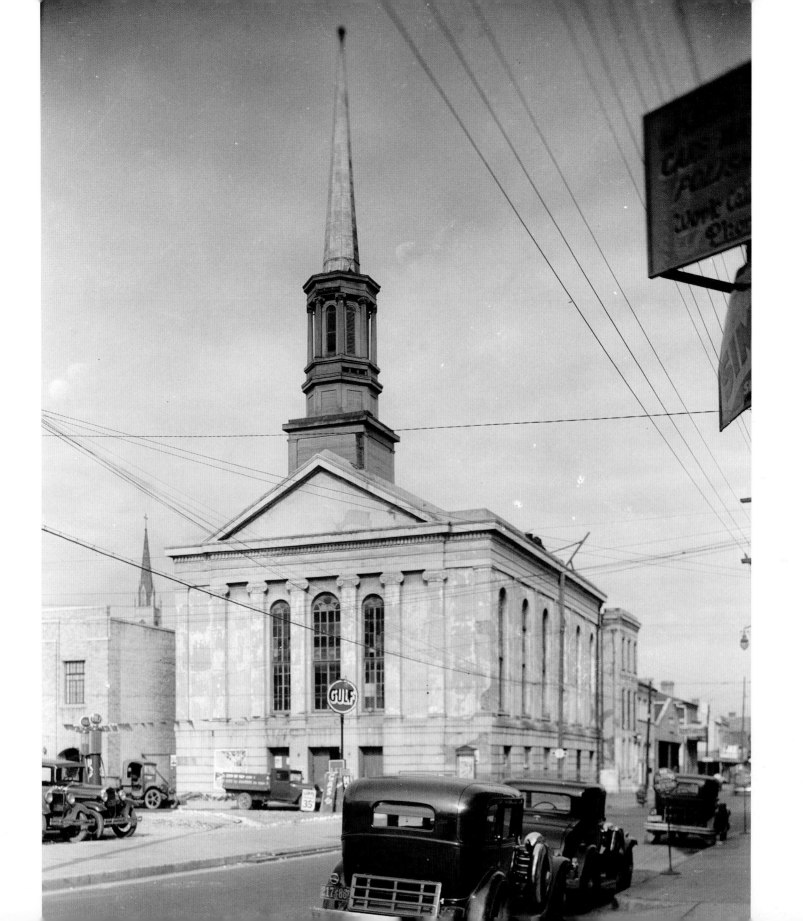

Central Congregational (Fourth Presbyterian) Church DEMOLISHED 1935

This majestic church traces its origins to the Presbyterian missionary work of Herman Parkard, who arrived at New Orleans in 1838 and died in 1858 while acquiring land for a church building. Over the next two years, workers for architects/builders Samuel Jamison and James McIntosh erected on the corner of South Liberty and Gasquet (later Cleveland) this imposing 43-foot-high Greek-order temple, notable for its Ionic pilasters and spire. First services at the Fourth Presbyterian Church were held in May 1860.

Twelve years later, the building was sold to the American Missionary Association, a New York-based African-American Protestant organization originally formed in 1846 to further the goals of abolition, education, and racial equality. Most members were Presbyterians, Methodists, or Congregationalists, and in New Orleans, each of these sects had segregated white and "colored" churches. This building, renamed the Central Congregational Church, became home to one of the four African-American congregations. After the 1872 sale, the Presbyterians built the Canal Street Presbyterian Church nearby on Canal Street at Derbigny, and moved there.

Worshippers at Central Congregational Church entered vestibules in the grade-level "basement" on South Liberty Street and ascended a double staircase to the main auditorium on the raised *piano nobile* (principal floor). Twelve feet above their heads was a balcony and choir loft supported by iron columns, and 27 feet above the 50 angled pews was a pressed-tin ceiling added during a renovation. Atop the temple was a 16-foot-high pediment and slate roof, a three-story octagonal tower, and finally the signature 49-foot spire, whose conspicuously slender proportions stand in contrast to the church's hulking dimensions. Architect Samuel Wilson, documenting the structure for the Historic American Building Survey, described the tower as a "frame construction with eight fluted wood columns with wood bases and cast iron Ionic caps. The slender spire is sheathed with sheets of copper and topped with a copper ball." The landmark was visible throughout downtown, all too visible to the hedonists and whores in Storyville on the other side of Canal Street.

Central Congregational Church stayed true to the American Missionary Association's foundational aims of racial equality, and for years its pastors marked Abraham Lincoln's birthday with special sermons on Lincoln's life and times. Sunday school and child care was also provided in the basement of the church. By the 1930s, expanding membership, an inland shift of the residential population, and economic pressure downtown for commercial building and parking space motivated church leaders to sell their aging structure. It was demolished in spring 1935 for a parking lot, even as Samuel Wilson, who would go on to become a founding member of New Orleans' historic preservation movement, took last-minute architectural measurements and sketches. Today the footprint of the circa-1860 church has been subsumed by the Tulane University Medical Center.

OPPOSITE & ABOVE *The Fourth Presbyterian Church on South Liberty and Gasquet, opened in 1860 and was sold to the American Missionary Association, a New York-based African-American Protestant organization, in 1872. Renamed the Central Congregation Church, it became one of the region's largest religious edifices with a black congregation. (Courtesy of Library of Congress)*

LEFT *The disproportionately slender spire of the Congregational Church made it easily recognizable on the downtown skyline. (Courtesy of the author's collection)*

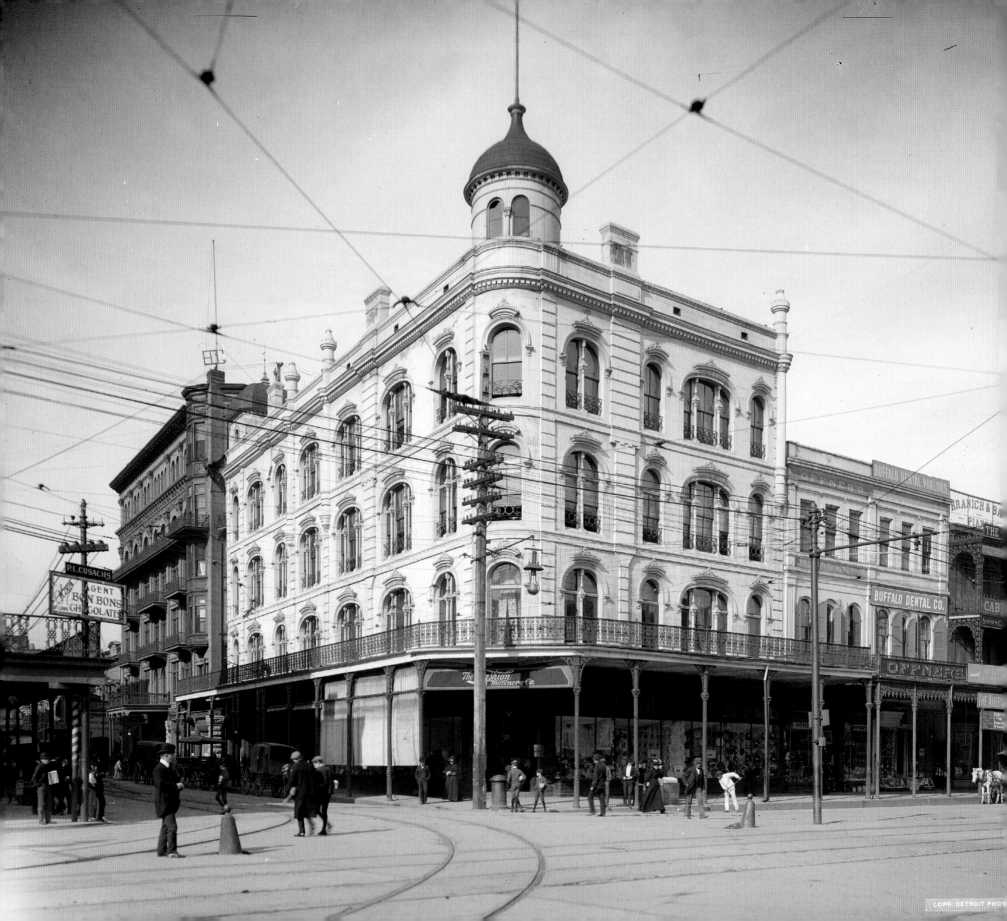

Chess, Checkers, and Whist Club

DEMOLISHED 1937

If, as Alexis de Tocqueville observed in 1835, Americans "made associations" for every conceivable reason—"to give entertainments, to found seminaries, to build inns, [to found] hospitals, prisons, and schools…" then New Orleans was a veritable city of associations. To this day, it's a clubby sort of town—the usual Rotary and Kiwanis but also old-line krewes like Rex and Comus and century-old civic societies such as Le Petit Salon and The Orléans Club for ladies, the Boston and Pickwick clubs for men, not to mention the Autocrat and Young Men Illinois clubs, various social aid and pleasure clubs, and Mardi Gras Indian tribes. Before television usurped people's evenings and air conditioning drove them indoors, clubs and other social associations prospered, and some were big enough to occupy landmark buildings on prominent thoroughfares.

The club behind this building on the corner of Canal and Baronne was a gentlemen's social and literary fraternity first organized in 1880 and formally dedicated in 1882 to "promote the knowledge and encourage the development of the scientific games of Chess, Checkers and Whist; the cultivation of literature and science…and thirdly the regulation of social intercourse and amusement." After meeting in a series of provisional homes, Chess, Checkers and Whist settled into the Perry House, a stately row building in the French style which had been erected on Baronne and Canal after the 1850 demolition of the Louisiana State House and a predecessor of Charity Hospital (1815). The club leased the space for an annual rent of $3,600.

Chess, Checkers and Whist was serious about its games. Just about any news of chess tournaments—and if New Orleans was a club town, it was also a chess town, home to champion Paul Morphy—involved this club and this clubhouse. At one point over a thousand members strong, the organization proudly claimed what the *New York Times* described as "one of the most valuable libraries in the world," including Morphy's archives and memorabilia.

All were lost one night in January 1890, when a fire broke out in an oyster stand in an alley behind the club. The loss of irreplaceable contents was heartbreaking, but the club's membership, which read like a *Who's Who* of the city's aristocracy, endeavored to persevere and had the money to do so. "The [destroyed] building…is one of the most desirable sites in New-Orleans," explained *The Times*, situated "in the clubhouse neighborhood, and without doubt the most elegant and costly club edifice in the South will rise from its ashes."

They were right. Shortly after the fire, the handsome building pictured here, distinctive for its twin turrets and finials, was constructed on the same site, and the club negotiated with its owner a $5,000 annual lease. For the next 30 years Chess, Checkers and Whist held their tournaments and amusements here, and used its perch on Canal Street for lavish Carnival balls and parade-watching. Among the more noted events in the club's history was the 1916 and 1919 visits of Cuban chess master José Capablanca, who treated members to a week of lectures and "individual and peripatetic play." The building also generated income through rental of storefront units and other spaces.

By the 1910s, Canal Street was becoming a bit too congested for Victorian-style gentlemanly leisure. The owner of the building renewed the club's lease at $10,000 per year, double the original rent, and when it rose again to $12,500, the club decided to buy their own home. At first they eyed a smaller structure farther in on Baronne, next to Immaculate Conception, but instead, in 1919, bought part of the circa-1892 Cosmopolitan Hotel on the first block of Bourbon Street for $215,000. The old clubhouse at Canal and Baronne took on new tenants and came to be known as the Beer Building. Investors contemplated the lucrative corner location for other uses, particularly with the Maison Blanche Building across Canal Street, with its dozens of doctor and dentist offices and high demand for medicinal prescriptions. Missing its signature corner cupola in its latter years, the old clubhouse was cleared in 1937 and replaced the next year by the streamlined Art Deco-style Walgreen's, still in operation today as a flagship location of the national pharmacy chain.

Chess, Checkers and Whist Club continued on Bourbon Street for another 15 years, but during that time some key first-generation leaders died and new members failed to fill their shoes or match their numbers. The halcyon days of Tocqueville's "associations" had plateaued if not peaked by this time, and operating a large building in prime real estate became harder to pull off in the spare time of even the rich. In 1935, the club's contents were auctioned off, its Bourbon Street high-rise was demolished for a Woolworth's, and the organization faded away.

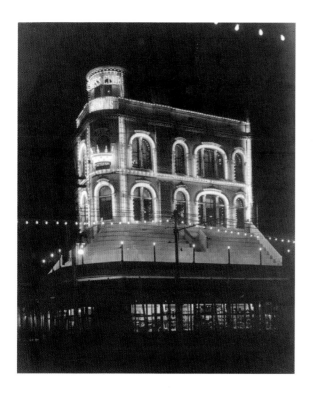

OPPOSITE & LEFT *One of a number of high-society men's clubs on or near this section of Canal Street, the Chess, Checkers, and Whist occupied this building at the Baronne intersection for 30 years before moving to Bourbon Street. Note the Hotel Grunewald (now the Roosevelt) at left in the main image. (Courtesy of Library of Congress)*

Carondelet (Old Basin) Canal FILLED BY 1938

Passage between Lake Pontchartrain and New Orleans in colonial times meant guiding a vessel up Bayou St. John and disembarking at Bayou Road for a two-mile portage to the city. A canal would make ingress and egress much more efficient, and in June 1794, Spanish Governor Francisco Luis Hector, Baron de Carondelet announced the excavation of just such a waterway, to be dug with the labor of prisoners and slaves "donated" by local planters. Decreed by the Cabildo to be called *Canal Carondelet*, the 15-foot-wide, six-foot-deep waterway was dedicated in August 1796 and put to use. But Carondelet was transferred to Quito the next year, and without his oversight, the canal became all but impassable by the early 1800s.

A French-born Saint-Domingue refugee named James Pitot, who arrived at New Orleans in 1796 and managed to get himself appointed mayor in 1805, saw promise in the muddy run. He organized the Orleans Navigation Company and, after $300,000 in expenditures and extensive legal battles, opened a much-improved channel in May 1817. "Where there was formerly a filthy ditch and noisy frog-pond," wrote John Adems Paxton in 1822, "we find a beautiful canal, with a good road and walks on each side, with gutters to drain off the water, and a large and secure Basin." Two tow paths paralleled the canal so beasts of burden could pull vessels with cargo at a fee of $1.25 per ton. A drawbridge at Bayou St. John, a lighthouse at the bayou's mouth, and an extra-wide timber-reinforced strait at the lakeside port completed the operation. The canal also became something of an urban amenity; New Orleanians enjoyed strolling along the Carondelet Walk and viewing the formal gardens planted adjacently.

The Carondelet Canal developed into a key commercial waterway through which small craft brought in, according to Paxton, "cotton, tobacco, lumber, wood, lime, brick, tar, pitch, bark, sand, oysters…furs and peltries" from the marshes and piney woods. The canal became a key asset of the lower-city Creole population in their heightening competition with recently arrived Anglo-Americans uptown. "We frequently see in the Basin," wrote Paxton, "from 70 to 80 sail, of from 550 to 600 barrels, from the West Indies, the northern states, Pensacola, Mobile, Covington and Madisonville…"

The Anglos uptown thought they could do better. In 1831, the New Orleans Canal and Banking Company capitalized with $4 million to bring the lake trade to the American side of town. Using Irish "ditchers" for labor, the Canal Bank completed a wider, deeper, straighter waterway—the New Basin Canal—by 1838 and swiftly pulled economic activity away from its downtown rival. The Carondelet Canal became, literally and nominally, the "Old Basin Canal;" the Orleans Navigation Company went bankrupt in 1852 and auctioned off its waterway.

A new company, the New Orleans Canal and Navigation Company, took over the asset that year, followed in 1857 by the Carondelet Canal and Navigation Company. Into the 1900s, the century-old course served as a local industrial corridor through a picturesque cityscape that included the Parish Prison, Tremé Market, Globe Theater (shown here), Storyville, St. Louis Cemeteries #1 and #2, Congo Square, expansive Creole faubourgs (suburbs, or neighborhoods) associated with the development of jazz, and the track bed of the Southern Railroad, which used the canal's right-of-way and deposited passengers at Terminal Station on Canal starting in 1908.

These same railroads were also competing with canals generally for cargo, and by the 1910s, trucks on roads diverted an additional share of the business. The old waterway suffered another defeat in 1913 when the Louisiana Conservation Commission ruled lake oysters must enter the city via the state-owned New Basin rather than the private Old Basin Canal, which had a reputation for cheating the commission of its taxes. Besides, the New Basin was more centrally located, had better wagon access, and earned tollage fees for the state. By 1919, the Old Basin Canal, now under the control of railroad companies, commanded barely one-third the business of its crosstown rival.

With its career winding down, New Orleans' first major navigation canal was declared unnavigable in 1927 and was filled in by 1938. Into the 2000s, the former bed formed a conspicuously open swath along Lafitte Street through otherwise densely populated neighborhoods. Citizen activism starting in 2006 impelled the city to transform the land into a walking and biking path once again aimed to connect the old city to Bayou St. John. The "Lafitte Greenway" is currently under construction.

RIGHT *The Old Basin Canal formed an industrial corridor through a picturesque cityscape that included the Parish Prison, Tremé Market, Globe Theater (building at center), Storyville, St. Louis Cemeteries #1 and #2, Congo Square, expansive Creole faubourgs (suburbs) and the track bed of the Southern Railroad.* **BELOW** *This circa-1910 scene shows the Carondelet (Old Basin) Canal's turning basin, essentially an inland port, where barges, schooners, and oyster luggers docked to deposit resources from around Lake Pontchartrain (firewood in this case) for downtown markets. (Courtesy of Library of Congress)*

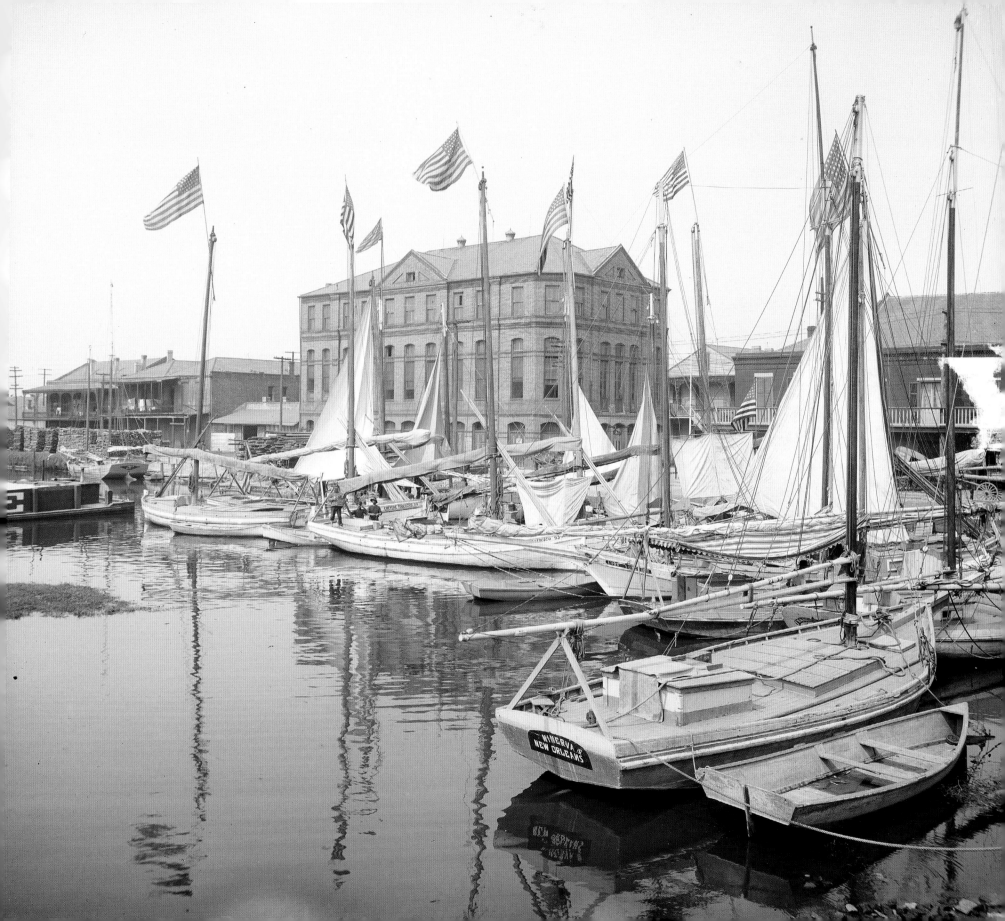

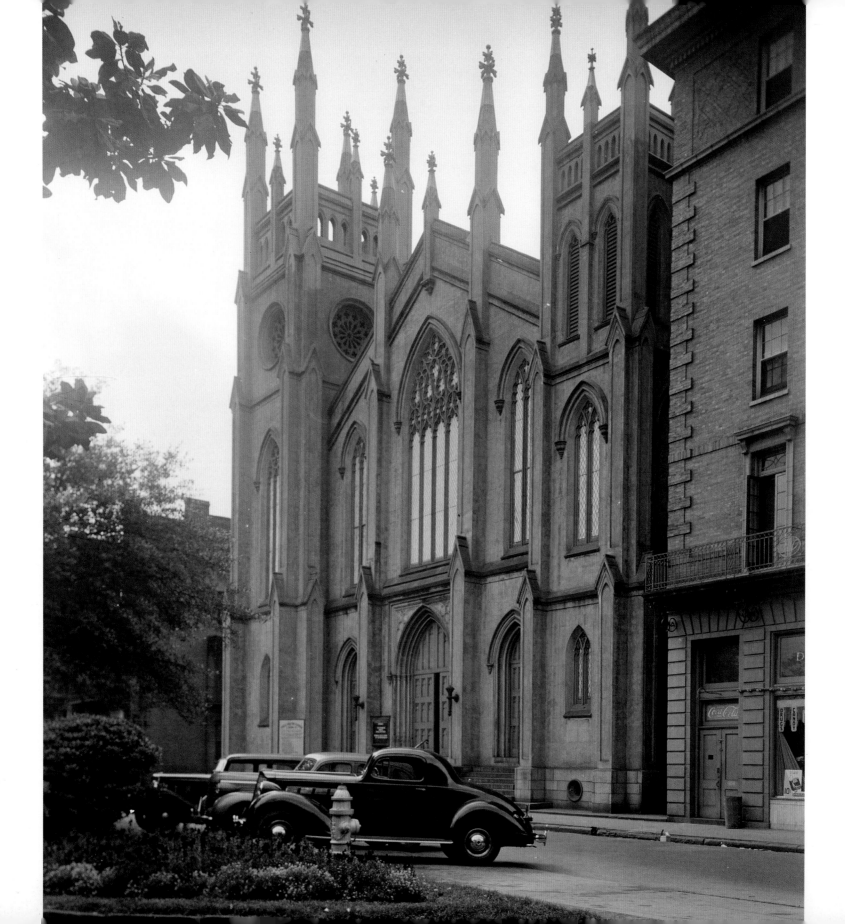

First Presbyterian Church DEMOLISHED 1938

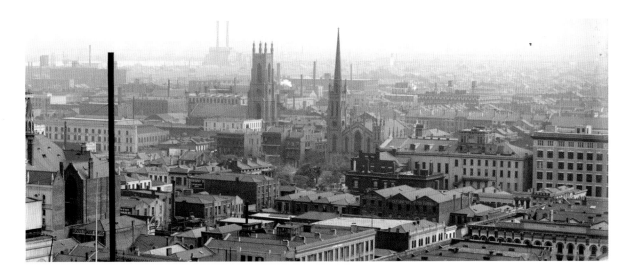

A Gothic landmark soaring over Lafayette Square, the First Presbyterian Church reflected changes in 19th-century New Orleans society's religion, language, ethnicity, and architecture. Presbyterianism first arrived here in 1817 when the Connecticut Missionary Society sent representatives to assess spiritual conditions in this Catholic city. Finding need, the Society dispatched Rev. Sylvester Larned to the city in 1818, and he proceeded to acquire a parcel and a $40,000 loan for the establishment of a Presbyterian Church.

Over the next year, the original First Presbyterian Church, a modest Gothic edifice more suited for a village than a city, arose on St. Charles at Gravier, a neighborhood where Anglo-American Protestants predominated. Larned died in 1820 and left his flock of 40 to the brilliant theologian Dr. Theodore Clapp, who stabilized the Presbyterians' earthly finances by selling the original church building to his friend, Jewish philanthropist Judah Touro. But on matters of Presbyterianism's Calvinist doctrine, Clapp was provocative—so much so that the Mississippi Presbytery deposed him from the ministry. Undeterred, he went on to found the Congregationalist Unitarian Church of the Messiah—the "Strangers Church"—within the old Presbyterian building now owned by Touro. It burned in the 1851 fire that also claimed the adjacent St. Charles Hotel.

The Clapp affair forced the Presbyterians to find a new home in a warehouse on the upriver side of Lafayette Square. Under the leadership of Dr. Parker, the congregation came into possession of the lot in 1835 and erected upon it, at a cost of $70,000, the "second" First Presbyterian Church of New Orleans, in what a source at the time described as "the Grecian Doric order."

On October 29, 1854, a fire destroyed the building. The prosperous congregation of 600 members promptly funded a new structure, designed in Gothic Revival style by architect Henry Howard and built by George Purves. This "third" First Presbyterian Church was completed in November 1857 at a cost of $87,000—"a more complete and elegant structure for the cost and purposes is not to be found anywhere," declared the *Daily Picayune*, "and it will be reckoned among the finest ornaments of the city." Purves erected the spire by assembling it within the tower and lifting it into position. Located across the street from the new City Hall, the First Presbyterian Church became a beacon of the First Municipal District—and the emergent Anglo-American economic and political power.

Ministering at this time was Rev. Benjamin Morgan Palmer, who would gain notoriety for his "Thanksgiving Day Sermon" delivered on November 29, 1860, a few days after the election of Abraham Lincoln as President of the United States. A gifted orator, Palmer passionately defended the institution of slavery and questioned the sanctity of the union. Palmer's sermon, which was widely distributed, fanned the flames of Secessionist sentiment and won momentum for Louisiana's joining the Confederate States of America. That April, war broke out, and Palmer would go on to be something of an unofficial minister to the Confederacy.

Among the many changes New Orleans witnessed after the Civil War was the movement of wealthy residents out of inner neighborhoods and into the new faubourgs (suburbs) farther uptown. Protestants in general, as well as Reform Jews, made the shift, and their houses of worship soon followed. In 1905 the Presbyterians acquired land on St. Charles and State, and in 1912 they built the St. Charles Avenue Presbyterian Church as their main house of worship, with a number of other branches distributed citywide. The Great Storm of 1915, meanwhile, felled the spire overlooking Lafayette Square and heavily damaged the main building, causing a debate among congregants as to the symbolic importance of their historic home. The old church was repaired without the spire.

The Corporation of the First Presbyterian Church held on to the title deeds of its historic Lafayette Square property until 1937, when a committee in Washington, D.C. selected the site for what is now the F. Edward Hebert Federal Building. In a bittersweet Easter Sunday service, members worshipped in their old home for the last time on April 17, 1938, and workmen commenced demolition the next morning. Funds earned from the sale underwrote the construction of the "fourth" First Presbyterian Church, on Claiborne between Jefferson and Octavia, which remains in use today. According to the congregation, relics from the 1857 church now in the 1939 structure include "the organ, bell, pews, [most] stained glass windows, matching tables [and] the four chairs on the altar, millwork on the rear choir loft, and two plaques."

Charity Hospital DEMOLISHED 1938

Charity Hospital, a legendary institution in local culture, traces its origins to the early French colonial era. The original *L'Hôpital des Pauvres de la Charité* (Charitable Hospital for the Poor, 1736) operated out of the provisional convent of the Ursuline nuns at Chartres and Bienville, reflecting the sisters' role in introducing physical as well as social and spiritual care to inhabitants of the rustic outpost. The infirmary moved in 1743 and again in 1786, when it received an endowment from Don Andres Almonaster y Roxas and relocated to the city's backswamp edge, in part to keep the infirmed segregated from the rest of the population. After New Orleans became an American city and population distribution shifted in an upriver direction, Charity moved in 1815 to Canal Street between Baronne and present-day University Place, and again, in 1832, to Common Street (now Tulane Avenue) between Howard (now LaSalle) and Robertson in the rear fringes of Faubourg St. Mary. Here, using slave labor, builders erected this elegant complex. The site was ideal because it was close enough to the bulk of the population while also being far enough behind the city to minimize fears of disease and contagion associated with hospitals in those days.

Run by the Sisters of Charity to serve ailing indigents, Charity Hospital had 800 beds in the Main Building plus two corner clinics for women and children. In the rear was a large courtyard for convalescing, surrounded by additional wards for white and "colored," plus kitchens, laundry, about 10 cisterns, power plants, and ancillary structures. Charity also had a horse-drawn ambulance service stabled across the street, one of the best equipped operation amphitheaters in the nation, and, by the end of the century, over 7,000 patients per year.

Its size and position attracted similar institutions to co-locate, to take advantage of skilled labor and key infrastructure such as gas lines, water lines, and laundry services. Among the other hospitals were the Maison de Santé (1840, at Canal and Claiborne, two blocks away) and the Hotel Dieu (1859, Common and South Johnson, five blocks away), the Tulane University of Louisiana's Richardson Memorial Hospital (1892, also known as the Josephine Hutchinson Memorial Building, built across Canal Street between Villere and Robertson), the Delgado Memorial Clinic and adjacent Richard Milliken Memorial Hospital for Children. This cluster would explain the formation of the modern-day Tulane Avenue medical district.

By the 1930s, advances in health care and structural safety catalyzed an effort to rebuild Charity Hospital according to modern standards. The century-old building had already been condemned by the State Board of Health and the New Orleans Fire Marshall, and renovating it was out of the question. In September 1935 the Public Works Administration granted the state $3.6 million for a modern 20-story structure with a much larger footprint. Other federal and state funds grew the budget to $12.5 million, and during 1937, the old complex was demolished in stages while work commenced on a new Charity—an immense art-deco structure designed by Weiss, Dreyfous and Seiferth and built by R. P. Farnsworth. Opened in 1939, the new state-run Charity for the next 66 years would become the free hospital for the birth, healing, and death for countless New Orleanians of the poor and working class, not to mention training ground for thousands of Tulane and LSU medical students. The Delgado and Milliken buildings were demolished in 1952 for the LSU Medical Building.

Administered by the two universities in an oftentimes contentious relationship, Charity eventually fell within the LSU system, and it continued its service to the poor until August 29, 2005, when Hurricane Katrina struck. The deluge inundated the complex's ground floor and basement and damaged its infrastructure, but to what degree, and at what cost, became hotly debated topics once it became public that the state would not reopen Charity. Repair estimates varied wildly between preservationists and advocates for the poor, who wished to keep the historic behemoth open, and state officials and development advocates, who held out for a new University Medical Center (UMC) farther up Tulane Avenue. The latter effort prevailed, and in 2010–2014, a vast expanse of the historic Third Ward was cleared for the UMC and adjacent Veterans Administration facilities. The circa-1939 Charity Hospital remains empty, with suggested tenants ranging from City Hall to a hotel to a mixed residential/commercial/office building. Demolition, however, is not out of the question.

OPPOSITE, TOP *Charity Hospital as an institution dates to the French colonial period. After a number of sites in and around the original city, the hospital moved to the rear of the Faubourg St. Mary in 1832, where its presence led to the formation of the city's medical district. (Photograph by Louis T. Fritch, courtesy of Visual Materials Collection, Southeastern Architectural Archive, Special Collections Division, Tulane University Libraries)*

OPPOSITE, BELOW LEFT *This panoramic photo from 1928 shows Charity Hospital at left, the Delgado Memorial Clinic at right, and the city's gasworks in the background.*

OPPOSITE, BELOW RIGHT *The Delgado Memorial Clinic (center left) and Richard Milliken Memorial Hospital for Children (corner) join Charity Hospital (cupola, left) to start to form a medical district. The city's gasworks appear in the background. (Courtesy of Visual Materials Collection, Southeastern Architectural Archive, Special Collections Division, Tulane University Libraries)*

BELOW *Richardson Memorial Hospital, built in 1894 as a gift for Tulane University's medical school, was not located in the heart of the medical district but rather on Canal Street, between Villere and Robertson—across the street from a brewery and the nation's largest legal red-light district, Storyville. (Courtesy of Library of Congress)*

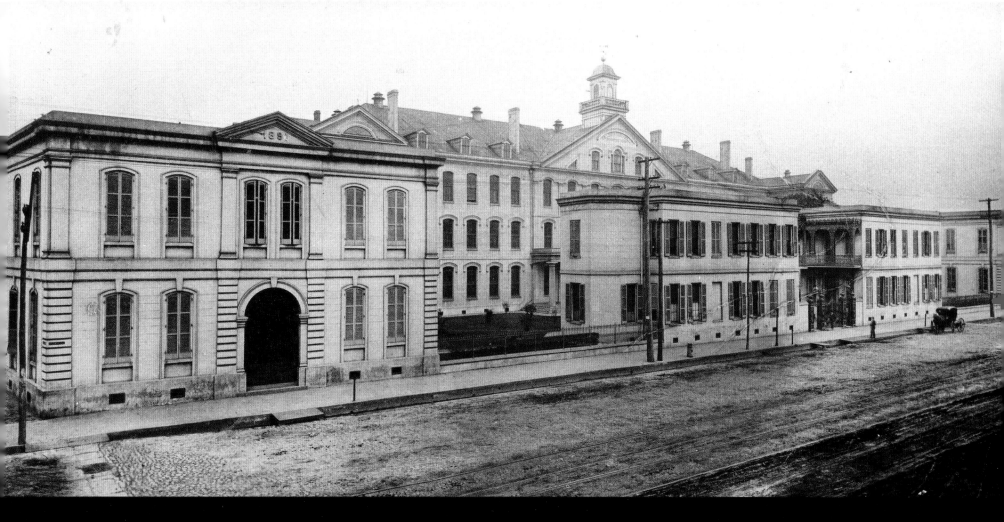

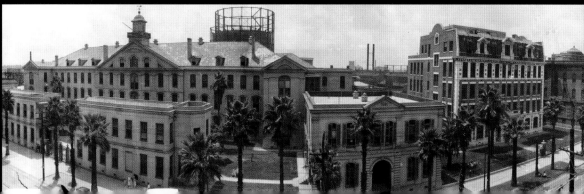
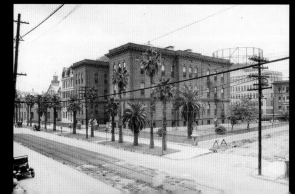

Storyville CLOSED 1917, DEMOLISHED 1940

The mounting visibility of the sex trade in the late 1800s motivated reformers in New Orleans to experiment with legislation to reign in vice. In early 1897, a newly elected councilman named Sidney Story came forth to present an innovative tactic. In the words of historian Alecia Long, Alderman Story and his allies, "acknowledging their belief that sins of the flesh were inevitable, looked Satan in the eye, cut a deal, and gave him his own address."

Story proposed isolating prostitution to the blocks bounded by Basin, Customhouse, Robertson, and St. Louis streets, an area that had been a den of iniquity since antebellum times. His ordinance deviated from previous legislative fixes in that it banned prostitution outright throughout the rest of the city, leaving, by default, sex-for-money freely and legally practicable therein. The proposal seemed better than the alternatives, and the ordinance passed.

"Storyville," as the district was sardonically dubbed, opened on January 1, 1898, and in short time a full suite of risqué entertainment businesses relocated to its 16-block domain. Business boomed, and in the process, the vice industry invented its own neighborhood. It created a signature streetscape in the form of Basin Street (a.k.a. "The Line," the same moniker given to Broadway in Manhattan's Tenderloin District), where magnificent mansions became gaudy "sporting houses" and prostitutes called down from balconies to men walking "down the Line." It also produced an iconic gateway in the

form of Tom Anderson's famous Basin Street saloon. It had accessibility, being located only steps from the French Quarter, Canal Street, and the new Terminal Station. According to Long, only three years into its existence it boasted, 230 brothels, 60 houses of assignation, and scores of cribs, concert saloons, bars, cafés, and restaurants—this despite a steep $5,000 licensing fee for concert saloons mandated by a 1903 ordinance. Storyville also generated employment for pianists and other musicians, nurturing the development of what would later be called "jass" or jazz. Most of all, it garnered national fame and infamy for New Orleans, and, to the chagrin of reformers, breathed new 20th-century life into the city's 18th- and 19th-century reputation for hedonism.

What darkened Storyville's prospects was the Great War. From a coldly economic standpoint, American involvement in the conflict was a godsend for New Orleans, as it catalyzed river traffic, motivated improvements, and sent newcomers by the thousands through the city, destined for war plants or the Western Front. Hotels and restaurants originally intended for leisure travelers now catered to men in uniform, and after victuals and a nap, many proceeded gingerly over to Storyville.

Reformers saw Storyville as the heathens' lair and targeted it for cleansing. But legal as it was, they redirected their efforts to a nearby cluster of illegal cabarets known as the Tango Belt, which competed with Storyville. Sometimes antagonisms got out of

hand: in March 1913, a feud erupted into violence and brought public attention to the ongoing "Tenderloin War." Storyville was becoming dangerous; its colorful reputation darkened. By the mid-1910s, Storyville had lost business to the Tango Belt, where, according to one enraged reformer in 1916, "there is more vice in one hour than in the so-called tenderloin district [Storyville proper] in twenty-four hours."

Such protests met with stony silence at City Hall, because authorities like Mayor Martin Behrman, despite their personal queasiness, knew all too well that the sex trade practically minted money. Berhman and the "ring Democrats" were also suspected by reformers to be in the pocket of tenderloin bigwigs like Basin Street saloonkeeper Tom Anderson.

City Hall's fiscal calculus changed, however, when the U.S. Navy expressed concern about the health and well-being of its fighting men and threatened to withdraw wartime investments from cities like New Orleans if local governments did not clean up their prostitution problems. In a remarkable commentary on the economic importance of the sex trade, Mayor Berhman travelled personally to Washington to persuade the Navy to spare Storyville. Arguing that policing, monitoring, and the recent racial segregation of the district—viewed at the time as a long-overdue progressive reform—should allay the Navy's concerns, Berhman initially met with success. But sentiments changed as the matter went up the ladder. Closure orders were issued, and on November 12, 1917, Sidney Story's 20-year-old experiment to segregate seediness officially ceased. Twenty-three years later, nearly every building was leveled for the Iberville Housing Project, and today only one complete Storyville-era structure still stands.

LEFT *View of St. Louis Street along the lower edge of former Storyville, December 3, 1934. (Courtesy of Corbis)*

RIGHT *This remarkable aerial photograph of Storyville was taken in the late 1910s. Note St. Louis cemeteries #1 (bottom right) and #2 (middle); the Old Basin Canal at extreme right, and the tracks on Basin Street to Terminal Station at extreme bottom. (Courtesy of Visual Materials Collection, Southeastern Architectural Archive, Special Collections Division, Tulane University Libraries)*

FAR RIGHT *This detail of a 1919 panoramic photograph captures Storyville at upper left center, with its famous bordellos "down the line" of Basin Street. The 200-foot-high smokestack at right marked the Consumers Electric plant between Rampart and Basin. (Courtesy of Library of Congress)*

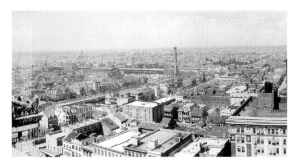

Street Peddlers DECLINED 1940s

New Orleans has long played host to street peddlers and itinerant vendors, who in their economic perambulations blurred the lines between wholesale and retail, between commercial and residential space, and between working and socializing. So much did peddlers dominate food sales in the colonial era, Spanish administrators, intent on inspection and regulation, decided to erect the city's first public marketplace explicitly to centralize them. According to Cabildo records of the 1780s, peddlers of "fresh beef, fresh pork, salted meat and sausages...mutton, venison, rice, fresh and dry vegetables, wild fowl...and fresh fish" were instructed to arrive to the market on a fixed day where they would be assigned a stall for "a small fee." But centralization left open the competitive advantage of convenience—that is, of bringing supply to demand by taking the product to the streets—and new peddlers eagerly seized it, despite the suspicious eye of envious storekeepers and tax-hungry authorities.

Peddlers came disproportionately from the less-privileged sectors of society: immigrants, the poor, women, blacks both enslaved and free, and children of all ages. Benjamin Latrobe reported in 1819 that "in every street during the whole day [enslaved] black women are met, carrying baskets upon their heads calling at the doors of houses." An 1843 *Daily Picayune* description of Madison Street called it "a sort of Congress of Nations," where you would find "a Swiss clockmaker...a French tailor...a Spanish harness maker...the store of a Jew peddler [sic], a Dutch knife grinder...a negro barber...then to a French restaurant, where professional musicians and others eat *gombo*..." A. Oakey Hall in 1847 characterized, with various levels of scorn, the peddlers he saw as the "Yankee with his curious knick-knacks," and "the Jew...with his hundred-bladed penknives, sponges, and metallic tablets." Peddlers also traversed municipal markets such that it was difficult to distinguish between stall venders and itinerants. A local journalist observed in the French Market in 1859,

> here the Italian, with his basket of eggs, there the Yankee, with a table covered with cakes of soap, trinkets and nick nacks; squatted on this side, the Indian squaw [with] sassafras roots [and] *gombo* powder; the plantation negro [with] honey, palmetto brooms and young chickens, rabbits, Guinea pigs and choice Shanghai or Bantam fowl. The Frenchmen solicits your attention to his cheap, fine goods [and] the Spanish oystermen crying 'salt oysters!'

For every depiction of charm, however, peddlers were dealt a dosage of contempt. An 1891 letter from Mayor Joseph Shakspeare, for example, illustrates how elites sneered at such groups: "We find [Southern Italians and Sicilians] the most idle, vicious and worthless people; they monopolize the fruit, oyster and fish trades and are nearly all peddlers, tinkers or cobblers... New Orleans could well afford...to pay for their deportation." Despite the derision, peddling empowered impoverished individuals to control their own economic destiny, and it prevailed well into the 20th century, as vendors of fruit, bread, sweets, snacks, novelties, and services ranging from knife-sharpening to chimney-sweeping strolled the streets of New Orleans, oftentimes with signature singsong cries.

Most ubiquitous of all were the newsboys. Hand-distribution of periodicals provided reliable employ for boys since the earliest days of print. During their turn-of-the-century prime, they emanated principally from Newspaper Row on Camp Street and Bank Place, where legions of newsboys, most of them orphans, would move papers from press to reader via foot and streetcar. For some, Newspaper Row was also home: on cold winter nights in the 1860s–1880s, some waifs would sleep in the corners of press rooms, "huddled together as thick as kittens in a rag basket," according to an 1885 *States* description. Their numbers were such that, in 1879, the Society of St. Vincent de Paul and the Sisters of Mercy of St. Alphonsus moved their newsboys' home to Bank Place and offered a school, dormitory, kitchen and chapel tucked among three floors of paper warehousing.

Child-labor laws, truck delivery, and coin-operated vending machines ended the era of the downtown newsboy by the 1940s.

LEFT & RIGHT *Images of peddlers and street life in New Orleans during the 1910s to 1930s. (Courtesy of Library of Congress)*

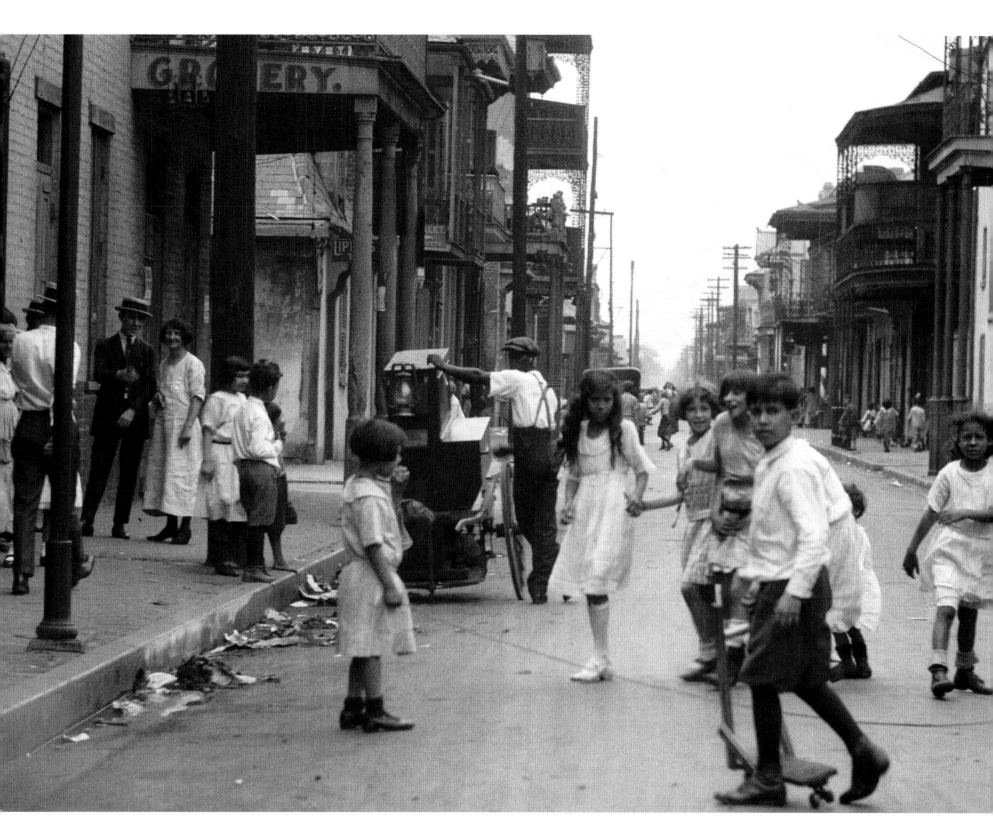

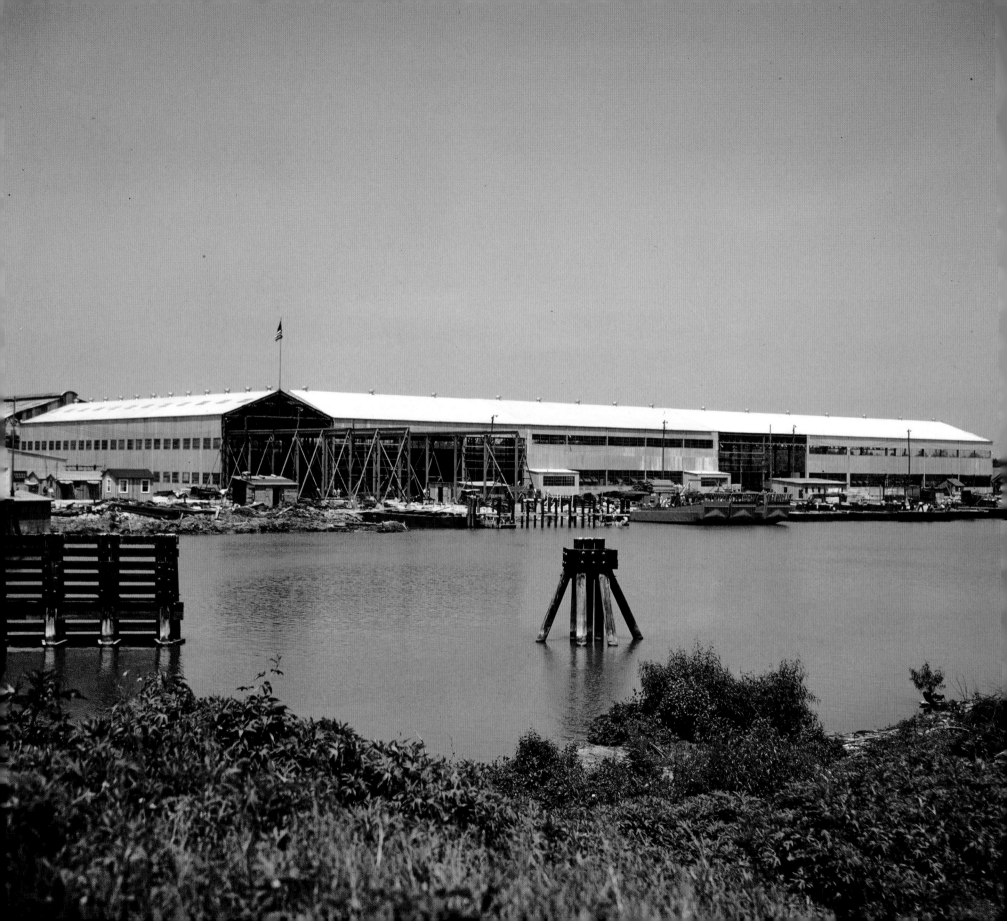

Higgins Industries **DOWNSIZED 1945**

The South in general and New Orleans in particular played significant roles in the American effort to fight Axis aggression in World War II. The federal government invested $4.4 billion in Southern war plants, including $1.77 billion into strategically positioned, oil-rich Louisiana, more than any Southern state save Texas. What brought the action to New Orleans proper was the energy of one man, Andrew Jackson Higgins, a Nebraska-born boat builder who for years specialized in designing shallow-draft vessels capable of navigating Louisiana's bayous—for everything from harvesting oysters to wildcatting for oil to running illegal rum.

Higgins had the answer to a perplexing tactical problem confounding American military planners: How do you land millions of troops on two overrun continents when the enemy controls all deep-draft harbors? By modifying his bayou boats, Higgins revolutionized amphibious warfare by dispersing invasions along sparsely defended beachfronts rather than dangerously concentrating them at a port which first had to be captured. With a mix of brilliant vision, dazzling managerial skills, and mercurial arrogance—his philosophy was that boat builders know more about boats than purchasers and should design a boat according to the purchaser's needs, not requests—Higgins won over East Coast-inclined Navy bureaucrats and landed lucrative contracts to build assault craft and other vessels in his adopted hometown of New Orleans.

No ordinary businessman, Higgins was personally involved in the design of his various vessels and practically invented production-line boat manufacturing, something the Ford Motor Company attempted but never mastered. One time in 1941, for example, Higgins got an emergency contract dated June 7 to build 49 tank lighters—amphibious vessels designed to land tanks on beaches—for delivery in two weeks. He got permission from the city to turn the 1600 block of Polymnia Street into a tented factory, scheduled 800 workers in round-the-clock shifts, arranged for materials—and successfully delivered 49 tank lighters to the Navy on June 21, 1941. With comparable verve, New Orleans, long a mercantilist city, became for the next four years a heavy manufacturing center, and while it paled in comparison to Northern counterparts, its industrialization was rapid and its output critically important.

Higgins Industries would produce 20,094 boats—most of the Navy fleet—and employ nearly as many people, including blacks and women, across seven gargantuan plants at City Park and Bayou St. John, along the lakefront and Industrial Canal (seen here), and at Michoud and Houma. Its most famous vessels included the Patrol-Torpedo (PT) Boat and the Landing Craft Vehicle-Personnel, or LCVPs, which deposited troops at Normandy on D-Day and in other amphibious landings in both theaters of the war, particularly the Pacific.

Thousands of rural Southerners moved to New Orleans for the work, creating housing shortages and transforming Louisiana's bucolic population to one that was mainly urban. Metro-area homeowners rented rooms to strangers, and historic mansions were hurriedly renovated for "war-working families." New Orleans' 1940 population of 494,537 swelled to an estimated 545,041 by mid-1943, and 559,000 by 1945. The coastal and riverine region, meanwhile, shifted dramatically from a 19th-century fur, fisheries, and sugar cane economy to one of petroleum extraction and processing, forever changing isolated Acadian (Cajun), Creole, and Native American folk cultures. Southern Louisiana became nationally important, and after years of poverty, Louisianians now had more work than they could handle, thanks largely to Andrew Jackson Higgins and the war.

Higgins Industries downsized radically in the three years following World War II, but managed to transition to civilian craft and other manufacturing and survive in different corporate forms into the 1970s. All but forgotten by then, Higgins, who died in 1952, received posthumous appreciation in the 1990s and inspired local historians, led by Stephen Ambrose, to launch the National D-Day Museum in New Orleans. The project was so successful following its inauguration in 2000 that it expanded its coverage to all Allied amphibious battles of the war, and later to the entire war.

Renamed the National World War II Museum, the complex now comprises permanent and rotating exhibits across three blocks in the Warehouse District and features "Higgins boats" in various states of renovation. Of all the old Higgins plants, only the Michoud site still operates in a manufacturing capacity; here, contractors for NASA and private industry build rocket fuel tanks and other aerospace apparatus.

OPPOSITE, LEFT & RIGHT *Higgins Industries produced 20,094 boats and employed over 20,000 people across seven plants at City Park and Bayou St. John, along the lakefront and Industrial Canal, and at Michoud. (Courtesy of Library of Congress)*

Fellman's/Feibleman's Clothing Store

DEMOLISHED 1948–1949

More conspicuous than the cupolas of Godchaux's and the Chess, Checkers, and Whist Club, the three-and-a-half-story turret of Fellman's Dry Goods Store on the corner of Carondelet Street formed an architectural landmark and a visual novelty in the Canal streetscape. The building attached to it was not originally built for retail but rather as a clubhouse for the Pickwicks, an organization of influential uptown Anglo-Americans famous for launching the Mistick Krewe of Comus in 1857 and introducing formal, tableau-based parades to previously desultory Mardi Gras celebrations. The Pickwick Club (1883) was one of a number of such fraternal organizations headquartered in this area; the Louisiana (Harmony) and Boston clubs were two and four doors down. After an 1893 fire, the Pickwicks moved the next year to a nearby building, which opened an opportunity for an up-and-coming merchant by the name of Leon Fellman.

Fellman had first arrived at New Orleans in 1864, during the federal occupation, and learned the merchant trade as an employee in one of the city's many Jewish-owned department stores. In the 1870s he and his brothers set off to establish Fellman's on Canal Street, where they specialized in fine women's attire and eventually moved into the Mercier Building (1887) at the corner of Canal and Dauphine. When the Mercier Building was remodeled in 1897 for Maison Blanche, Fellman looked across Canal Street and found the former Pickwick Club, with that iconic turret and great location, ideal for his budding operation. He had it remodeled for retail and reopened therein by 1898. Three years later, a terrible fire destroyed the interior and all stock, but Fellman, using insurance money, had the business rebuilt, at which time the façade was enhanced with stout balconies ideal for viewing Carnival parades as well as masking otherwise unsightly fire escapes.

For the next decade and a half, Fellman's thrived on this corner selling fine garments, from head to toe, under and outer wear, for all seasons, both sexes, and all ages. Profits earned at this flagship location went into other downtown investments, and Fellman became something of a real estate tycoon in early 20th-century New Orleans. He was

also a mentor to young aspiring merchants within his community: as Fellman himself had learned the business from mentors in the 1860s, he took under his wing protégés such as brothers Max and Leopold Feibleman, who, after Fellman's retirement in 1918, took over the store. Now known as Feibleman's, the company had the store remodeled and expanded in 1919. Six years later, it built a much larger modern building on Baronne and Common and merged with Sears, Roebuck, moving into "the Sears on Baronne" in 1931. That left the

turreted building on Carondelet and Canal open for other tenants, including Stein's discount clothier and, upstairs during World War II, the United Service Organization, with an entrance at 119 Carondelet. Here, thousands of "soldiers, sailors, Marines, paratroopers, WAACs, and other service men and service women," as the *Times-Picayune* reported in 1943, would register upon arriving in town and get advice on where to stay and what to do. Being exactly one block from the bars and clubs on Bourbon Street, the USO office at this locale probably aided the skyrocketing notoriety of Bourbon in this era.

Once the war was over, however, the aging edifice found itself inadequate for modern needs. Photographs from the 1940s show that the once-gleaming whitewashed façade had become weathered and dingy, although the structure appeared sound. The Gus Mayer Company, a locally founded department store that had expanded throughout the South, wanted a streamlined new modern building to match the postwar zeitgeist, and acquired the property in 1946 for $750,000. The turreted landmark was demolished and replaced in 1948–1949 with a 50,000-square-foot Modernist building notable for its streamlined negotiation of the corner at Carondelet, complete with wrap-around display windows. Gus Mayer operated here for 40 years until a wave of closures of old institutions in the 1980s–1990s swept through downtown New Orleans, claiming both Sears and Maison Blanche with which the original Fellman's had relations. The circa-1949 Gus Mayer building is now occupied by a CVS chain drug store.

LEFT *From Canal looking toward the lake, 1905–1910. More eye-catching than useful, the turret of Fellman's Clothing Store was an architectural signpost marking the key intersection of Carondelet and Canal Street—and the store.*
RIGHT *Looking up lower Carondelet around 1905, with Fellman's on the right. (Courtesy of Library of Congress)*

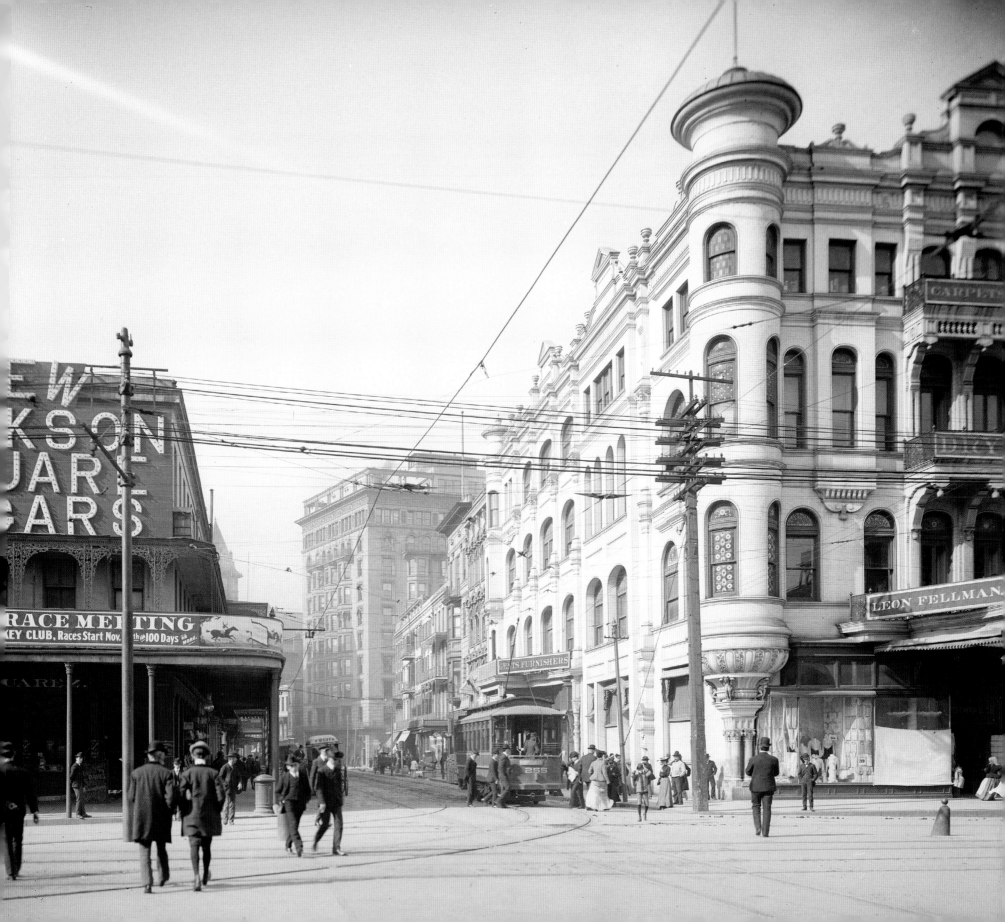

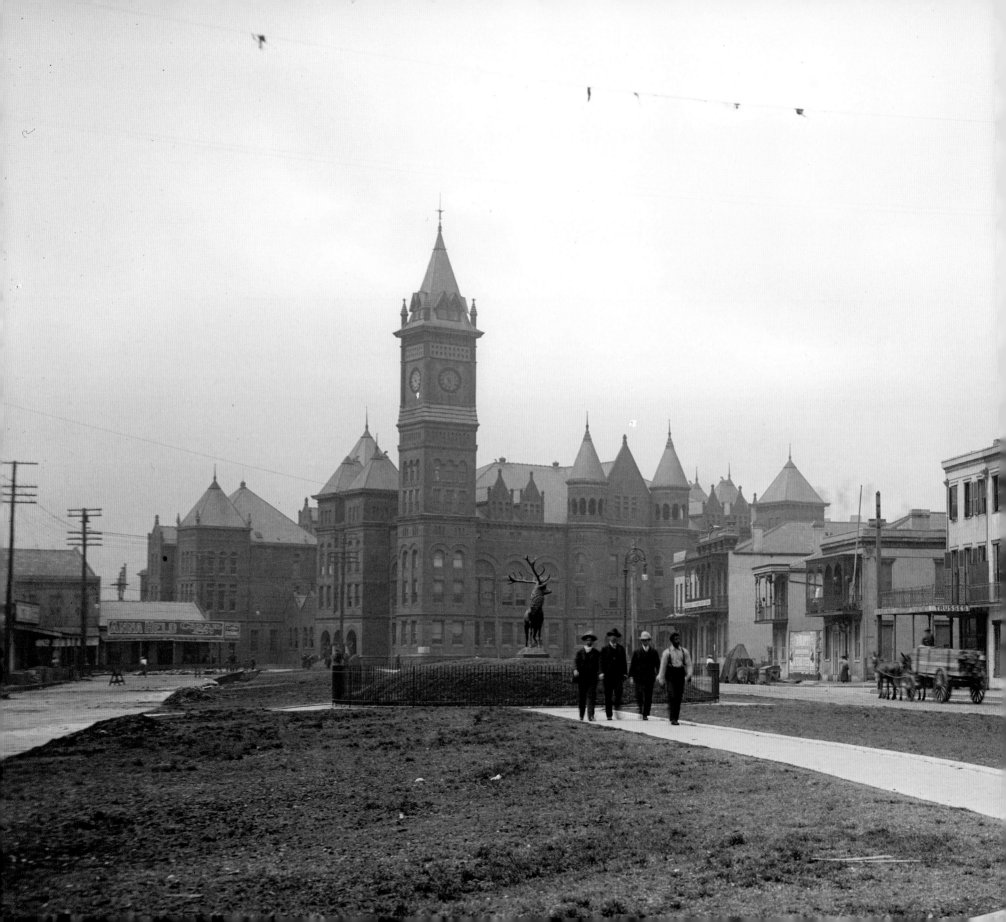

Orleans Parish Criminal Courts Building

DEMOLISHED 1949

Long in need of modernizing its police infrastructure, New Orleans' Comptroller Office in February 1892 issued a call for a challenging set of architectural proposals. On the square bounded by Gravier, Common (now Tulane Avenue), Basin (now Loyola) and Franklin (now gone), it wanted a criminal courthouse complete with courtrooms and dozens of chambers for judges, attorneys, clerks, and juries; a parish prison with cells for 300 men and 50 women plus additional spaces for everything from a chapel to "condemned cells;" a citywide headquarters for the Police Department as well as a First Precinct Police Station, and a Recorder's Office for all the bureaucracy the agencies would generate. "Particular attention," the Request for Proposals read, "must be given to the ventilation and lighting of the entire premises, as well as full provision for water closets and sewerage and drainage with distinction for both sexes." Indoor plumbing was new at the time, and the city wanted the latest amenities. Total expenditures would be $350,000 for design, supervision, and construction.

What architects devised—for an area that neighbor Louis Armstrong called "the back-a-town" and what others called "the Battleground"—would stun the eye and cower any criminal. Wrote one *Times-Picayune* columnist years later,

> viewed from a distance, [the courthouse] reminds one of an old-time chateau or Norman country house, circular towers rising in the center, [giving the] distant impression of being castellated, with turrets, battlements and slits for the archers. However, a closer view shows a…mixing of the Romanesque, the Gothic and the nondescript of hurried get-through-quick style of the latter day.

Above the complex was a reconnoitering tower, designed to be seen—and to see—miles around. Inside operated all the proscribed programming with the exception of the Orleans Parish Prison, which was contained in a smaller adjoining unit on Gravier at Basin. An open prison yard was located directly behind the prison, and until a change in state law, convicts were hanged publicly from the gallows here, the last of such spectacles in New Orleans history.

It was all a bit too much for that price. The first blow to its civic reputation came just as the complex opened, when nearly half of City Council members, according to a *Times-Picayune* report, "were indicted for bribery and graft…in connection with the construction of the building." Likely as a result, the edifice, despite its sturdy appearance, suffered structural problems, as did the prison, which within weeks of its 1893 opening was further compromised by a lightning strike. According to the *Daily Item*, the bolt "tore the slates and tiling" off its

ABOVE *The foreboding Orleans Parish Prison (1836, seen here around 1890) on Orleans Street in the Faubourg Tremé was demolished three years after its replacement opened in 1892.* **LEFT** *Like a medieval castle, the law enforcement complex loomed ominously—by design—over one of the more vice-prone areas of the city. In this circa-1900 bird's eye view, the prison is the separate complex to the left of the court house. (Courtesy of Visual Materials Collection, Southeastern Architectural Archive, Special Collections Division, Tulane University Libraries)*

OPPOSITE *The Criminal Courthouse, police precinct, and parish prison (to the left of the main building with the tower) viewed from Elk Place looking uptown, circa 1906. (Courtesy of Library of Congress)*

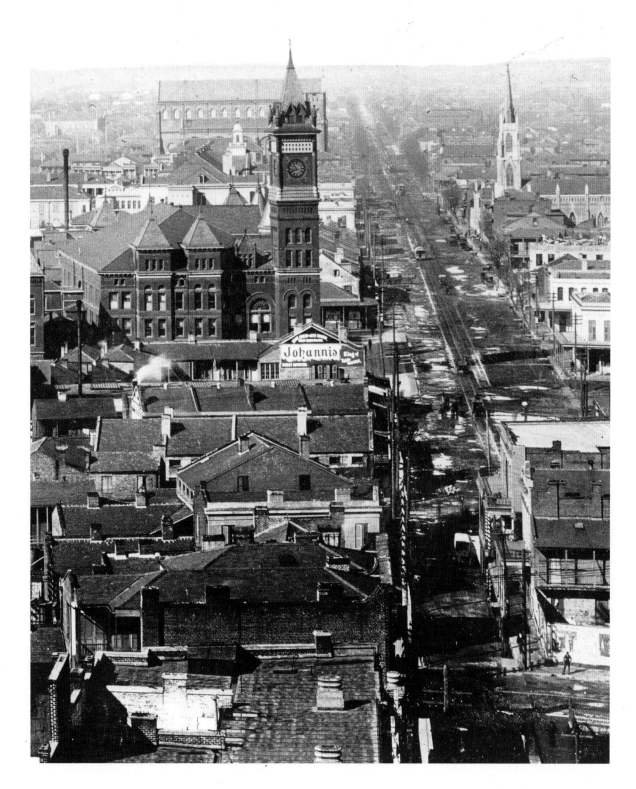

tower and "went clean through the roof and found a conductor to the ground by means of a metal pipe." Damages cost $500, and they would only grow when further structural and infrastructural problems developed.

As the city expanded lakeward in the new century and new technologies such as radio communications and automobiles came to policing, the headquarters found itself increasingly inadequate. Prison and court functions were relocated to the new and still-active courthouse and adjoining facilities at Tulane and Broad in 1931, leaving only the precinct station, and around 1940, the clock tower had to be removed for its cracks and leaks. A relic by mid-century and known loosely as "the Old Criminal Courts Building" or "the Police Station," the Victorian citadel housed sundry ministerial operations of governance, from driver's licenses to permitting to recruiting offices. It became something of a city joke in 1948 when "hoboes" were discovered living—rather sumptuously, and for six years—in "the ancient catacombs under the old criminal courts building," which a *Times-Picayune* journalist dubbed "Hotel de Bastille." Unloved by residents and a liability to the city, the complex was unceremoniously dismantled during 1949–1950, something Mayor Chep Morrison cited proudly as an accomplishment of his administration.

The footprint of the Old Criminal Courts Building is today partially subsumed by a widened Loyola Avenue and the New Orleans Public Library main branch.

LEFT *The tower looking up Tulane Avenue, with Chinatown in the center, around 1915. (Courtesy of Library of Congress)*

RIGHT *Despite its fortress-like appearance, the Old Criminal Courthouse was beleaguered with structural problems, some of them traceable to financial shenanigans at the time of its construction, and was razed after only 57 years. (Courtesy of Visual Materials Collection, Southeastern Architectural Archive, Special Collections Division, Tulane University Libraries)*

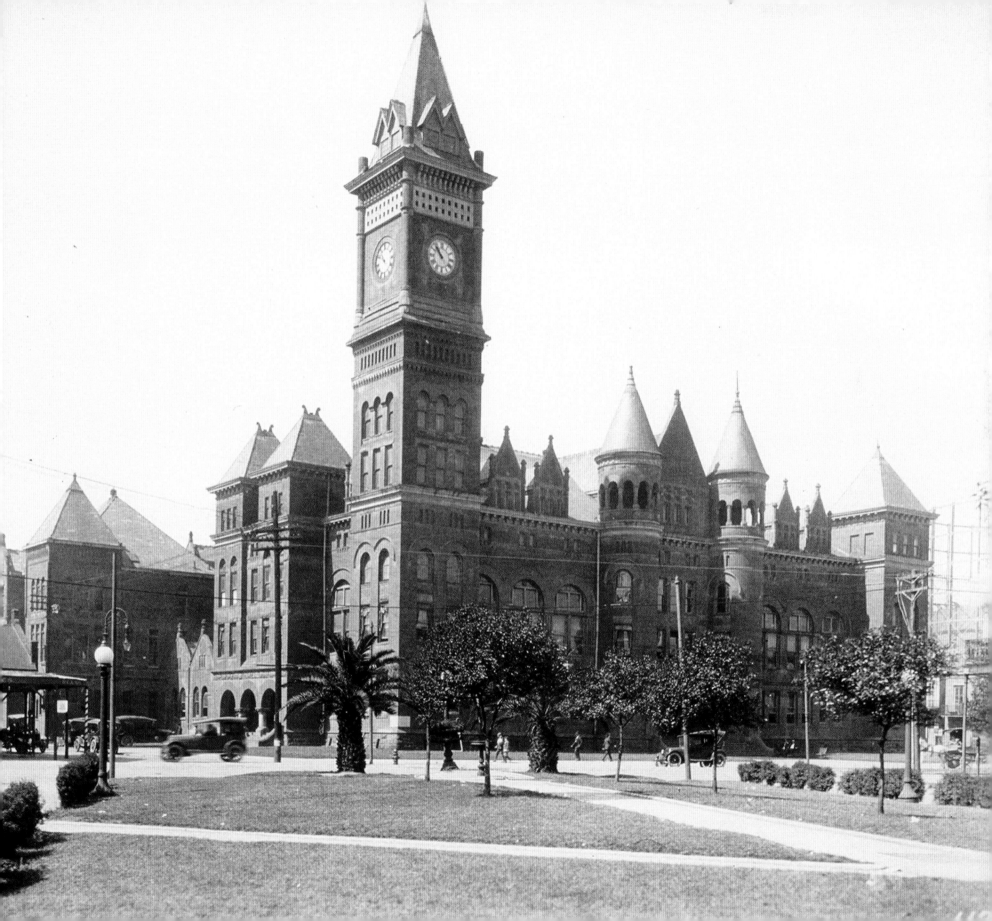

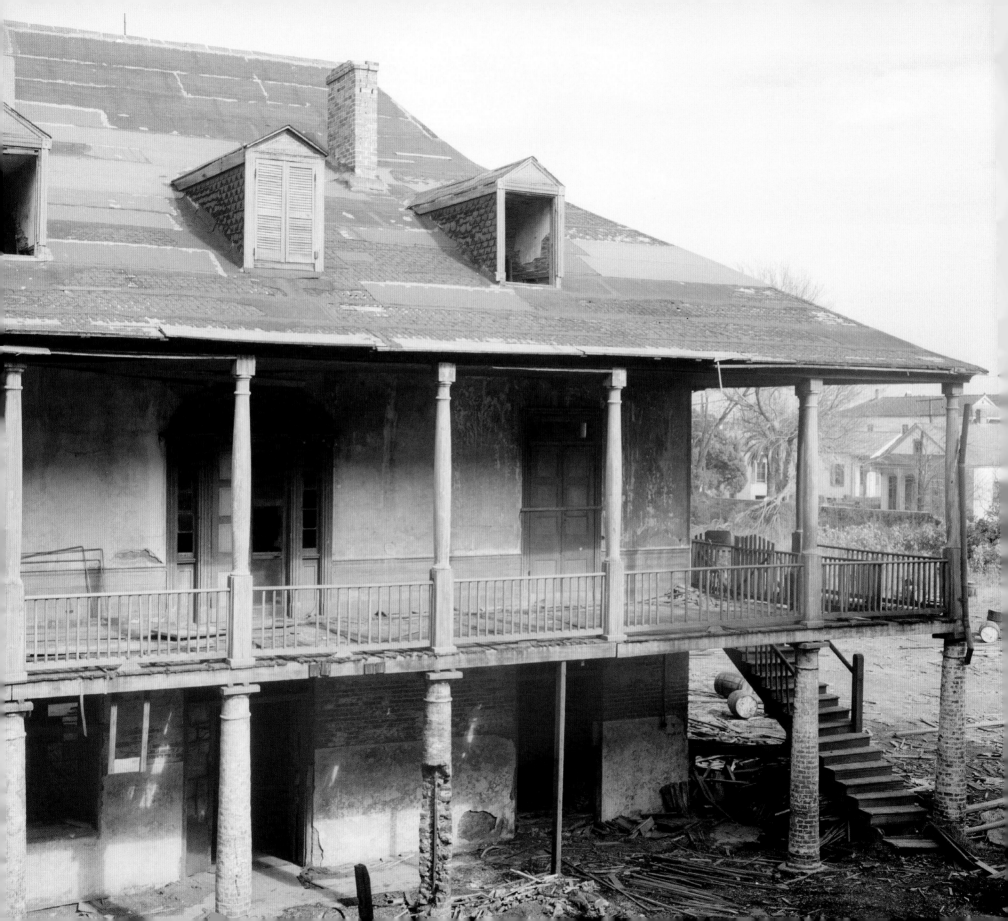

Olivier Plantation House DEMOLISHED 1949

The lower banlieu—that is, the outskirts downriver from New Orleans' urban core—hosted in the early 19th century an eclectic mix of land uses before it got subsumed into the expanding city. Like most of the natural levees on the deltaic plain, these higher riverfront lands in colonial times had been delineated into French "long lot" plantations, stretching 40 *arpents* (roughly a mile and a half, an arpent measuring 192 feet) from the Mississippi to the backswamp. Crops of tobacco, rice, indigo, and, after 1795, sugar cane, were raised here through the use of slave labor.

By the early 1800s, as faubourgs (platted suburbs) spread into those parcels immediately abutting the city, parts of the lower banlieu evolved into a multi-use semi-rural landscape of villas with gardens, orchards, horse farms, dairies, distilleries, brickyards, lumber mills, and other light industry, while the remainder continued with commodity crops. Along the river front, spaced every four to eight arpents or so, were what scholar S. Frederick Starr described as "a formidable collection of high-end Creole, French-American, and American rural architecture" used as plantation houses, behind which could be found dependencies, workshops, sheds, and slave cabins.

Among the most arresting of these homes was the Olivier House, built as early as 1820 but more likely in the early 1830s for the Frenchman Antoine David Olivier and his American family, on what is now 4111 Chartres Street between Mazant and France. The parcel was sized two arpents wide by 40 arpents deep, and the house was the epitome of French Creole design with West Indian influences: an airy wrap-around gallery (veranda) supported by slender cypress colonnades and brick Doric columns with seven bays on the front and back and five on each side, an outdoor staircase, an oversized double-pitched hip roof with dormers and center chimneys, a raised basement, and with adjacent pigeonniers, kitchen, and stable. But it also manifested one major American architectural import: a center hallway. As such, the Olivier House reflected New Orleans' gradual assimilation into American culture even as the structure as a whole typified Creole structural philosophies.

Olivier died in 1840, and within the next few years, much of this area, a neighborhood now known as Bywater, was gradually subdivided into street grids, though it still remained semi-rural in its land use. As part of this transition, some old riverfront parcels came to host light industry or port-related uses, whereas others became social and religious institutions, such as an alms house, a Catholic convent, schools, and orphanages. "Their existence," Starr states in his book *Une Belle Maison: The Lombard Plantation House in New Orleans's Bywater*, "can be explained by the fact that nearly all the plantations [in the lower banlieu] were owned by French Catholics. When several decided to abandon agriculture, they were only too glad to deed or sell their properties to the church."

Olivier's complex thus became the Catholic Orphans Association's St. Mary's Orphan Asylum, established by the Congregation of the Holy Cross in Le Mans, France. Business boomed in the worst sort of way: the city's yellow fever epidemics left behind all too many orphans, particularly among Irish and German immigrants, and St. Mary's expanded with an addition designed by architect Henry Howard for 300 boys plus staff. A lovely brick chapel in an unlikely English Gothic style, named St. Aloysius, was added to the campus in 1893, by which time St. Mary's was the region's premier boys orphanage and vocational school. The complex's "death knell," Starr says, came with "the decision by the populist-socialist governor Huey P. Long to place most social services under the state of Louisiana," which prompted the closure of most religious orphanages. These photographs were captured in 1934, after the orphanage closed. The original Olivier House and Henry Howard's annex were demolished in 1949. Had they survived, they would be major city landmarks; today they are empty lots.

LEFT Olivier's house became home to St. Mary's Orphan Asylum, for which architect Henry Howard designed the addition seen behind the main building in this 1934 photo. After the orphanage closed, the compound fell into disrepair and was demolished in 1949. **OPPOSITE** *The graceful Creole plantation house of Antoine David Olivier is seen here in 1934, when it was a little over a century old and in decaying condition. (Photographs by Richard Koch, courtesy of Library of Congress)*

West End TRANSFORMED 1938–1950

West End originated from the 1832–1838 excavation of the New Basin Canal, which gave New Orleans access to a previously wild marshy shore along Lake Pontchartrain. It soon became the third of three lakefront enclaves devoted to lakeside trade as well as recreation, following Spanish Fort, where Bayou St. John flowed into the lake, and Milneburg, at the lakeside terminus of the Pontchartrain Railroad (1831).

Into the 1850s, future West End was little more than a lighthouse, service buildings, and a long dock where schooners and barges entered and exited the canal. The lakeshore itself was unprotected by levees, and brackish tides allowed only saline marsh grasses to grow among the strewn shells and organic matter. Inland could be found cut-over swamps and rivulets, good for hunting and trapping but little else. By the time of the Civil War, the Jefferson & Lake Pontchartrain Railroad was built parallel to the canal a half-mile to the west, linking the Jefferson Parish City of Carrollton and the Metairie Road with the lake.

West End came into its own starting in 1871, when the state authorized the Mexican Gulf Ship Canal Company to build lakefront levees and dig canals to drain the swamps. That latter goal failed, but the company did shore up the lakefront and excavate the original beds of what are today the 17th Street, Orleans, and London Avenue outfall (drainage) canals. Spoil was deposited offshore between the termini of the Jefferson & Lake Pontchartrain Railroad and the New Basin Canal, forming a harbor within piers and jetties.

In April–June 1876, the New Orleans City Railroad Company opened a steam line running along the canal to the lake, and two years later, the city, recognizing the lake's recreational potential, passed an ordinance enabling the same company (also known as the Canal Street Railroad Company) to improve the spot and reduce its passenger fare to encourage patronage. Up to that time, the area had been called "New Lake End," to distinguish it from Milneburg, which folks called "Old Lake End;" to impart character to the project, someone affiliated with the 1878 transformation rebranded it with the catchier moniker "West End." The name stuck. Reported the *Daily Picayune*, "no expense will be spared to make [West End] a pleasant resort for the public. The revetment levee is to be repaired, sheds, pavilions etc., erected, and other improvements made."

OPPOSITE *West End began as a lakeside port in the late 1830s and developed into a lakeside resort in the 1870s, becoming "the Coney Island of New Orleans" around the turn of the century. (Courtesy Library of Congress)*

BELOW LEFT & BELOW *Whereas West End catered to day-trippers and recreational sailors at the Southern Yacht Club (below left), the lake shore across the parish line, an area known as Bucktown (below, photo by H.J. Harvey, 1890s), was decidedly more working-class, dedicated to the fin and shellfish trade. (Below left, courtesy of Library of Congress; below, courtesy of Visual Materials Collection, Southeastern Architectural Archive, Special Collections Division, Tulane University Libraries)*

Hotels, restaurants, and amusements followed, and the place became popular. "In the summer, New Orleans goes to the West End," reported B. R. Forman in 1900; "by electric cars that start on Canal and Bourbon streets. In some respects it is like Coney Island in New York." Outdoor moving pictures premiered at West End—a first for New Orleans, in June 1896—and visitors could embark pleasure boats to tour the lake while enjoying entertainment by first-generation jazz musicians. Joe "King" Oliver's "West End Blues," played most memorably by Louis Armstrong, captures the spirit of the place in this era.

Admission to West End was free, and a typical summer night saw thick crowds—whites only—enjoying lake breezes before heading back home on a swift street ride through the undeveloped landscapes of today's Lakeview. A secondary line connected West End with Spanish Fort, whose fortunes as an amusement declined in this era, leading to its relegation to "colored" families.

By the 1920s–1930s, automobiles and new highways had enabled middle-class New Orleanians to take weekend jaunts to regional destinations like Biloxi or Pensacola. More so, the reclamation project of 1926–1934 had turned West End's eastern flank into land, while allowing the new Pontchartrain Beach in old Milneburg to open with a full-scale amusement park and a beautiful sandy beach, amenities West End could not match. In response, the WPA, in 1938, carried out a $1.78 million reconfiguration of West End to include new breakwaters, a municipal yacht harbor, and other modernized facilities while removing the walkways, pilings, and bulkhead pier. By 1950, nearly the entire length of the New Basin Canal had been filled in and the West End streetcar lines were replaced by buses. The heyday was over.

Nevertheless, despite incessant batterings from storms and without its destination amusement park, West End still managed to retain a festive seaside ambience. To this day, the area and adjacent Bucktown in Jefferson Parish boast family-owned seafood restaurants, parklands, fishing, and the Southern Yacht Club, which traces its origins to 1849 and its presence in New Orleans to 1857.

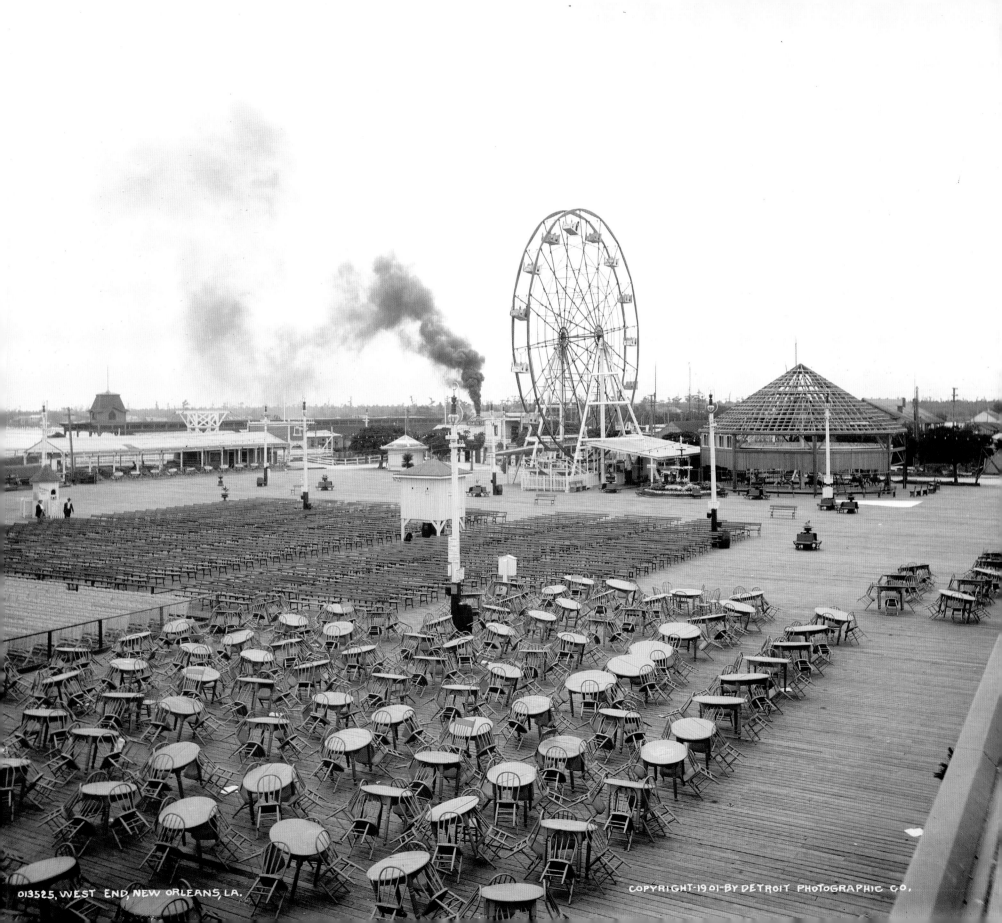

013525. WEST END, NEW ORLEANS, LA. COPYRIGHT-1901-BY DETROIT PHOTOGRAPHIC CO.

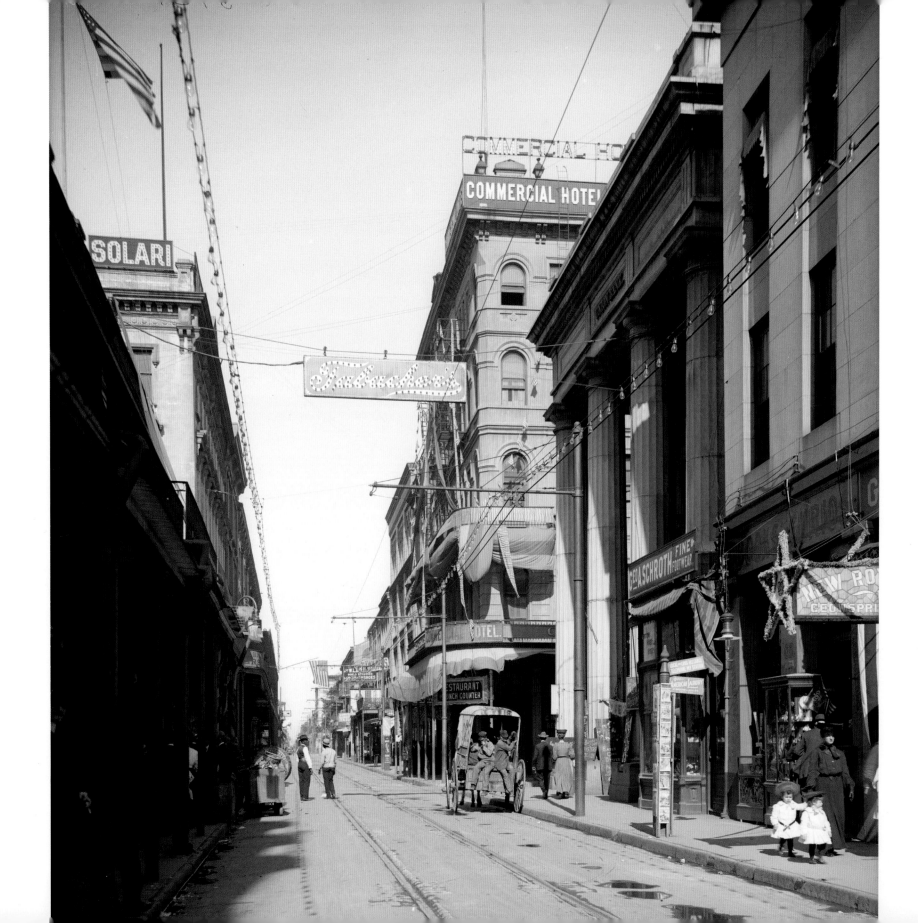

100–200 Blocks of Royal Street TRANSFORMED 1950s

Though not nearly as famous as Bourbon Street, Royal Street is arguably New Orleans' signature thoroughfare, particularly since this French Quarter artery—which abounds in elegant antique shops and bistros and boasts some of the city's most splendid iron-lace galleries—becomes the equally iconic St. Charles Avenue once it crosses Canal Street. All the more significant, then, are the architectural losses experienced on Royal's 100 and 200 blocks around the Iberville intersection. Five key historical elements visible in these 1900s photographs have been lost: the Merchants' Exchange, Union Bank, Commercial Hotel, Solari's, and the Desire Streetcar Line.

The Merchants' Exchange (1835), noted for its surprisingly modernistic façade, classical interior, and striking dome, served as a post office, business exchange, and district court for many years. Commercial uses in the 20th century included a book store and Gluck's Restaurant. The last surviving project of the Gallier-Dakin partnership, the Merchants' Exchange was destroyed by an arsonist in 1960.

Next door to the Merchants' Exchange, on the corner of Iberville (Customhouse Street until 1900) was the Union Bank (1838), an influential financial institution from the city's antebellum era. Its four-columned Greek Revival entrance was later enclosed to produce additional rentable storefronts along Royal Street, while its Iberville side remained in its original state. The Union Bank later housed Citizens' Bank (1874), the New Tivoli Concert Saloon (1885), and the Bijou Variety Theater (1896). It was demolished in the late 1940s and replaced by a Walgreens Pharmacy.

Solari's Delicatessen, founded by J. B. Solari in 1864, was a popular grocery store and lunch spot specializing in gourmet foods and wines. It moved into this structure, designed by Thomas Sully and constructed in 1887, and became a local epicurean institution for the next eight decades. In 1961, to make economic use of the upper floors, Solari's was demolished and replaced by a parking garage disguised with rudimentary French Quarter accouterments.

The Commercial Hotel (1890), one of the tallest buildings in the French Quarter at the time, started as the Hotel Victor and soon became home for immigrant cobbler Antonio Monteleone's foray into the lodging business. His success led to the demolition of the adjacent buildings for the construction of the Beaux-Arts-style high-rise Monteleone Hotel, designed by Toledano and Wogan and built in 1908, about 30 years before the official protection of the French Quarter by the Vieux Carré Commission. In 1946, the VCC's jurisdictional limits were tweaked to exclude portions of 200 Royal as well as North Rampart Street frontages, leading to a wave of demolitions which otherwise would have been prohibited. During this time, the former Commercial Hotel was demolished (1955) for a nine-story, $2.6 million, 200-room annex to the Monteleone. The gerrymandering also explains Solari's destruction, but not the demise of the Union Bank and the Merchants' Exchange, because all the 100 blocks of the French Quarter never fell within VCC protection, having been deemed overly modernized when the Commission was created in 1937. VCC jurisdictional limits were returned to their original position in 1964, but by then, much of the zone in question had already lost its historical structures. The Monteleone Annex is today the tallest structure within VCC limits.

One of the most picturesque elements of old Royal Street was its Desire streetcar. Streetcar lines had been expanding citywide since the Civil War, and in response to petitions from residents, rails were finally installed on Bourbon and Royal in 1873–1874. Bourbon's service was designed as a downriver extension of the uptown Clio/Carondelet line, which looped around the foot of Canal Street and turned down Bourbon to Elysian Fields (later to Desire Street) and returned on Royal to Canal. Because tracks had to be uni-directional, lines on narrow arteries required that one-way directionality be officially mandated for all vehicles on that street.

Thus traffic on Bourbon had to flow downriver, while Royal's moved upriver, as it does today. With the advent of automobiles and rubber-tire buses, streetcars, despite their aesthetic appeal, became increasing unpopular with residents, particularly because they also cluttered the airspace with overhead electrical wires. Neighbors and businesses alike petitioned for the removal of the Desire Line and it was discontinued in 1948—one year after a French Quarter playwright named Thomas "Tennessee" Williams penned a play named *A Streetcar Named Desire*, and two years before the movie version made the now-defunct streetcar line world famous.

*LEFT This circa-1906 view of Royal Street at the Iberville intersection shows the columned Union Bank on the corner and the Merchants' Exchange at right, two buildings of high architectural and historic value that were lost to the wrecking ball and an arsonist. **RIGHT** The river side of the 100 block of Royal Street, circa 1900. All buildings visible here have been razed and replaced. (Courtesy of Library of Congress)*

Washington Artillery Hall DEMOLISHED 1952

In an effort to revive economic and social activity in postbellum times, business leaders in the late 1860s decided to build a great hall where events and meetings could be held, and, as a *Picayune* reporter explained, "objects of interest to the planter, the mechanic, the merchant, or the mere amateur of inventions" might be displayed "all the year round...under one roof." Designed by Albert Deitel and built by William Ames in 1870–1871, Exposition Hall measured 80 feet wide and spanned the entire 340 feet from St. Charles to Carondelet streets, between Girod and Julia, making it among the largest structural spaces in the city.

The exterior exhibited "a simple but elegant adaptation of renaissance style of architecture;" inside, it was perfectly spectacular. A visitor entering from St. Charles would encounter two grand staircases on either side, which led to a vestibule separated by a glass partition from the main concert hall, which at 160 feet deep and 35 feet high, ranked as the largest hall in the city, some said the nation. On the Carondelet side was a Fine Arts Hall, 170 feet deep and 20 feet high, and to the sides were four "refreshment rooms" (restrooms), four cloak rooms, a dining hall, and a library. Actual exhibitions, which usually entailed heavy objects, occurred on the ground floor, where a railway system facilitated movement. Huge windows allowed air and light to circulate throughout the cavernous interiors.

Part conference center, part concert venue, and part ballroom, Exposition Hall was a success, having landed among other major customers the 1872 Grand Industrial Exposition. Its size and location also attracted a bidder: the Washington Artillery, a famed local militia organization whose members came from the city's elite (its motto was "Try Us"), found itself in need of a headquarters and arsenal, its previous home having been destroyed by Union troops during the Occupation. Exposition Hall had all the right attributes, and in 1878 the battalion purchased it and renamed it Washington Artillery Hall for the upper space and Washington Artillery Armory for the ground floor. Locals generally called it either, or the St. Charles Armory.

The building, under the management of the Washington Artillery, had two distinct programs. Upstairs continued to be used for elegant society balls, including Rex and other carnival organizations, and for reunions, expositions, political conventions, conferences, and fraternal get-togethers. In the April 1910 photograph shown opposite, for example, the Hall played host to the Shriners, the Merry Widow Social Club, and the Grand Fancy Dress and Masquerade Ball of the Gladukum Club. Downstairs, however, was reserved for the business of war. There the battalion stocked rifles, cannon, uniforms, ammunition, and materiel of all sorts; it even had a live shooting range—in the heart of downtown New Orleans, in this era before zoning.

Modernization and congestion made the notion of an inner-city arsenal impractical, and in 1922 the Washington Artillery moved its equipment to Jackson Barracks at the lower city limits while keeping the St. Charles building for social uses. After World War II, it moved all of its functions to Jackson Barracks and sold the 75-year-old landmark. A Buick dealership was its last tenant, and in 1952 it was demolished; today a stout Modernist office building occupies the site.

While its capacious hall is gone, the storied organization behind it lives on. Known today as the 141st Field Artillery Regiment ("Washington Artillery" is officially recognized as a special designation authorized by the Center of Military History), the organization is a component of the Louisiana National Guard and remains stationed at Jackson Barracks. It has seen extensive action in conflicts starting with the Mexican War and continuing to Iraq in the 2000s.

RIGHT *Part conference center, part ballroom, and part armory, the Washington Artillery Hall started out as Exposition Hall. This view down St. Charles Avenue captures the Masonic Temple in the distance (note spire). (Courtesy of Library of Congress)*

BELOW LEFT *The ballroom prior to demolition.*

BELOW *Inadequate for most uses other than its original purpose, the former Washington Artillery Hall became a mundane Buick dealership in its waning years and was cleared away in 1952. (Courtesy of Visual Materials Collection, Southeastern Architectural Archive, Special Collections Division, Tulane University Libraries)*

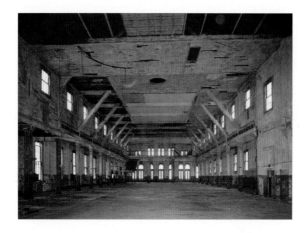

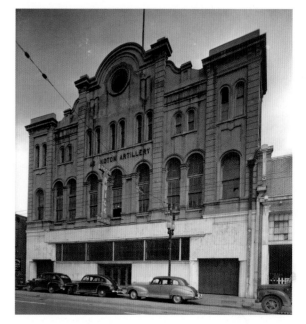

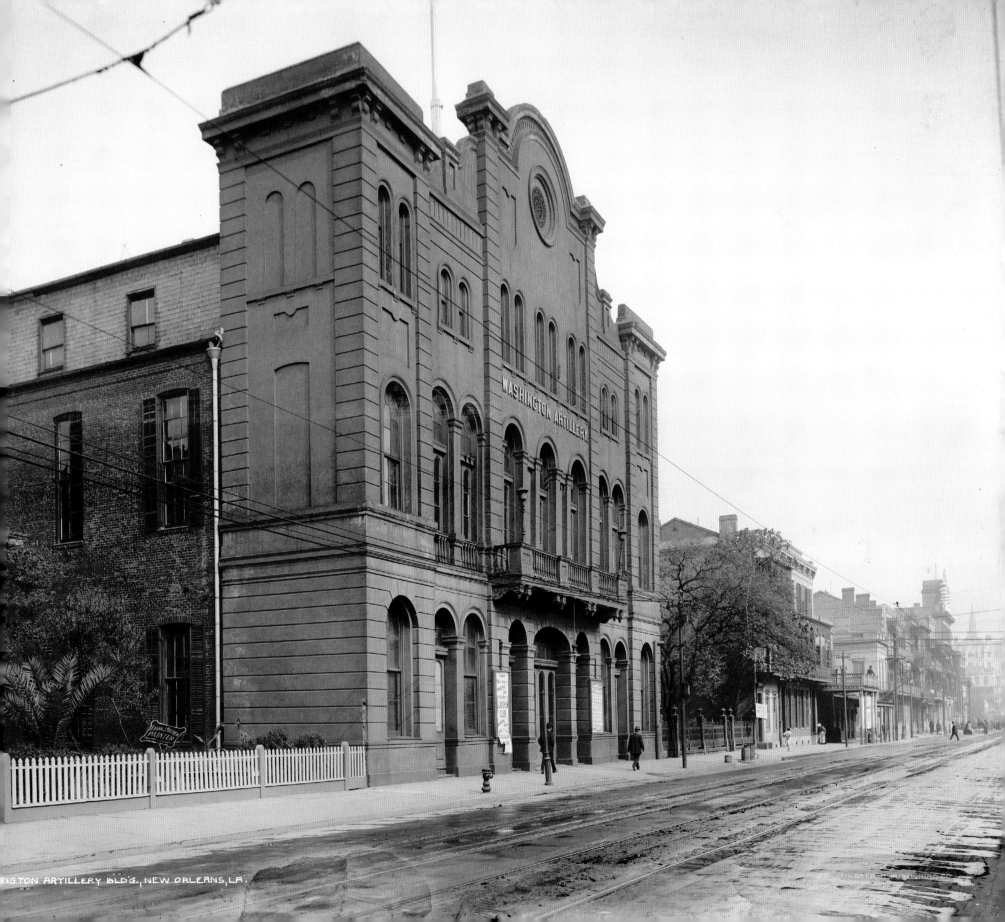

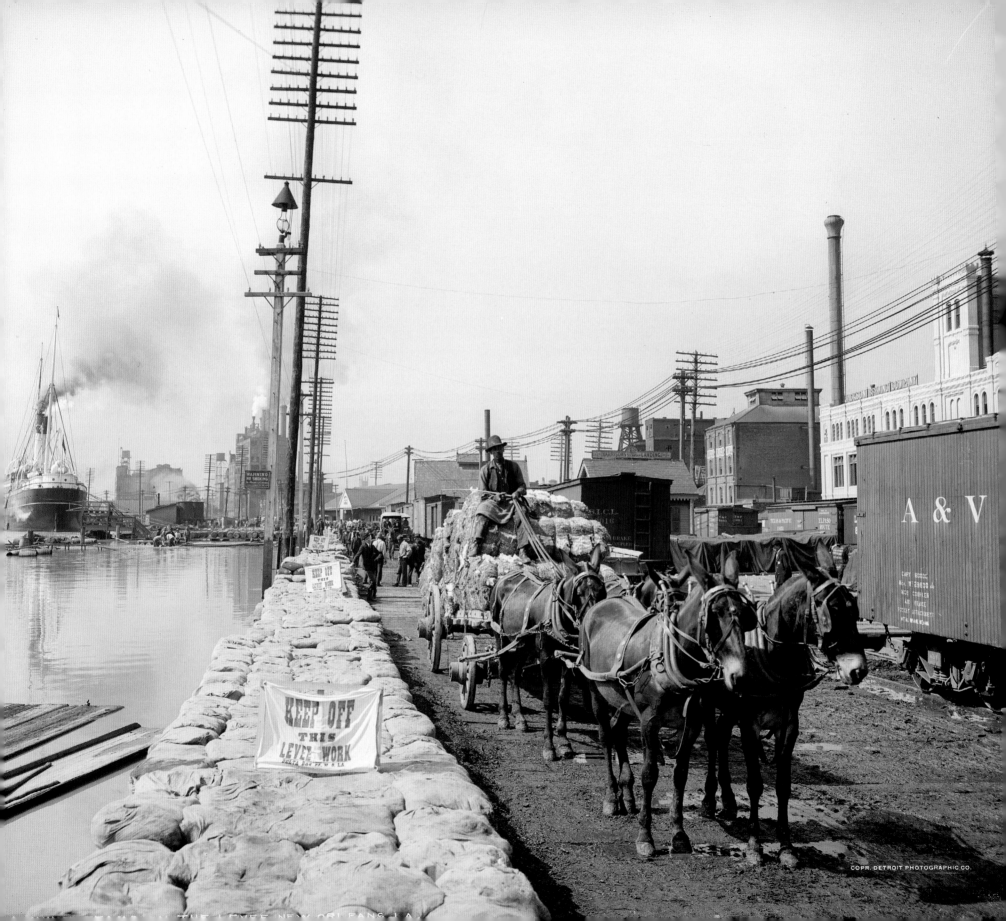

KEEP OFF
THIS
LEVEE WORK
DELTA BAG 77 N.O. LA.

KEEP OFF
THIS
LEVEE WORK

WARNING
NO SMOKING

A&V

COPR. DETROIT PHOTOGRAPHIC CO.

Mule Drayage MOSTLY ENDED 1953

Beasts of burden in 19th-century New Orleans tended to be mules more so than horses. Though usually associated with the rural South, mules had certain advantages over horses in this environment: they tolerated better the region's heat and humidity, they were easier to corral and stable in an urban setting, they needed to eat only once or twice daily, they abided abusive handlers and chaotic traffic, and most importantly, they pulled stronger than horses, if not faster, with their sturdier legs and steadier footing. Before the rise of the internal combustion engine, mules could be found in dray service for everything from cotton bales and sugar barrels, to lumber and bricks, to the delivery of milk and Creole cream cheese (seen here), the peddling of fruits and vegetables, the buying and selling of rags, and the collection of street debris and household garbage.

Their premier use in New Orleans from 1835 to 1893 was to pull streetcars, and as the rail system spread, so it increased the need for mules. Because the Gulf South lacked rich pasturelands for the raising of horses and donkeys, it never developed the equestrian heritage of places like Kentucky and Tennessee. Thus, most mules had to be imported down the Mississippi River to satisfy the city's needs. Streetcar service in particular required a mule's strength and sturdy stoicism even as it taxed its weary legs and hooves, to which drivers responded with hateful abuse. Treatment grew so appalling that, as researcher Brittany Mulla reports, progressive forces in civic society helped form the Louisiana Society for the Prevention of Cruelty to Animals and successfully applied pressure to convert the entire streetcar system to electrical power in 1893.

Mules put out of streetcar work after 1893 found plenty of other uses in the city. Mule-drawn wagons could be found on just about any downtown block, and stables and shoe shops dotted neighborhoods as garages and gas stations do today. The rise of gas-powered forklifts and trucks cost mules their port-related dray work in the 1910s–1920s, but they remained the most efficient way to peddle in neighborhoods and collect garbage, and hundreds if not thousands still plied the streets during the Depression. Working-class areas were full of amusing characters pushing picturesque carts or guiding mule-drawn wagons. Del Hall, born on South Rampart Street in 1935 and raised in the Iberville Projects, remembers the Fruit Man (*"I gotta peaches, lay-dees; I gotta melons"*); the Rag Man, who bought and sold old clothes at a time when paper towels were scarce; the Knife Sharpener, with his cringe-inducing grinding wheel; and the Milk Man, who got around in an electric truck with no doors and a stand-up steering wheel—a harbinger for the mules' decline.

As for the city, its 357 mules in 1929 represented peak stock; stabled at five back-of-town sites, the city-owned mules had two main daily tasks: to pull garbage-collection wagons through neighborhoods for weekly domestic trash pick-up, and to pull open dump wagons into which street cleaners could empty leaves and gutter debris. During Mardi Gras, the mules were loaned to Carnival krewes who would shroud them eerily in white capes and rig them to pull parades' floats through ecstatic crowds. For all three tasks, mules had certain advantages: they moved steadily at just the right pace, they had none of the roar and fume of heavy trucks, and they imparted a picturesque distinctiveness to the streetscape.

But they also required specialized care and, as city dwellers became greater consumers and disposed more of what they consumed, the gentle beasts' costs started to exceed their benefits. The city used fewer of them for garbage collection each year through the 1930s and 1940s. In the early 1950s, Mayor Chep Morrison's administration aimed to bring New Orleans into the modern age and, because mule-drawn city wagons did not lend helpful imagery to that aim, the city in 1953 gave away its mules and switched permanently to garbage packer trucks. Mardi Gras krewes switched to tractors, and the only remaining mules in the streets served the last of the peddlers and, increasingly, to pull nostalgia-hungry tourists through the French Quarter. By 1973, a journalist for *Dixie Magazine* could find only three mules still in use outside the tourism industry—one for a vegetable peddler, one for a rag and paper collector, and one to vend Roman Candy in the streets of uptown.

Today, only the Roman Candy Man still uses a mule, and they may be seen on St. Charles Avenue selling candy to children on any afternoon.

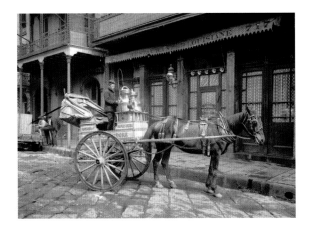

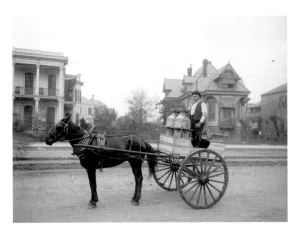

OPPOSITE & LEFT *Mules vastly outnumbered horses in New Orleans. They were a common sight throughout the city well into the 20th century. These photographs date from circa 1905. (Courtesy of Library of Congress)*

Union Railroad Depot DEMOLISHED 1954

The Union Railroad Depot (also known as Union Station but not to be confused with the present-day structure of the same name) was built in 1892 in a Chicago School Moderne style designed by Louis Henry Sullivan aided by a young protégé named Frank Lloyd Wright. Its name and location spoke to the aspirations of its owners at the Illinois Central Railroad. In this era, six major and minor trunk lines sliced across the cityscape, tying New Orleans into critically important regional and national railroad networks but also transecting city life with delaying and potentially dangerous track beds. The Union Depot was designed for expansion should the decision be made to unify—thus the name—all passenger lines into a single station. It was, but not for 60 years. Company officials had positioned the depot on South Rampart and Howard in part to take advantage of the open right-of-way for tracks along the New Basin Canal, and also in the expectation that a Mississippi River bridge would someday be built along a trajectory favoring this locale. They were right about that too—but 40 to 60 years ahead of their time.

Union Depot instead became the Illinois Central passenger station serving connections to Chicago, and, after working out arrangements with competitors, for receiving trains on the Yazoo and Mississippi Valley and the Southern Pacific railroads. By World War II, over a dozen trains came and went from Union Depot daily, and it was here, starting in 1947, that the legendary City of New

Orleans line would arrive and depart daily for Chicago. Just outside the depot one could catch streetcars plying the Clio Street, Dryades Street, and Peters Avenue lines, which in turn connected to neighborhoods citywide. Like most other stations in the city, the Union was located in a dicey precinct, with the dock-lined turning basin of New Basin Canal directly across Howard Avenue on the east, coal yards and light industry all around, and tough back-of-town neighborhoods to the rear.

City planners had long aimed for station unification were it not for stubborn and overly powerful rail companies, who jealously guarded their rights-of-way and looked askance at both competitors and government intervention. But when travelers increasingly opted for cars, buses, and planes, the railroad companies lost their bargaining chip and tried instead to maintain profits by minimizing costs. World War II rejuvenated rail travel, but only briefly, and with new highways being built and suburbanization occurring here and nationwide, passenger trains saw ridership plummet. Resizing the declining rail system against the rise of automobiles became a priority of Mayor Chep Morrison's administration, and the unification foreseen in the late 19th century finally came to fruition in 1953, when a new $2.25 million Union Passenger Terminal was built 200 feet behind the 1892 depot. After tracks were realigned, the new station commenced service in early 1954 and the old one was demolished for a traffic plaza.

At first, only the Illinois Central, Southern Pacific, and Missouri Pacific Gulf Coast lines called at Union Terminal. But as the wrecking ball visited other stations throughout the city, the remaining lines, including the Louisville and Nashville, Southern, Texas and Pacific, Kansas City Southern, and Gulf, Mobile, and Ohio lines sent their cars to the new and now truly unified Union Terminal.

Unification benefitted everyone but could not stave off the hemorrhaging of passengers on America's rails. Congress intervened in 1970 with the Rail Passenger Service Act, which created the publicly funded National Railroad Passenger Corporation, or Amtrak. Today, the Union Passenger Terminal serves Greyhound intercity bus lines, local bus lines as well as the new Loyola streetcar outside, and, as its primary tenant, Amtrak, including the City of New Orleans train.

ABOVE *The landscaped park across the street from the Union Depot stood in contrast to the rather industrial atmosphere of this area, as seen in this 1922 aerial photo in which the station appears at left center, next to the New Basin Canal. (Courtesy of Library of Congress)*

LEFT *The graceful sheds under which the trains pulled to the station.* **RIGHT** *Union Depot, seen here in 1917, was designed and named in the hope that it would unify the city's six railroad lines. (Courtesy of Visual Materials Collection, Southeastern Architectural Archive, Special Collections Division, Tulane University Libraries)*

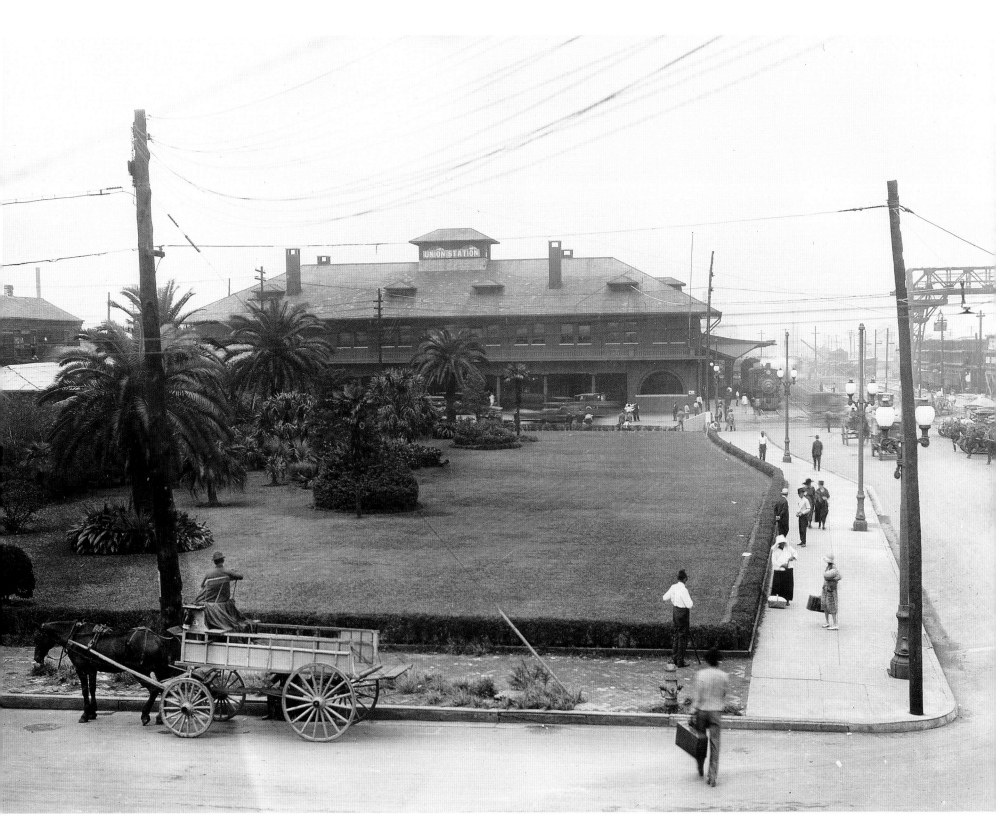

Bayou Metairie FILLED IN 1954

These are the remnant waters of Bayou Metairie at Metairie Cemetery along the western edge of New Orleans city limits. Choked off from the river incrementally starting in the mid-19th century and finally filled a century later, Bayou Metairie nonetheless deeply affected regional geography because, as a distributary (and, millennia earlier, a former channel) of the Mississippi River, the waterway deposited sediment whenever it overflowed and thus left behind a walkable topographic ridge, two to four feet above sea level, through otherwise impounded swamps. Bayou Metairie flowed eastward connecting with Bayou St. John to the north and continuing as Bayou Gentilly and Bayou Sauvage before petering out in the eastern marshes.

As the city developed, this high ground—the only local uplands not adjacent to the Mississippi—became a key road for west–east passage as well as a perfect place for dairies and small farms (*metairie* in French) and Sunday excursions. Pierre Clément de Laussat, Louisiana's last French administrator at the time of the Louisiana Purchase, recalled in 1831 an excursion along the Metairie Ridge he took decades earlier near the scenes in these photographs,

> I organized a trip on horseback along the Metairie road…The day was delightful, the sky serene, and the breeze…cooled off the heat of the sun. Trees were still thick with foliage: evergreens, magnolias, vines, oaks, wild grapes, a great number of shrubs heavily laden with fruit…all form a lovely sight deep in the heart of these uninhabited wastelands and forests. Sprinkled here and there are log cabins and some cultivation, alive with herds and multitude of curious birds. Sundays were generally observed as holidays… Whoever had a horse or a carriage was on [Metairie] road; it was full with an unbroken line of traveling coaches, cabriolets, horses, carts, spectators, and players.

Later in the 19th century, the Metairie-Gentilly Ridge became ideal for land uses that needed to be on dry ground near populated areas, but not so close as to drive up real estate costs. Hence the ridge attracted race tracks, fairgrounds, parks, cemeteries, and institution campuses, in addition to the old uses of truck farming and dairying.

Metairie Cemetery, visible in these scenes, is a perfect example of a ridge land use. It had been designed by Benjamin F. Harrod and laid out in the 1870s on the old Metairie Race Course, a circa-1838 horse track situated to take advantage of the area's high elevation and proximity to the city. As the city's first major landscaped cemetery, complete with elaborate mausoleums and a circular street network, Metairie quickly became the fashionable resting place for elites and eccentrics alike. Adding to its appeal were the manmade Lake Prospect and the natural Horseshoe Lake, parts of Bayou Metairie's channel which had been deepened and landscaped with banks, islands, bridges, and ornamental plantings of palms and weeping willows.

Unfortunately, Horseshoe Lake became something of a traffic bottleneck in the 20th century as development mounted in suburban Jefferson Parish and Metairie Road represented one of its main access arteries. As part of Mayor Chep Morrison's ambitious street improvement program, the ridge-top road was widened in 1953–1954 from two to four lanes at the expense of the ancient channel-cum-lake, which was either filled or covered. Today, the only remaining evidence of bayous Metairie and Gentilly are the lagoons of lower City Park, the above-sea-level elevations of the ridge, and the historic land uses of fairgrounds, race tracks and cemeteries.

OPPOSITE *By the time this photo was taken around 1905, Bayou Metairie had been severed from the Mississippi, and the channel by Metairie Cemetery, seen here, had been transformed into ornamental lagoons.* **BELOW** *Widening of Metairie Road (at left edge of photo) led the city to fill in the ancient bayou, which a few thousand years ago had formed the main channel of the Mississippi River.* **BOTTOM** *The wending course of the distributary may be seen in this 1863 map by Nathanial Banks. (Courtesy of Library of Congress)*

Robb Mansion/Sophie Newcomb College

RAZED 1954

James Robb, an eccentric globe-trotting Pennsylvanian who made millions in banking, utilities, and railroads during the 1840s–1850s, had the Italian palazzo-style mansion shown here built on Washington Avenue between Camp and Chestnut. Building commenced in 1852, the same year the former Jefferson Parish City of Lafayette was annexed into the City of New Orleans as its Fourth Municipal District. Completed in 1854 and surrounded by an entire block of ornamental shrubbery and statuary, the Robb House became known as one of the most splendid homes in the city and helped earn this area the nickname "garden district," a sobriquet that has since become a formal name. "The building," commented the *Daily Picayune* in January 1856, "two stories high, eighty feet square, [on a] gently elevated terrace…had about it an air of quiet beauty, refined taste and substantial comfort… No expense was spared on finishing; its fresco painting was particularly superb, [as are the] marble steps, with massive railings, [leading] to a spacious hall…." It was never meant for Robb, a global capitalist with diverse accomplishments and investments all around the Atlantic and Caribbean, to enjoy. He was forced to sell the house shortly after its completion on account of estate matters following his wife's death.

Robb left New Orleans for Chicago in 1859, but not before selling the house's art, which the *Daily Picayune* described as a "large and choice collection of oil paintings, water colors, engravings, bronzes, marble statuary, vases, and other articles of *vertu*." The mansion was sold that year to merchant John Burnside for $55,000, and after Burnside died in 1881, the estate was acquired by Sophie Newcomb College, a private women's institution of higher learning which would become a fixture in uptown society. Newcomb College added an annex in 1894 and a second story to the original house in 1900, both visible here. Seventeen years later, Newcomb moved uptown to join the campus of Tulane University, forming an early female and male "coordinate college" system, predating the better-known association of Harvard and Radcliffe.

The former Robb property next came into the ownership of the Southern Baptist Convention, which started seminary classes within its walls on October 1, 1918, only to close the next week for the influenza epidemic. Over the next 35 years, the Baptists saw their student body grow nearly tenfold, for which they added a $200,000 dormitory in 1947. Soon it became apparent they had outgrown their 19th-century home, and in 1953 they moved to a new campus in Gentilly, where they remain today.

What to do with their Garden District complex? No institutional tenant came to inquire, and the campus could hardly revert to a private residence. "As far the seminary was concerned," explained a real estate agent interviewed in 1956, "it received more for the vacant ground…than it would have with the buildings on it." "Robb's Folly," as the house came to be called, might have been his plan to build so grandiosely in the first place. The mansion and annexes were demolished in 1954, the double square was subdivided into 17 parcels, roughly $340,000 changed hands, and within a few years, a new neighborhood of pricey modern houses arose in the heart of the historic Garden District.

As for Robb, his fortunes declined amid financial and legal troubles. Some say he died broke and insane, thus giving new justification for the nickname "Robb's Folly." But Robb would have pointedly disagreed, stoically declaring in his last days, "My signature is not outstanding for a penny; the remnant of fortune left is equal to my wants; my life one of tranquility, and my daily companions instruct me in wisdom and impart consolation more precious than riches…" James Robb died in Cincinnati in 1881, the same year his New Orleans palace became Sophie Newcomb College.

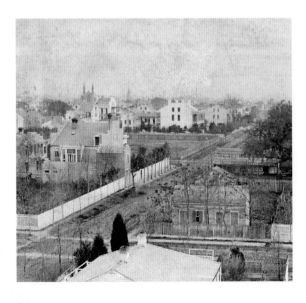

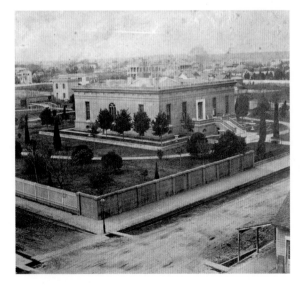

RIGHT *James Robb's original 1856 mansion, the first floor at left, was expanded in 1894–1900 for Sophie Newcomb College, a private women's institution of higher learning which later moved uptown as a coordinate college under Tulane University. (Courtesy of Library of Congress)*

LEFT *Jay Dearborn Edwards captured this photograph of the Robb Mansion around 1858 from the wooden tower of a fire station on Washington Avenue in the Garden District.*
FAR LEFT *After taking the photo of Robb Mansion, Edwards turned around and took this scene looking downtown. (Courtesy of Louisiana Architecture Photographs, Southeastern Architectural Archive, Special Collections Division, Tulane University Libraries)*

Terminal (Southern Railway) Station

DEMOLISHED 1955

The New Orleans Terminal Company, an asset of Southern Railway, built this passenger station at the spacious intersection of Basin and Canal in 1907–1908. Designed by Daniel Burnham in his grandiose style but scaled to fit the narrow neutral ground, "Terminal Station" comprised a magnificent waiting room at the Canal Street end, offices on either side of the ticketing corridor, and a concourse in the rear where passengers would access two 704-foot-long, steel-frame open-air metal sheds each parallel to the tracks. Locomotives would pull coaches out of Terminal Station and up the trackbeds lining the Old Basin (Carondelet) Canal, which also accessed the company's freight yard between St. Louis Street and the canal. The rails continued out to the cemeteries district around the Metairie/Gentilly Ridge, at which point they bifurcated to all points east and west.

In the early 1900s, Terminal Station, or Southern Railway Station as it was alternately called, was one of six such stations scattered through the inner city. Each had its own home line, and each line had rights-of-way for its trackbeds transecting the cityscape at odd angles, which yielded scores of frustrating and potentially dangerous grade-level crossings of automobile, streetcar, passenger, and freight traffic. Each railroad company assiduously fought attempts to unify lines into a single station, as each saw the other as competitors and wished not to sacrifice the lucrative status quo for a government-negotiated unknown. They did,

however, work out deals with rival lines to share certain stations, and Terminal Station from the beginning hosted not just its own Southern Railway but also the Mobile & Ohio, the New Orleans & Northeastern, and the New Orleans Great Northern lines.

Burnham and his clients had originally planned a much larger structure, in expectation that the city would eventually force unification and consolidation, and in the hope that other lines would acquiesce and become tenants at Southern's station. What resulted was what the *Daily Picayune* described as a "modern structure, handsomely finished, and large for all trains entering the city." Two stories high, 82 feet wide and 385 feet long, and set on pilings driven beneath a concrete foundation, the building was made of a base course of granite with Bedford stone, and the structure was capped with a re-enforced concrete roof. Inside were a lobby and waiting rooms segregated by gender and race, all with Italian marble floors, as well as ticket offices, telegraph rooms, baggage handling facilities, and a newsstand. Offices for Terminal Company officials were located upstairs.

In designing the New Orleans station, Burnham drew from his experience with Washington, D.C.'s Union Station, particularly in the "umbrella type" sheds, which ventilated and dispersed the smoke spewing from the steam engines. Construction of the station was carried out by James Stewart & Company and the total cost was $260,000. After a

ceremony on May 30, 1908, the inaugural run of the Queen and Crescent Route (between the "Queen of the West," Cincinnati, and the Crescent City, New Orleans) left the station on June 1. Passengers would have been taken "down the line" of the Storyville bordellos along Basin Street as they left town. They also would have seen some early automobiles bouncing along downtown streets.

The rise of automobiles and the attendant expansion of roadways and roadside amenities made rail travel less popular for regional sojourns. Commercial air service would further challenge railroads' command of cross-country service. These two factors, plus the Mayor Chep Morrison's post-World War II modernization drive, led to the unification of rail stations and trackbeds into the appropriately named Union Station in 1954, which remains in service today.

Terminal Station and the other turn-of-the-century depots by 1954 found themselves obsolete, hard to adapt, and without a friend in City Hall. That same year, the city advanced a bond issue to acquire the site and promptly clear it, ostensibly to widen Basin Street and create an open grassy vista between Morrison's envisioned Civic Center and Cultural Center, but really because it no longer served any purpose. The wrecking ball swung in spring 1955 and the site was immediately used for a statue to Latin American liberator Simon Bolivar, reflecting Mayor Morrison's larger vision for New Orleans as Gateway to the Americas.

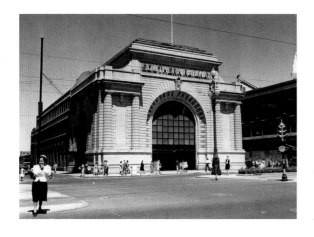

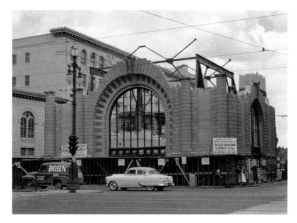

LEFT *Demolition in early 1955.* **FAR LEFT** *By this time known popularly as the Southern Railway Station, the hulking depot is seen here in its last years. (Courtesy of Visual Materials Collection, Southeastern Architectural Archive, Special Collections Division, Tulane University Libraries)*

OPPOSITE *Designed by Daniel Burnham and built in 1908, Terminal Station was one of all too many train stations and rail beds transecting the city redundantly, a situation which eventually led to their demise. (Courtesy of Library of Congress)*

Mississippi River Bridge Right-of-Way

BULLDOZED 1956–1957

America had entered the Atomic Age and practically the Space Age before the largest city in its Southern region finally got a bridge across its river. To be sure, the Huey P. Long Bridge had opened over 20 years earlier, in 1935, but, Gov. and later Sen. Huey Long being no friend of New Orleans, that span served semi-rural Jefferson Parish six miles upriver, and was designed primarily for railroad traffic. Urbanities had to make do with ferries to cross the Mississippi, and as a result, what we now call the West Bank remained far less developed, indeed downright rural outside of Algiers and Gretna—so much so it did not even have a formal place name. New Orleanians used to call it the "right bank," and into the mid-20th century, some called it "the west side," others "the west bank," still others just "Algiers." Even fewer thought of the main part of the metropolis as being the "East Bank;" that almost went without say.

What changed this riverine relationship was an idea developed in New York and other states, in which a state authority would issue bonds for bridges and other major infrastructure and then charge tolls to defray costs of construction. A local naval engineer named Neville Levy, shipbuilder and tireless civic advocate, championed the concept and found a willing partner in Mayor Chep Morrison, who prioritized for metropolitan modernization. In 1952 a state legislative act created the Mississippi

River Bridge Authority, and with Levy as chair, questions regarding bridge location and design were debated. Would the span be suspended or cantilevered? Would it afford sufficient clearance for port traffic? And mostly importantly from an urban perspective, how and where would its right-of-way transect New Orleans?

Planners decided to use the now-filled New Basin Canal corridor, already state-owned and devoid of structures, to bring traffic from points west into downtown. That trajectory dictated that a swath would have to be cleared along Calliope and Gaienne streets, plus adjoining areas for on- and off-ramps, from Simon Bolivar Boulevard to Camp Street. It would come at the expense of dozens of historic structures set within an intimate 19th-century urban fabric, but few citizens protested outside a small but growing preservationist movement, whose members particularly mourned the impending destruction of the circa-1815 Delord-Sarpy House, St. Paul's Episcopal, and the First Methodist Church.

After two years of eminent-domain land acquisitions and $3.5 million in compensatory payments, the demolitions began in 1956, by which time the bridge was well underway. Salvage businesses had a field day: "Attention: All Buildings Must Go Immediately; Prices Right," declared a 1956 ad from the Crescent Demolishing and

Lumber Company on Poland Avenue; "52 buildings to be demolished for state right-of-way Mississippi river bridge approach; single houses, double houses, steel buildings, brick buildings…bricks, lumber, pipes, blinds, sash and doors, iron railings—both plain and ornamental." In an odd incident whose poignancy seems to have been lost on those involved at the time, Neville Levy himself, while inspecting the old McDonogh Boys High School No. 1 (also known as the Maybin School) just before its destruction in April 1956, found in the basement a brick in which he had carved "N. Levy" while a student there 50 years earlier.

By early 1957, the right-of-way was clear, and work commenced in earnest on the Pontchartrain Expressway and ramps, matching arteries on the Algiers side, and what had been described at the time as the largest cantilevered highway bridge in the world, at 1,575 feet and twice that length in its full approach. It opened on April 15, 1958 and proved so popular that within a few years, talk of a second span began. Completed in 1988, the second span together with the original became known as the Crescent City Connection, and ranks today as one of the busiest bridge systems in the country. The CCC spawned a clear spatial distinction between the East and West banks, the latter of which boomed on account of the access. It also left a gash in the cityscape, probably unavoidable, and represented one of the largest single-project transformations of historic New Orleans.

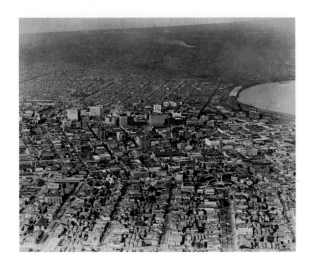

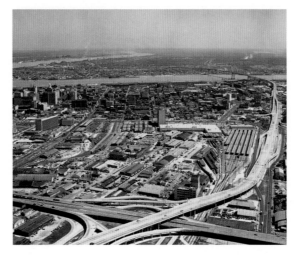

RIGHT *Construction began on the span even while demolitions continued on the ramp rights-of-way. This photograph was taken on January 8, 1957. (Courtesy of Corbis)*

FAR LEFT *Detail of a rare 1919 aerial view captures the swath of cityscape that would be cleared 37 years later for the Mississippi River bridge.*

LEFT *The completed bridge in the late 1950s. (Courtesy of Visual Materials Collection, Southeastern Architectural Archive, Special Collections Division, Tulane University Libraries)*

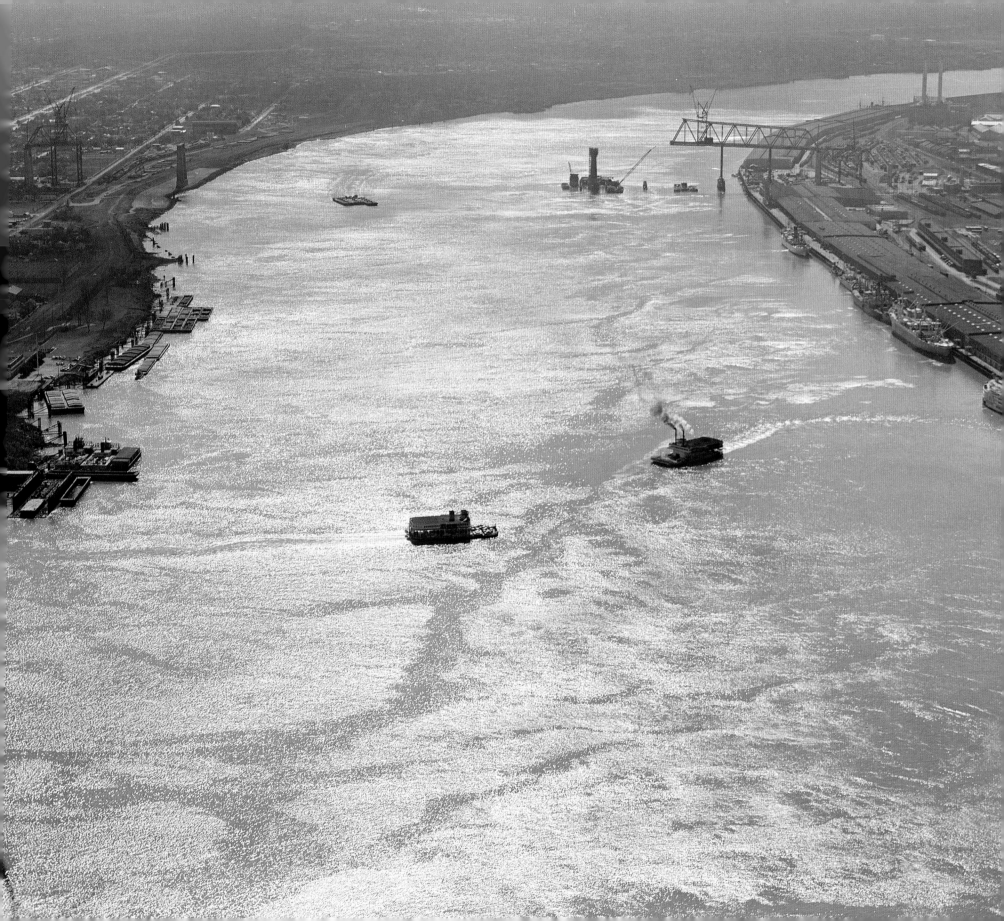

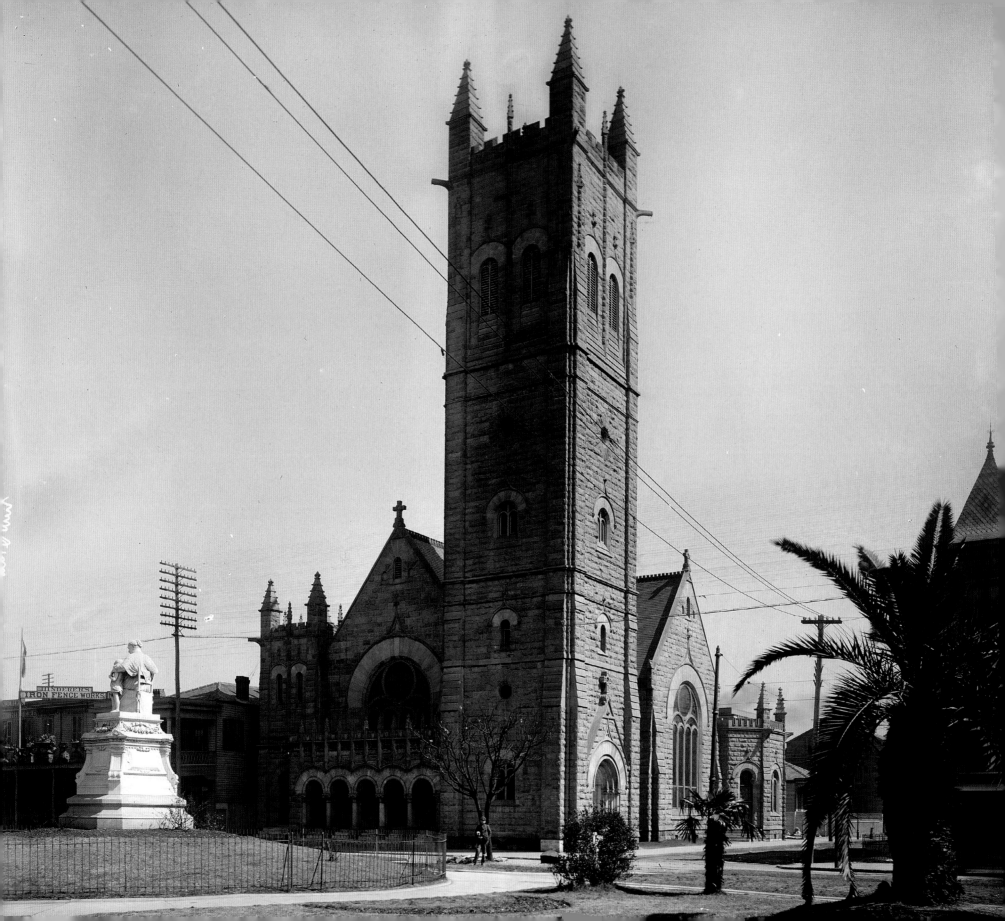

St. Paul's Episcopal Church DEMOLISHED 1958

St. Paul's Episcopal Church was located in the heart of a neighborhood initially subdivided during 1806–1810 out of six colonial-era plantations—Duplantier, Solet (Saulet), La Course, L'Annunciation, des Religieuses (Ursuline Nuns), and Panis—which had been purchased and aggregated. The expansive terrain allowed surveyor Barthelemy Lafon to pursue an imaginative Classical design featuring streets named for Greek gods and muses, a *Place du Tivoli* (now Lee Circle), a *Place de Annunciation*, and a keyhole-shaped interstice envisioned for a *pritanee* (prytaneum, or school) and a *collesée* (coliseum). Neither came into being, but both became street names, and the space became a lovely city park called Coliseum Square.

Known today as the Lower Garden District, the neighborhood reached full urban development by the 1840s, with industry and working-class households near its riverfront and more affluent families inland, particularly around the squares. This being uptown, the dominant ethnicity tended to be Anglo-American Protestants as well as Irish and

German immigrants of Catholic, Protestant, and Jewish faiths. Episcopalians in the area originally congregated in a rented room near Tivoli Circle in 1836, and later borrowed space in nearby Methodist and Jewish places of worship. By the 1850s they were ready for a place of their own, and Coliseum Square became a favored locale for religious institutions, being home to St. Teresa of Avila Catholic Church, St. Paul's Episcopal Church, and the Coliseum Place Baptist Church all within 1849–1855.

The original St. Paul's Episcopal Church was designed "in the latest pointed style of Gothic architecture in its transition to the decorated period," as the *Daily Picayune* put it, by John Barnett and built by Theodore Grand and Thomas Lewis in 1853. Its two asymmetrical towers with peaked crenellations gave a sort of inverted appearance to the building and a stoutness to its proportions. Spires were originally planned for both, the higher reaching 150 feet, but it does not appear they were ever installed. The interior had open timber work, "stained and varnished…in the pure

thirteenth century style." St. Paul's was destroyed by fire on March 23, 1891, surely fueled by that wood. Massive brick walls prevented the flames from spreading, but also contained them to destroy utterly the interior.

Two years later the congregation erected a comparable but more modern Romanesque church designed by McDonald Berthas. Problems were encountered with the tower, whose mass settled immediately after completion and necessitated its dismantling and reconstruction upon a sturdier foundation. The building opened for services on April 16, 1893 and served nonstop into the 1950s.

Congregants at that time heard rumors that the planned right-of-way for the Mississippi River Bridge might intersect their property. In fact, both the elevated highway and its Camp Street on-ramp missed the church by a matter of feet—but a bit too close for safety. Authorities allowed the church to remain standing to give time for the Episcopalians to erect a new church in Lakeview. In early 1958, as the span neared completion, the 65-year-old building was razed, making it one of the very last structural victims of the progress represented by the Mississippi River Bridge.

The loss of St. Paul's left only St. Teresa (1849) and the Baptist Church (1855) overlooking Coliseum Square. Hurricane Betsy toppled the tower of the latter in 1965, and Hurricane Katrina destroyed the stained glass window of the former in 2005. In the spring of 2006, vagrants set fire to the then-empty Baptist Church, and the ruins were cleared away within days.

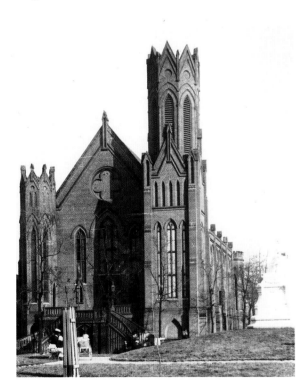

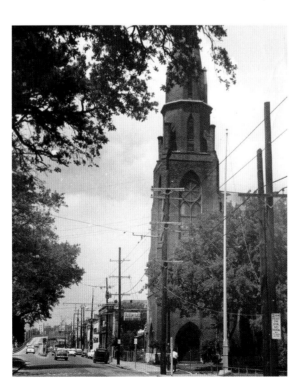

LEFT *One of three historic churches in the area, the Coliseum Square Baptist Church survived the bridge construction but lost its tower to Hurricane Betsy in 1965, one year after this photo was taken, and was destroyed by fire a year after Hurricane Katrina.* **FAR LEFT** *The original Gothic-style St. Paul's Church (1853) was destroyed by a ferocious fire in 1891 (Courtesy of Visual Materials Collection, Southeastern Architectural Archive, Special Collections Division, Tulane University Libraries)*

OPPOSITE *St. Paul's was rebuilt in Romanesque form in 1893. (Courtesy of Library of Congress)*

Early Uptown Mansions DEMOLISHED 1957–1959

The two majestic landmarks shown here stood as relics of the first generation of city buildings erected on the former colonial-era holdings of Duplantier and Saulet (Solet) in the present-day Warehouse and Lower Garden District. These two long-lot plantations were subdivided during 1806–1810 by Barthelemy Lafon, the renowned local surveyor who found inspiration in Classical designs and executed here a whimsical plat complete with parks and streets named for the nine Greek Muses.

Among the early notable mansions erected on a street within Lafon's new Faubourg Duplantier was the Delord-Sarpy House, dating to around 1815 and reflecting French Creole styles similar to those of the famous Girod (Napoleon) House, its contemporary on Chartres Street. Both were likely designed by Jean Hyacinthe Laclotte. Despite its appearance and orientation toward the river—we are looking at the side of the house here, with the front gallery at left—this building was not a plantation house serving an agrarian function, as was its circa-1765 predecessor, built by Francois Duplessis and located closer to the Mississippi. Rather, the circa-1815 structure was a city house designed with a spacious country-like air because this vicinity at the time was largely provincial.

But within a generation, wealth moved uptown and industry moved next door, and this street—once named Delord, then Howard, now Andrew Higgins Place—transformed into a sweaty port-city manufacturing and warehousing district. This photograph captures this mixed urban environment as it stood in the 1920s, with a functional garage squeezed within inches of the mansion's columns and the stone spires of St. Paul's Church visible in the distance. By the mid-20th century, the Delord-Sarpy House was the oldest surviving structure above Canal Street.

What spelled the doom of the old mansion—as well as the church—was not industry but transportation: by a matter of feet, it stood in the path of a planned off-ramp for the Mississippi River Bridge. Given the sensibilities of the era, it was deemed much more cost-effective to remove the house than alter the ramp, despite the pleas of architectural historian Samuel Wilson Jr. and the Louisiana Landmarks Society. The building and its neighbors were cleared away in 1957, and today, motorists exiting onto Camp Street from the West

Bank now pass through the space of the lost landmark. For a brief while in 2012, the floor and courtyard bricks of the house and its neighbors reappeared as workers prepared the area for an addition to the National World War II Museum.

In the adjacent faubourg of Saulet, on Annunciation Street between Melpomene and Thalia, stood the Saulet House, built around 1832–1834 to replace a 1760s structure from agrarian times. Like the Delord-Sarpy House, the Saulet House was positioned as a city home but designed with a bucolic air, so much so that Historic American Building Survey researchers noted its interior plan was nearly identical to that of Seven Oaks, a truly rural plantation house. As happened

to a number of large old mansions, changing needs called for changes of use, and in 1860 the Sisters of Charity bought the Saulet House and opened within it the St. Simeon's Select School, which operated here and in adjacent buildings until 1912, after which it became the parochial school for nearby St. Teresa's Catholic Church. Last home to Mercy Hospital, the Saulet House complex and land were sold in 1959 and replaced by a Schwegmann's, New Orleans' original modern supermarket chain. Robert's took over the business in the late 1990s but the building has remained shuttered since Hurricane Katrina.

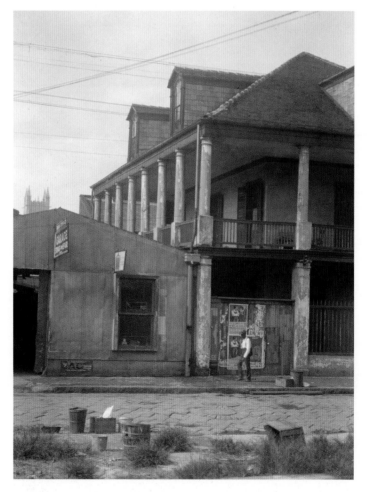

LEFT *The resplendent Delord-Sarpy House, seen here 113 years after its construction in 1815, was felled for an off-ramp for the Mississippi River Bridge in 1957. (Photograph by Arnold Genthe, courtesy of Library of Congress)*

RIGHT *The Saulet House, built 1832–1834, later became St. Simeon's Select School (seen here, circa 1906), then a parochial school, and finally Mercy Hospital, before its demolition. (Courtesy of Library of Congress)*

019316. ST. SIMEON'S SELECT SCHOOL, NEW ORLEANS, LA.

New Orleans Public Library DEMOLISHED 1959

For over 50 years, this majestic Greco-Roman temple near Lee Circle was home to the New Orleans Public Library, an institution whose origins date to private philanthropy on, of all places, Bourbon Street. There, Massachusetts-born merchants Abijah and Alvarez Fisk donated a house at the riverside/upriver corner of Bourbon and Customhouse (now Iberville) and stocked it with books. Popular with citizens and students of the various "academies" (small specialized private schools) in the neighborhood, the private nonprofit library shortly outgrew its downtown space and, known as the "Fisk Free Library," moved to the domed St. Patrick's Hall on Lafayette Square.

In 1896 a city ordinance merged Fisk's ample collection with municipal book holdings and officially birthed the New Orleans Public Library. Reflecting the spirits of the Progressive Era (1880s–1920s), private donations from local cigar tycoon Simon Hernsheim financed the acquisition of additional volumes, while a much larger donation from steel-magnate and philanthropist Andrew Carnegie funded the erection of four branches and the main branch seen here, at Lee Circle.

The site had a tumultuous history. In late antebellum times it hosted the old Carrollton Railroad Depot, a way station for travelers between downtown and the gradually developing precincts of uptown. The station was removed in 1866 and overlaid in 1872 with the foundation of a proposed Masonic Temple. The masons abandoned their plan and moved their project down St. Charles Avenue, and the idle platform was instead used for traveling circuses, theaters, and even a roller coaster. In 1890, the German-American singing club Saengerbund erected for $50,000 an ornate temporary hall for the national group's festivities in New Orleans. Used for only four days, it was cleared away within a year by the Masons, who still owned the property. The city acquired the site 10 years later and in 1907 work commenced on the main branch of the New Orleans Public Library. Architectural firm Diboll, Owen, and Goldstein devised a Roman temple design typical of Carnegie libraries built across the country, and constructed it upon concrete pilings, a recent innovation replacing the yellow pine trunks traditionally used for foundations here. Inside, the circulation and reading rooms spanned 125 feet in length beneath 25-foot ceilings supported by 22

Corinthian columns of fine Vienna marble. Iron staircases, electric lights and elevators, and a landmark copper dome topped the imposing edifice. Opened in 1908, the so-called "Carnegie Library" or "Lee Circle branch" would become an integral memory of school children for half-a-century, and older citizens to this day speak nostalgically of the place.

The library survived—barely—the numerous demolitions of 1956–1958 making way for the Mississippi River Bridge and Pontchartrain Expressway. But an equally massive project of Mayor Chep Morrison in this era, to centralize city government at a new civic center on Loyola Avenue, led to the razing of the 1908 building in favor of a new library with four times the floor space. During the 1959 demolition, workers encountered the wooden pilings from the foundation (1871) of the never-constructed Masonic Temple amid the more recent concrete pilings. The former John Hancock Building (1961, designed by Skidmore, Owings & Merrill) now occupies the library site, serving for decades as headquarters of K & B, the famed local pharmacy chain founded by Gustave Katz and Sydney Besthoff in 1905. The new public library at

Loyola and Tulane, designed by Curtis and Davis and itself a landmark of late-1950s Modernism, serves today as the main branch of the system as well as the official archive of the City of New Orleans.

OPPOSITE *Opened in 1908, the main branch of the New Orleans Public Library, which locals called "the Carnegie Library" or "the Lee Circle branch," became an integral memory of citizens who came of age in the 1910s–1950s. Note the tower of Temple Sinai in the background.* **BELOW** *In the 1800s the city's reading resources were an ad-hoc mix of private and public collections. This building, photographed around 1900, was designed by Louisiana-born architect Henry Hobson Richardson in his famous "Richardson Romanesque" style. After his death, the plans were commissioned to become the privately funded reference archive known as Howard Memorial Library (1888). Specializing in Louisiana history, the collection grew to 107,000 items by 1938, when it merged with Tulane's Tilton collection to become Howard-Tilton Library. Still standing, the building is now a meeting hall affiliated with the adjacent Ogden Museum. (Courtesy of Library of Congress)*

Stoop Sitting DECLINED 1950s–1960s

Cities are social experiments, and it is in the public space that residents' social interactions, good and bad, play out. Since time immemorial, New Orleanians, like urbanites throughout the warmer climes, perched themselves at the interface of private and public spaces—on their front stoops—to seek the company of neighbors, the sight of strangers, relief from stuffy interior heat, or warmth from the mid-winter sun. A stroll through any residential neighborhood prior to the 1960s, particularly those of the working class and poor, would have given a veritable insight into the demographic profile of local inhabitants: children of all backgrounds playing in the streets, housewives gossiping, husbands puttering about, elders swapping stories. People also read, knit, played games, and got work done in these spaces between private and public realms. Architects understood the appeal and designed balconies into façades, and adorned them to the point that iron balconies and wooden gingerbread adornments have become

iconic motifs of New Orleans. A *Daily Picayune* column in 1852 praised the increasing popularity of one form of such perches, iron-lace galleries, on the new building stock of the booming city,

> One of the most admirable innovations upon the old system of building tall, staring structures for business purposes, is the plan…of erecting galleries and verandahs of ornamental iron work. [Instances include] the new row of houses erected on St. Charles street for Judah Touro, and several others of a similar style on Carondelet Street, in the vicinity of Common.

Iron-lace galleries spread throughout the inner city during and after the 1850s, while wooden porches predominated in outer neighborhoods. On shotgun houses and cottages too small to sacrifice the space, the stoop—that is, the short run of brick or concrete steps connecting the street grade with the main floor—sufficed.

Porch-, balcony-, and stoop-sitting offered comfort and free entertainment to its practitioners. But they also played a deeper role in city living, creating a time and a space for community-building. Interacting regularly with neighbors built valuable social networks, which in turn yielded lifelong friendships, opened up economic and cultural opportunities, reduced vulnerability during times of risk (such as illness and hurricanes), and connected people with broader flows of information and ideas. Stoop-sitting produced what sociologists call "social capital"—that is, valuable networks of human relationships. It allowed local folklore, stories of the past, lessons learned, and visions of the future to move from neighbor to neighbor, from elder to child. Stoop-sitting also put, in the phrase of urbanist Jane Jacobs, "eyes on the street," sending a message to deviants that they were being watched, that residents cared about their neighborhood, and would intervene to keep it orderly.

Three factors undermined stoop-sitting in the

mid- to late-20th century. The advent of window-mounted air-conditioning, which became affordable to the middle class after World War II and to the working class a decade or so later, reversed household climates such that it was now more comfortable to stay indoors than sit outside. The simultaneous rise of television gave residents a "social" activity to do indoors—only the socializing was at best one-way, and at worst intellectually detrimental. Architects responded by eliminating porches and even operable windows from new ranch houses erected by the thousands in spacious suburban subdivisions, all of which further drove neighbors apart. Automobiles cleared the streets of pedestrians, to the point that planners eradicated sidewalks, or the city failed to maintain them. Americans stopped joining civic, fraternal, and religious associations, and increasingly drove to commercial spaces rather than walked to social spaces. Rise of crime in the 1970s made stoop-sitting potentially dangerous, and the benefit of "eyes on the street" converted into the fear of becoming a witness—or a victim.

Today in the streets of New Orleans, one still sees folks on stoops. But scenes such as these, where nearly half the block would spill into the streets, socialize, and produce culture, are a rarity in all but the poorest neighborhoods.

LEFT, RIGHT & OPPOSITE *These photographs from the early 1940s show New Orleanians using their stoops as social spaces, to escape summer heat or soak up winter sun while chatting, playing games, and engaging with their neighbors. (Courtesy of Library of Congress)*

Bourbon Street

END OF BURLESQUE "GOLDEN AGE," 1960s

Bourbon Street emerged as a nighttime entertainment strip as a result of a shift in the geographies of "sin" from the outskirts of the city in the mid-1800s to the urban core by the late 1800s. Previously a rather prosaic downtown artery, Bourbon Street boasted in this era the Old French Opera House plus a number of nearby theaters, "coffee houses," concert saloons, and restaurants, as did adjacent streets. What set Bourbon apart was its successful adoption of a new social innovation of the 1920s, the "night club," where, despite Prohibition, both men and women could socialize in exclusive, stylized spaces over dinner, drinks, and entertainment. The nocturnal appearance of middle-class women on a street that had previously been mostly male—and decidedly sketchy—helped lay the groundwork for large-scale modern tourism.

After Prohibition, and despite the Depression, Bourbon Street became home to three dozen clubs and bars, locally noted as a fancy nightspot but little known beyond city limits.

That changed when World War II broke out, and millions of servicemen and war plant workers found themselves crossing paths in New Orleans. To Bourbon's clubs and bars they bee-lined, and by 1945, Bourbon Street had become big, raucous, lucrative, nationally famous, and locally notorious.

Over the next 20 years, Bourbon Street's "golden age," swanky burlesque clubs with elaborate shows operated door-to-door with bars and fancy restaurants. What "gilded" this golden age, however, was not purely entertainment. Many clubs profited extravagantly because organized crime ran illegal gambling operations in the backrooms and padded their profits with "B-drinking" scams, in which dancers would sucker a mark into buying overpriced drinks and bouncers would roll him in back alleys for any remaining cash. Residents of the French Quarter, meanwhile, bitterly fought Bourbon bar owners over vice, noise, signage, litter, architectural transgressions, and other flashpoints.

Bourbon Street changed dramatically in the 1960s. Modern jet travel and new corporate hotels brought mass tourism directly to the street's doorsteps. Young people increasingly eschewed burlesque, and hippies replaced well-heeled couples. Most significantly, the newly elected district attorney Jim Garrison, aiming to appeal to voters, calculated that burlesque clubs could only turn a profit if they ran illicit schemes on the side. By cracking down on illegal but lucrative activities, Garrison made the legal but costly main attraction untenable. Clubs closed left and right during 1962–1964 and were gradually replaced by tawdry joints and junk shops whose operating costs were low enough to turn a profit without extralegal subsidies.

The decline of traditional burlesque meant that visitors increasingly strolled up and down the street past the clubs, even as barkers cajoled them to enter. In 1967, one enterprise came up with a better idea: instead of convincing people outside to buy drinks inside, why not sell inside drinks to people outside? One by one, bars, clubs, and restaurants opened tiny retail outlets in carriageways, windows, alleys, and secondary doorways. The go-cup was born, and in a few years, it would completely rewire the dynamics of Bourbon Street. Whereas historically the action was inside the exclusive private space of the clubs, now it shifted outside to the passing parade. "Window hawking," as it was called, brought litter and public intoxication to what had previously been a stylish destination. To New Orleanians, Bourbon Street had become a carnivalesque embarrassment.

Mayor Moon Landrieu knew something had to be done, and in 1976 formed a task force to devise new policies to bring order to the strip. On account of these reforms and the ensuing prosperity of the 1980s–1990s, Bourbon Street recovered from its 1960s–1970s nadir and reinvented itself with a "beachy tropicality" theme designed to appeal to college students. Since then, Bourbon Street has been relatively stable; a walk down the street today is remarkably similar to the experience 15 or 30 years ago.

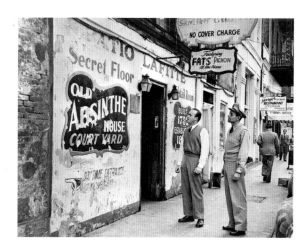

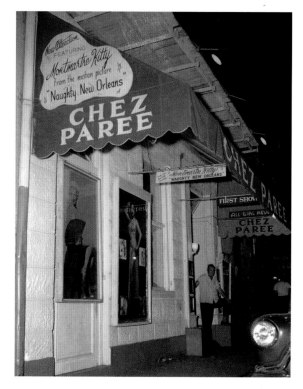

OPPOSITE, ABOVE & RIGHT *Night clubs started to cluster on Bourbon Street in the 1920s, and after World War II, the strip became nationally famous for the sort of night clubs and burlesque venues seen here. Legal and social changes during the 1960s transformed Bourbon Street into the public drinking pedestrian mall it is today. (Opposite page, courtesy of Getty Images; this page, courtesy of Corbis)*

Foot of Canal Street TRANSFORMED CIRCA 1960

If the Clay Statue on Canal at Royal/St. Charles was New Orleans' psychic center, Canal's "foot"—that is, its terminus at the Mississippi River—was the nexus of its transportation infrastructure.

In the early 1800s, lower Canal Street comprised mostly two- to four-story row structures used for warehouses, port services, wholesalers, and distributers. Riverside of Levee Street (now Decatur), Canal's urbanism gave way to a wide-open wood-planked landing which the wharfmaster officially reserved for steamboats, as opposed to "up country" flatboats, which were directed to the wharves above Julia Street, and ocean-going sailing ships, which docked below Conti Street. In and around the foot of Canal were a variety of salient structures, among them the cast-iron City Water Works Building (1859) and the Harbor Station/Ferry Building, notable for its cupola and graceful roof. Later, a landmark viaduct allowed pedestrians en route to the Algiers ferry to walk over the passenger trains pulling in and out of the Louisville & Nashville (L & N) Station, while a major eight-track terminal served the various streetcar lines that began and ended here. According to Hennick and Charlton's *Streetcars of New Orleans,* "the foot of Canal Street saw in 1902 more lines terminating and grouping there than did the famous streetcar terminus at the Ferry Building in San Francisco; the cars of twenty lines could be seen at the layover terminus."

When passions spilled out into the public space of 19th-century New Orleans, they did so either at the Clay Statue or at the foot of Canal Street. Most were celebratory; some were not. In 1929, for example, a strike among streetcar workers here got out of the control, and grew into a riot—although it was not quite the disturbance of 55 years earlier. On September 14, 1874, the Crescent City White League, a post-Confederate Democratic militia vehemently opposed to the federally backed Republican state government, attempted to oust Governor W. P. Kellogg after his seizure of an arms shipment. A violent battle ensued in front of the Customs House in which White Leaguers fought hand to hand with the governor's predominantly black Metropolitan Police, causing 32 deaths and scores of injuries. Though the action failed to overthrow the governor, what came to be known as the Battle of Liberty Place—really an attempted

RIGHT *The foot of Canal Street in 1938, in which the traffic circle featuring the controversial Liberty Place Monument is visible at lower right center. The monument commemorated an attempted coup d'état in 1874 which led to the end of the federal occupation and the installation of a white supremacist state government. (Courtesy of Visual Materials Collection, Southeastern Architectural Archive, Special Collections Division, Tulane University Libraries)*

BELOW LEFT *Wharves at the foot of Canal and Poydras streets in 1906, about a decade before they were covered with sheds and modernized.* **BELOW** *Detail of a 1910 panoramic photograph by A. L. Barnett showing Rex arriving to the Ferry House at the foot of Canal Street to begin the city's Mardi Gras celebrations.* **BOTTOM** *Inland detail of the same 1910 panoramic shot, showing the Louisville & Nashville Railroad Station at the foot of Canal Street. (Courtesy of Library of Congress)*

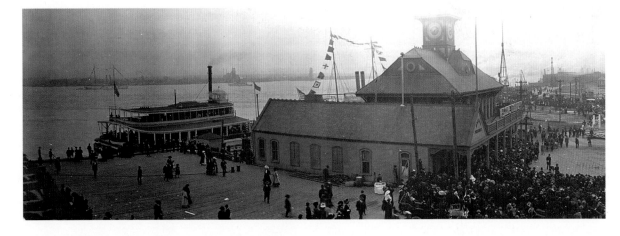

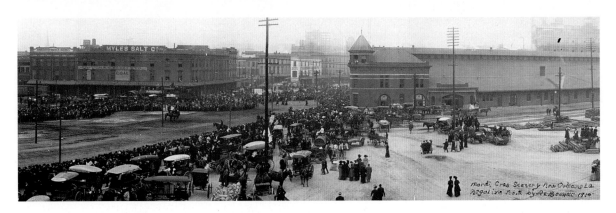

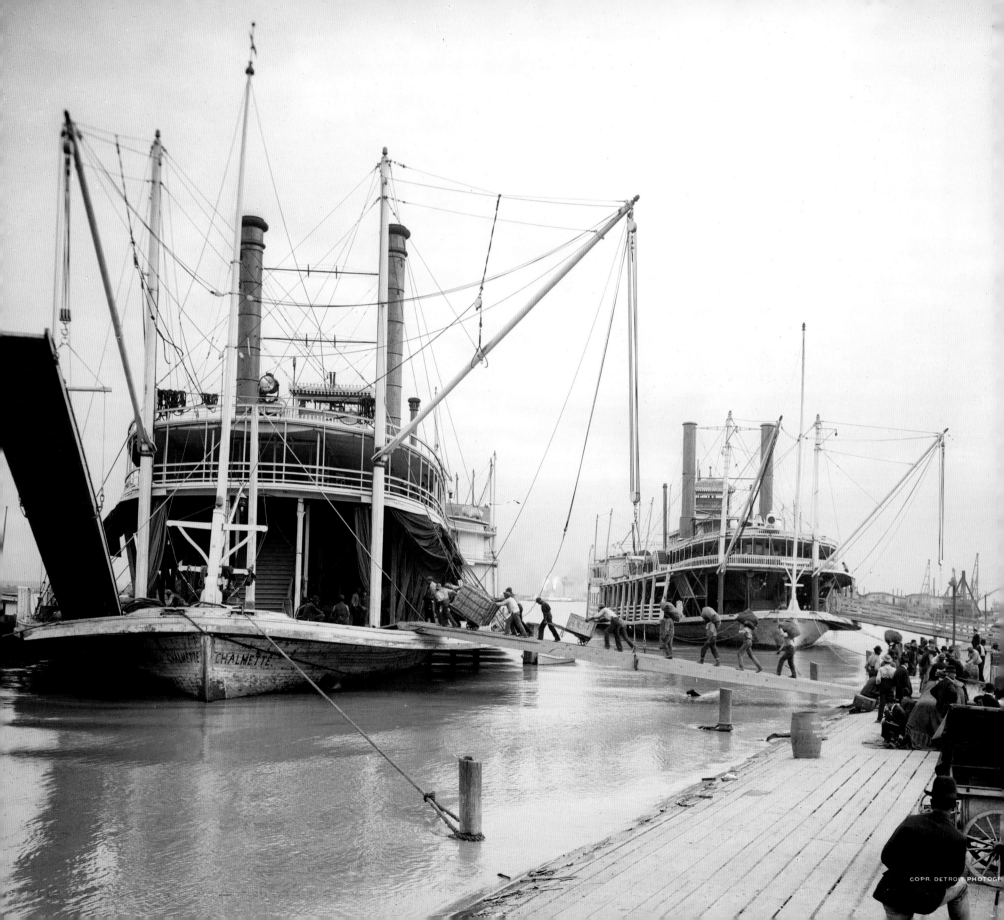

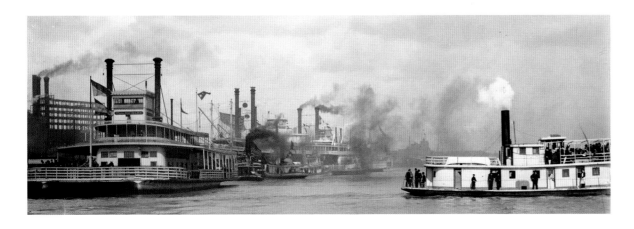

coup d'état—provided momentum for the White League to achieve its true aim: the withdrawal of all federal troops (1877) and the installation of a white-supremacist state government. Memories of the battle, both hagiographical and critical, would draw citizens to the Liberty Place Monument at the foot of Canal Street into the 1990s.

What clinched the mystique of this spot, however, was its happier role as the landing site of Rex on the day before Mardi Gras. From the 1870s to 1917, the King of Carnival arrived here on steamboat or yacht, and amid throngs, a chariot would carry him to various social engagements preceding his one-day reign on Fat Tuesday. The tradition was revived decades later, and starting in 1987, became formalized into a series of events taking place on a new holiday dubbed Lundi Gras (Fat Monday).

The foot of Canal Street diminished as a transportation node in the 1950s and 1960s, when passenger trains and streetcar lines were removed and only ferries and tour boats continued to dock. Land use switched to the budding tourism industry and oil-driven demand for office space. In 1965, one of New Orleans' first true skyscrapers, the cruciform-shaped 33-story International Trade Mart

(now the World Trade Center) was erected on this prized real estate, along with the visually astonishing Rivergate Exhibition Hall (1968), whose construction, as well as the concurrent excavation of a tunnel for the planned (but later defeated)

Riverfront Expressway, turned the foot of Canal Street into a vast expanse of overturned soil. Following the completion of the Mart and Hall and their inauguration as part of the 250th anniversary of the city's founding, in 1968, a series of skyscraper hotels and tourism spaces were built around lower Canal, among them Canal Place (1979), the Riverwalk Marketplace (1986, renovated 2014), the Aquarium of the Americas (1990), and Harrah's Casino (1999), for which the Rivergate was demolished in 1995.

No longer is the juncture of New Orleans' greatest thoroughfare with the Father of Waters the geographical node it once was; it is now something of a staging ground for adjacent features. Nevertheless, a strong sense prevails among architects and planners that the foot of Canal Street remains the premier real estate in the city, and debates are ongoing as to what to do with the World Trade Center and how to capitalize on what had previously been New Orleans' foremost showcase.

LEFT, ABOVE & RIGHT *These riverfront scenes around the foot of Canal Street show the last years in which steam-driven stern-wheel paddle boats moved commodities on the Mississippi River. They were gradually phased out in the early 1900s in favor of diesel-driven cargo ships (right), or tug boats pushing barges. By the 1920s, the few remaining steamboats were converted to recreational use. (Courtesy of Library of Congress)*

Solari's Delicatessen DEMOLISHED 1961

In 1864, a New Orleans insurance executive of Italian descent named Joseph B. Solari and his brother Angelo opened a retail business devoted to imported fine foods. Angelo's forte, according to a 1927 retrospective, was management and customer relations; Joseph's was venturing abroad for all that was rare and fine to eat and drink. Leveraging their compatible skills, and despite the economic malaise of the wartime and Reconstruction era, the Solaris did well at 45 Royal Street (now 229 Royal), where, in 1872, they advertised in the *New Orleans Times* "ale, porter, biscuits, Cross & Blackwell pickles, Spanish olives, [and] Holland cheese" amid "an extensive and well selected stock of foreign groceries and delicacies." The A. M. and J. Solari Grocery Company moved its operation briefly to lower St. Charles Avenue and in 1877 opened at the corner of Royal at Customhouse (now Iberville), with a second location on Camp Street near Poydras.

Later that year Solari's became one of the first businesses in the city to adopt an exciting new technology. "In order to facilitate communication between his store…and the one at 75 Camp Street," reported the *Daily Picayune* in October 1877, Solari's "has established a line of wires between the stores, and a telephone in each." The experiment was a success, and orders of shipments were placed between the old and new stores—perhaps New Orleans' first-ever over-the-phone food order. How else to celebrate but with a feast of fancy foods? "In honor of the christening, an elegant collation was spread. With that congeniality characteristic of the host, [Joseph] Solari extended the hospitalities of his store with the 'laisser aller' of a man of the world, and entertained his guests in handsome style."

J. B. Solari's elegant and cosmopolitan manner was reflected in his business, which expanded to the point that he decided to erect a larger, specially designed edifice. In 1887, Solari contracted architect Thomas Sully to design and build this ornate three-bay, four-story storehouse with high-ceiling retail space on the ground floor and upper-story storage space for imported bottles, bins, tins, and cans. Under the management of the A. M. and J. Solari Grocery Company, this Solari's, plus an uptown branch on St. Charles at Louisiana Avenue, became a cornerstone of epicurean New

Orleans at the turn of the century. "There's an appetizing air about SOLARI'S that you don't find in every grocery house," read a typical newspaper advertisement in 1912; "The stock is appetizing. It's clean. Fresh. Full of variety. Goods from the Southland, the North, East and West, and all foreign lands." Sensing that customers of the modern day "would not feel entirely at home in a store whose fixtures and fittings were reminiscent of the time of the crinoline, the basque and the banquette-sweeping skirt," Solari's had its circa-1887 interior massively updated in 1926–1927 to include, among other things, a marble lunch counter and new cooking facilities, in addition to candies, liquors, coffees, cheeses, meats and other upscale edibles.

The shift of the French Quarter from a residential neighborhood to a tourist destination laid the groundwork for Solari's decline. Because of a 1946 change in the protective jurisdiction of the Vieux Carré Commission, this particular building became prone to the decisions of its ownership, which in 1960 shifted from A. M. & J. Solari to a group of businessmen. With parking pressure ever increasing in the French Quarter, the new proprietors saw Solari's upper floors as a waste of valuable space. With no way to retrofit the 1887 structure and little interest in historical architecture, they had it demolished in 1961 and replaced in early 1962 with a building "reminiscent of a store of the 1860s," as the *Times-Picayune* generously reported. What resulted was a rather ersatz garage with retail space on the ground floor, including a wine cellar and a "natural cave" for aging cheese. After a temporary location on Dryades Street, Solari's reopened in the new space, but because there was no more self service, and because there were fewer and fewer French Quarter residents and more and more purchasing power in supermarkets and in the suburbs, it never quite gained traction and closed permanently after a Texas company named Diversa bought the building in September 1965. The site, 201 Royal Street, is now home to Mister B's Bistro, which mostly serves visitors, their cars parked above.

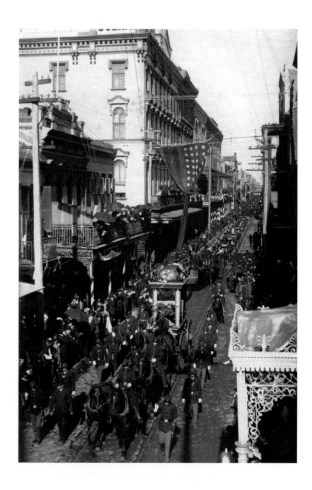

ABOVE *Two years after Solari moved his fine foods business to this new building (center) on the corner of Royal and Customhouse (now Iberville), the elaborate funeral procession for former president of the Confederate States of America, Jefferson Davis, who died in New Orleans in 1889, rolled up Royal Street.* **RIGHT** *Solari's 1887 building is seen here being readied for demolition in 1961. Food retail in the French Quarter has never quite been the same. (Courtesy of Visual Materials Collection, Southeastern Architectural Archive, Special Collections Division, Tulane University Libraries)*

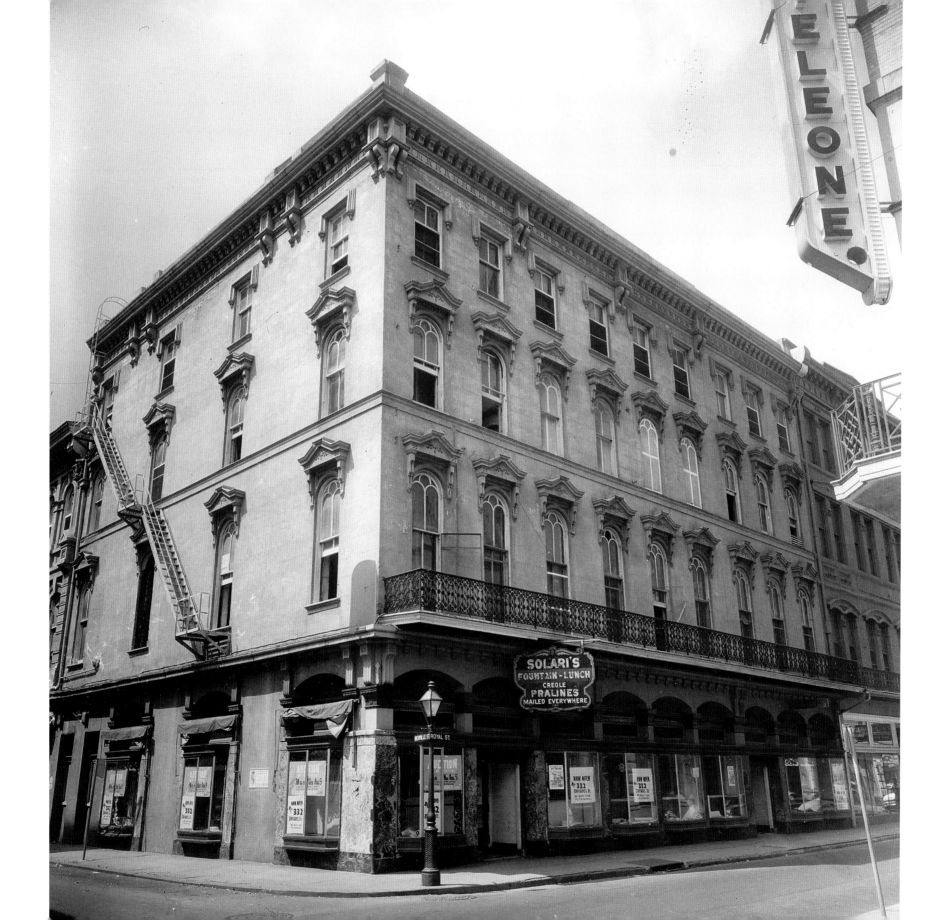

The Sugar and Rice Exchange DEMOLISHED 1963

Francis B. Fleitas' New Orleans Sugar Shed Company (1870) served as a *de facto* rendezvous for merchants, factors, weighers and other New Orleans middlemen stewarding the inflow of raw sugar and outflow of the refined product. The company also earned itself criticism as a corrupt monopoly known for mishandling produce and overcharging for storage. This led members of the Louisiana Sugar Planters' Association to consider forming a Sugar Exchange, where sugar could be sold by sample and merchants could share information and agree upon standards.

The idea, inspired by the success of the New Orleans Cotton Exchange and the realization that other local industries were forming similar organizations, came to fruition at the association's meeting in February 1883. The group obtained a charter on March 6, wrote a constitution and by-laws, and selected officials and committees. Members next purchased four lots at the corner of Bienville and Conti—at the heart of the Sugar District—from one Madame Blanche for $16,262 plus fees, and hired noted local architect James Freret to design their headquarters. The Louisiana Sugar Exchange Building was built by Joseph R. Tureck during the next year for a total of $52,000 and dedicated on June 3, 1884. Comprising planters and producers on the supply side and dealers and buyers on the demand side, the Exchange endeavored "to govern and direct how commodities offered on our floor may be sold, purchased, and delivered; to fix penalties for failure to comply with contracts; to establish standards and rules for the government of inspectors, weighers and gaugers, and to determine the order of meetings of the Exchange..." At its 1884 inauguration, speaker John Dymond explained the need for the Exchange,

> All the world has changed and our turn has come…. We are now competing with all the world; to succeed in it every device suggested by modern economy must be availed of. Sugars must be bought and sold quickly and correctly, and at a minimum of expense; disputes must be quickly settled by arbitration; abuses must be settled by authority; new, good methods must be brought out, and old, bad ones rejected; and modern experience shows that this can be best done by an Exchange….

The shipping and marketing activities of Louisiana rice also settled in this vicinity, and in 1889, the Sugar Exchange incorporated this sister crop and renamed itself the Louisiana Sugar and Rice Exchange. Not as extensively grown and not nearly as industrially intensive, rice was secondary to sugar in the district and at the Exchange, though many workers attended to both commodities.

Freret's graceful Beaux-Arts design featured triptych walls in front and rear, large windows, a landmark clock in the pediment, and a skylight atop a 65-foot-high dome supported by four fluted Ionic columns. Members lived in a world of sugar: there were sugar and molasses warehouses in almost every direction, steamships and freight trains, cooperages and mixing shops, "The Brokers' Charm" Saloon at 35 (now 335) North Front, and even a small triangular "Sugar Park" sandwiched among Bienville, North Front, Conti, and Wells. Acres of sugar barrels covered the wharf space, traversed by itinerant clusters of weighers, samplers, and merchants going about their tasks.

The Sugar and Rice Exchange was only as healthy as the Sugar District, which in turn depended on the health of the cane and rice fields. With the declines of the 1920s–1930s the Exchange closed, and with the temporary exclusion of this area from Vieux Carré Commission jurisdiction, the building lost its protection from demolition. In ruinous condition, the 80-year-old shell was sold and promptly demolished in 1963. Today its site, like most of the old Sugar District, is a parking lot.

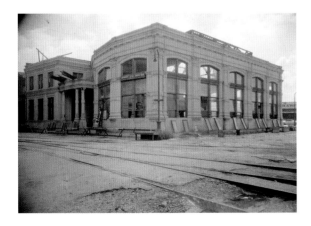

OPPOSITE, ABOVE & LEFT The Sugar and Rice Exchange during demolition in 1963. To this day its footprint is nothing but an asphalt parking lot. (Courtesy of Library of Congress)

RIGHT The Sugar and Rice Exchange (seen here in the early 1900s) was the center of professional trading activity in the vast industrial and shipping district devoted to these two commodities. (Courtesy of Visual Materials Collection, Southeastern Architectural Archive, Special Collections Division, Tulane University Libraries)

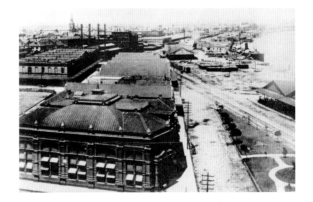

Old Orleans Ballroom/ Holy Family Convent and School **DEMOLISHED 1964**

In the late 1800s, the Society of the Holy Family, an order of African-American nuns, purchased an old ballroom-turned-courtroom at present-day 717 Orleans, directly behind St. Louis Cathedral. Originally built in the late 1810s in affiliation with the adjacent Theatre d'Orleans, the ballroom had gained fame in antebellum times for its so-called Quadroon Balls, where, according to (likely overstated) legends, white men would meet women of color to establish liaisons. The Sisters of the Holy Family had a very different program for their place, and when a fire cleared the adjacent lot on the corner of Bourbon Street, they expanded their operation with the St. John Berchman's Orphan Asylum (1892), which later became St. Mary's Academy high school.

For the next seven decades, the Sisters resided in their Orleans Street convent and fulfilled their mission to educate young black girls. By mid-century, however, that section of Bourbon had become engulfed by bars and adult entertainment. Needing more space and beleaguered with high maintenance costs, the Sisters were ready to decamp, arguing that "none of the students in the school come from the Quarter and the location...is definitely not desireable..." The only way they could fund their relocation was to sell to a developer who had for-profit plans for the site, which required a zoning change from the City Council.

They found the right man in investor Wilson P. Abraham who, to the dismay of neighbors and preservationists, proposed to construct a 65-foot-high lodge modeled on the recent success of Royal Orleans Hotel. The envisioned "Bourbon Orleans" was controversial on a number of levels, not the least of which was the fate of the historic Holy Family complex; there was also the requested zoning downgrade, from residential to commercial, which preservationists feared could set a dangerous precedent. When the City Council rejected that request, Abraham re-proposed an apartment-hotel, which cleverly circumvented the zoning change by making the project *both* residential and commercial. Homeowners worried that "hotel" meant transients and parking problems, and feared the out-of-scale proposal could, in the words of one opponent,

"open the flood gates directly bringing Bourbon Street into the age-old heart of the Quarter."

A compromise was reached in 1963 in which zoning changes would be limited, concessions would be made on the hotel's size and design, apartments would be swapped for hotel rooms, and the ballroom on Orleans would be preserved. In early 1964, the Sisters moved to their new home on Chef Menteur Highway; the circa-1892 school was demolished; and work commenced on the 241-room lodge. Pile-driving and excavation destabilized nearby historic buildings, including some ballroom walls, and necessitated their razing. These photographs capture the scene during that period.

After the Bourbon Orleans Hotel opened in July 1966, it seemed to validate preservationist arguments. For one, entrances were placed on St. Ann and Orleans, which was good because it shifted taxi congestion off Bourbon. But it also left the Bourbon frontage stark and over-sized, with sky-high galleries supported by colossal steel posts. Altogether the structure interrupted the block-to-block *tout ensemble* (the total impression of the historic structures) on Bourbon Street, while extending its din up to the St. Ann intersection. For preservationists, the project was at best a vinegar victory, more like a mitigated defeat. They exacted structural concessions and saved the ballroom's exterior, but they lost the residential zoning, the nuns, the school children, the apartment, the ballroom interior, and adjacent historical structures. For the merchants of the Bourbon strip, however, the Bourbon Orleans and its hundreds of nightly guests meant warm bodies and pure profit.

OPPOSITE *Here the former convent is being incorporated into a modern hotel.* **RIGHT** *Theater, ballroom, courtroom, convent: this building's uses and occupants tell a complex story across 150 years of New Orleans history. The black and white drawing is from Gibson's Guide and Directory, 1838. (Courtesy of Library of Congress)*

BELOW *While the convent was mostly preserved, the entire half of the block facing Bourbon Street between Orleans and St. Ann was cleared in 1963 for the new hotel. (Courtesy of Visual Materials Collection, Southeastern Architectural Archive, Special Collections Division, Tulane University Libraries and Historic American Building Survey)*

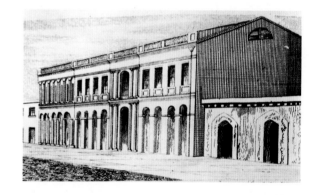

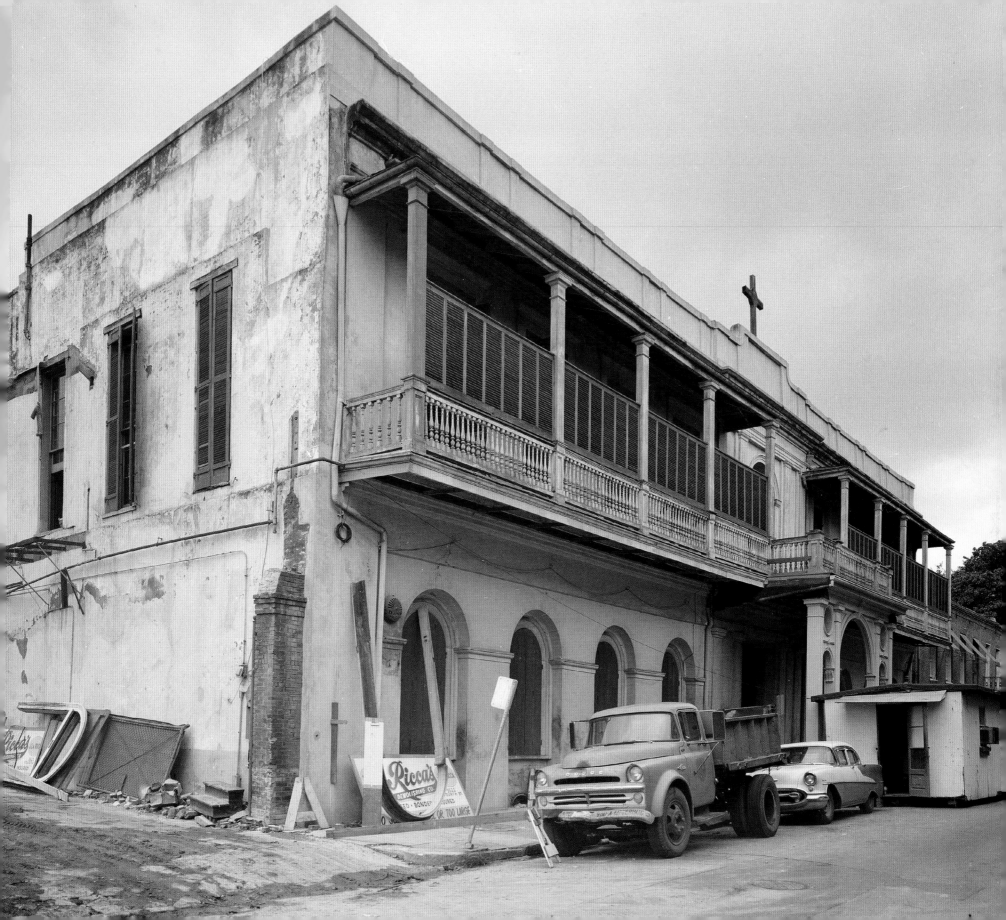

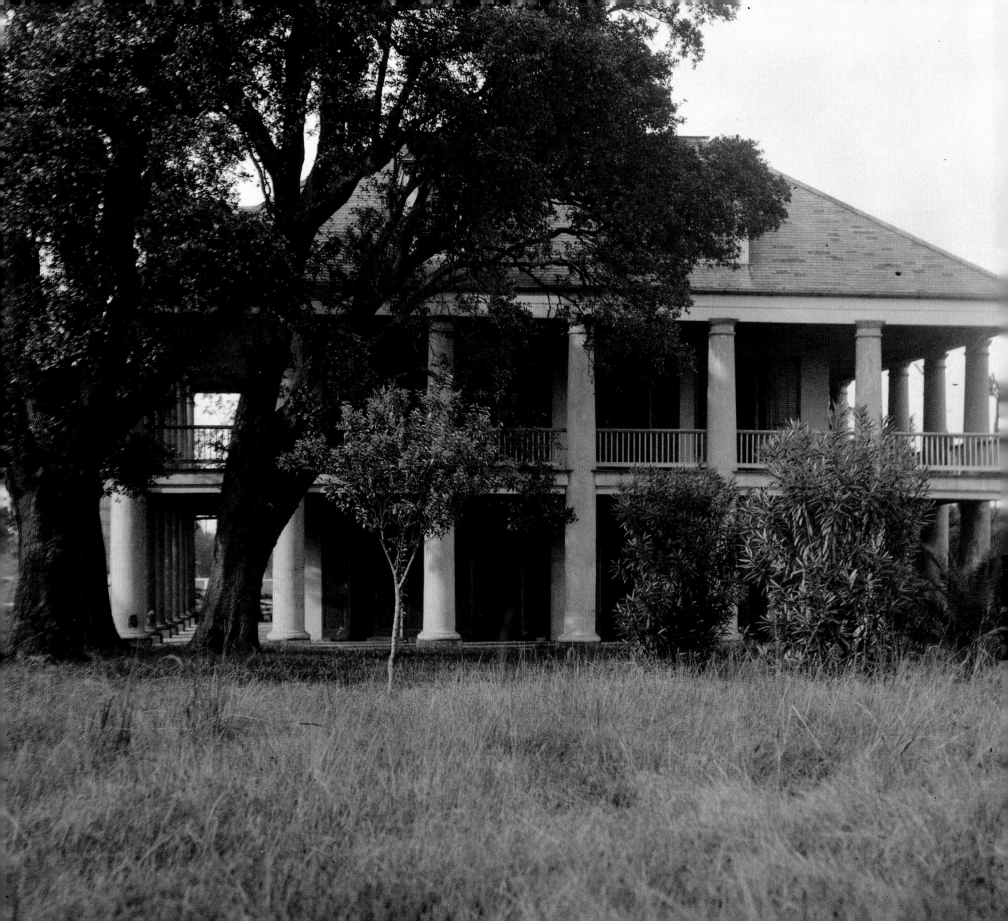

Three Oaks DESTROYED 1965

Upper St. Bernard Parish in the early 1800s was mostly sugar cane country: scores of plantations lined the Mississippi below New Orleans, stretching from the riverfront 40 *arpents* (one French *arpent* measuring 192 English feet) back to the Bayou Bienvenue swamps and continuing seamlessly almost down to the mouth of the Mississippi in lower Plaquemines Parish. Fronting each were the planters' homes, some of which were functional and others opulent. Among the latter was Three Oaks, built around 1831 for Sylvain Peyroux it was one of the largest houses below New Orleans proper. It was located within steps of the already-famous Chalmette Battlefield, where in 1815 American

ABOVE *Three Oaks endured in a stable condition on the property of the American Sugar Refining Company (seen here in a 1913 panoramic shot by H. J. Harvey taken from the Chalmette Monument) until a mishap in 1965 at the Chalmette Refinery motivated company officials to make some changes—among them, the sudden unannounced demolition of the landmark.* **LEFT** *Three Oaks, built circa 1831 for Sylvain Peyroux on a St. Bernard Parish sugar cane plantation, outlived most of its contemporaries as the communities of Arabi and Chalmette transformed from agrarian to industrial environments. The eponymous trees appear at left in this 1928 photograph by Arnold Genthe. (Courtesy of Library of Congress)*

militiamen routed invading British soldiers attempting to open a Southern front in the conflict known as the War of 1812. For decades, Peyroux, also an importer of French wine, oversaw his sugar cane plantation from this building, whose solid Doric columns and massive hip roof made it a landmark from the river. Legend has it that, after Admiral Farragut's Union fleet successfully penetrated the Mississippi River after a naval battle at forts St. Philip and Jackson in April 1862, a Confederate battery at Chalmette fired on the warships and a return volley knocked down one of Three Oaks' columns. The brief action represented the last and only exchange of fire just prior to the Union's capture of New Orleans.

Three Oaks' destiny shifted from the raising of sugar cane to the refining of cane juice when the American Sugar Refining Company bought the land in 1905 along with at least three substantial 19th-century houses, including two major plantation buildings. During 1909–1912 the company erected its main project, the Chalmette Refinery, which had the effect of transferring most regional sugar refining from the so-called Sugar District in the upper French Quarter to these previously rural precincts of St. Bernard Parish. By this time the adjacent community of Arabi had been laid out (1906) with streets and houses, and Three Oaks found itself on the industrial fringes of a growing metropolis.

Because Three Oaks was fenced off and guarded by the American Sugar Refining Company, it managed to stave off the capricious speculators, vagrants, and vandals who had doomed so many other planter houses in this era. Occasionally the firm would open the house to visitors and tour groups, including for the New Orleans Spring Fiesta, an annual civic-society fête held during the 1930s–1960s to call attention to the region's historical and architectural charms. But one gets the impression that the Company tolerated such visits more than it encouraged them, and because of its secured and off-the-beaten-path location, Three Oaks remained little-known among New Orleanians and not nearly as famous as its counterparts upriver. The company would later point out that only seven visitors came to see the century-old building over a period of 10 years, leaving out the fact that the company had made the place largely unvisitable.

In 1965, an explosion occurred at the Chalmette Refinery, alarming company officials and setting them on a program of reform and modernization. Among their targets were three old buildings once used to manufacture barrels, a molasses factory, a lime storage shed, old oil tanks, a former clock-in office—and the Three Oaks plantation house, which, as company officials explained to the Louisiana Department of Commerce and Industry, suffered from dry rot and attracted few visitors. Before preservationists could intervene, the Company hurriedly had the 134-year-old landmark bulldozed so thoroughly that stunned citizens who had heard rumors of its impending demise could not even identify its former site just days later. The surreptitious action earned the company the ill will of preservationists and led to public-notice laws requiring owners to alert citizens of such plans before they are executed.

Three Oaks' destruction left only two antebellum plantations houses between the lower limits of New Orleans and suburban St. Bernard Parish. In 2013, one of them, the LeBeau House, burned to the ground in an act of drug-induced arson. Remaining is the circa-1844 Cavaroc House owned by the current proprietor of the Chalmette Refinery, Domino's Sugar.

Godchaux's DEMOLISHED 1969

The Godchaux Building (1899) was the last major project of Leon Godchaux (1824–1899), a French-born Louisianian of Jewish ancestry who climbed out of childhood poverty to become a successful merchant and major figure in the sugar industry. His empire began with a tiny clothing store near the French Market and grew to include sugar plantations, railroads, and clothing outlets. Success of his firm's flagship garment store on Canal Street led the Leon Godchaux Company to seek additional space, and, as no adequate building existed to accommodate the vision, it cleared the corner of Chartres at Canal and hired architects Sully & Stone to design an eye-catching mixed-use retail and office building to herald the new century. Demolition of the antebellum storehouses commenced in April 1899, and construction proceeded swiftly under the guidance of builders Darcantel & Diasselliss, who drew upon their recent experience erecting similarly scaled steel-frame structures.

"Sanitary, fire-proof and modern," the Godchaux Building was designed for clothing retail on the ground floor and offices on the five upper stories. "Every appliance relating to hygiene, lighting, heating, comfort and convenience," reported the *Daily Picayune*, "has been attended to and installed without regard to cost." As such, the Godchaux Building represented one of the first large and truly modern structures to have been both designed and constructed entirely by local firms.

Inside, Godchaux's became famous for its clothing line; outside, it caught the eye for its lovely corner cupola and fancy Parisian stained-glass awning above the Canal entrance. From a distance, what stood out were the building's two elevated water towers and attached supergraphics reading GODCHAUX'S visible for a mile around. While the Canal Street frontage exhibited an ornate neoclassical façade, the building's French Quarter flank betrayed a relic from colonial times: an angled wall which conformed to an oddly shaped lot traceable to the old fortification once positioned around the original city.

Godchaux's operated here for the next two decades, rivaling Maison Blanche and D. H. Holmes, the two Canal Street heavyweights, as well as Mayer Israel, Fellman's, Mercier's, and other stores. Competition was fierce but never acrimonious; employees of each store battled each other good-naturedly in the Clothing Store Baseball League and enjoyed regular coverage in the Sports section of local newspapers.

What led to Godchaux's abandonment of its 1899 store was not an inability to compete, but rather its location: the marketplace for elegant clothing retail had by the 1920s shifted to the 800 and 900 blocks of Canal, home to D. H. Holmes and Maison Blanche. Being on the 500 block meant shoppers had to go out of their way to Godchaux's, and that's never good for business. So in 1921, the company leased the Macheca Building at 828 Canal, across from its two main rivals, and after a massive renovation, moved there entirely in 1926. This part of Canal Street would thence become the crux of the city's luxury shopping district, particularly for women's clothing, and although it would start to decline in the 1960s, all three would remain open into the 1980s.

The up-street shift of the garment trade left lower Canal Street a bit more raffish, and by the 1960s the 1899 Godchaux Building's tenants included the likes of pawn shops and greasy spoons. Godchaux's continued at 828 Canal but realized its future was in the suburbs, where it would develop anchor stores in regional malls.

As downtown retail declined and tourism grew, the corner of Chartres and Canal became more valuable for its land than its buildings. In 1968, plans were announced to clear the entire block for a twin-tower Mariott Hotel, and the next year, the Godchaux Building and all its 19th-century neighbors were demolished. Completed in 1972, the Mariott won over few historic preservationists, for its Modernist designs as well as its height and position looming over the city's most historic neighborhood. In 1972 the *Vieux Carré Courier* gave the hotel its award for Worst Skyscraper, Quarter's Worst Disaster, and City's Worst Interior Design, calling the complex a cross between "a 42-story Scarlett O'Hara drag show and a Walt Disney 'Mississippi gambler's' riverboat, a shameless five-star catastrophe of phony historicism, misspelled French, and bald bad taste." The reviewer suggested "Willard Marriott needs to learn the difference between atmosphere and odor."

Godchaux's, meanwhile, prospered in the suburbs and peaked in 1984 with eight stores spread from Houma to Biloxi, with six in greater New Orleans. But with all its eggs in a Gulf Coast basket, the company was hit hard by the oil bust, even as its out-of-state competitors benefitted from the booming national economy. In 1987, Godchaux's went bankrupt.

OPPOSITE *"Sanitary, fire-proof and modern," the Godchaux Building (1899) was designed for a clothing store on the ground floor and offices above. Its lovely Parisian-style entrance was on Canal at the Chartres intersection, seen here circa 1905.* **RIGHT** *The stately cupola of the Godchaux Building overlooked lower Canal for 70 years. This photo is from 1915, when the structure was whitewashed. (Courtesy of Library of Congress)*

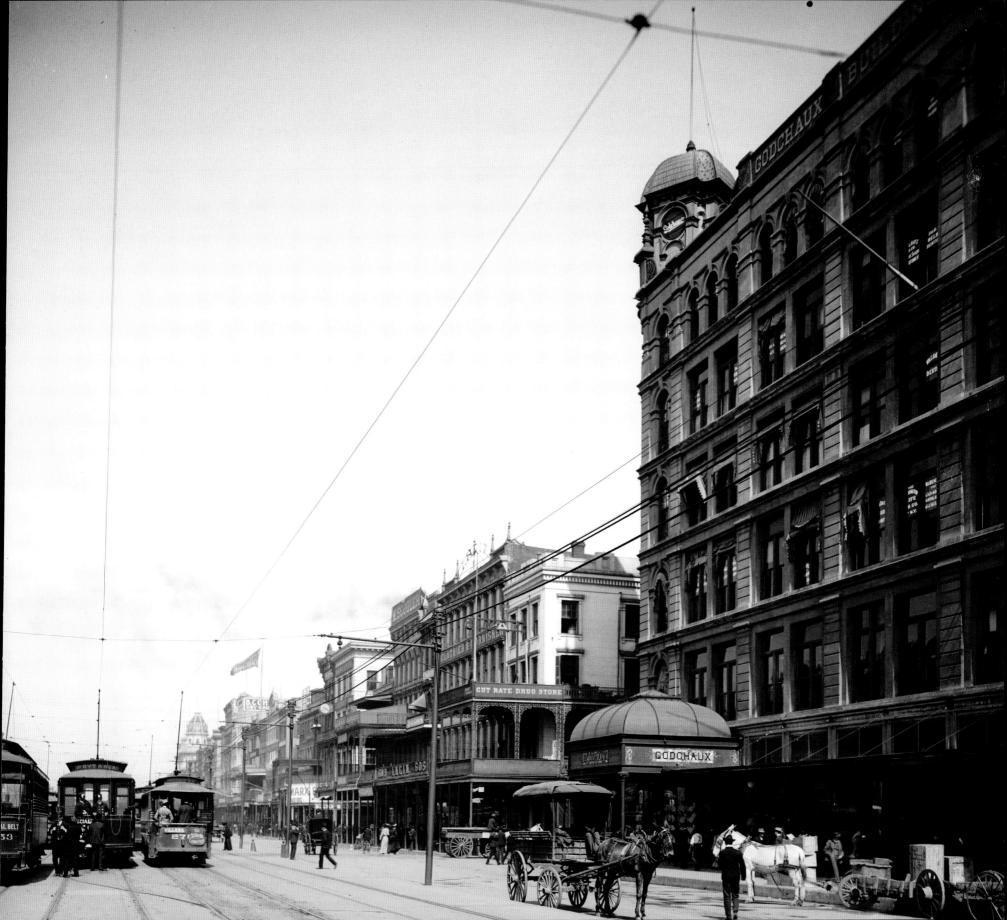

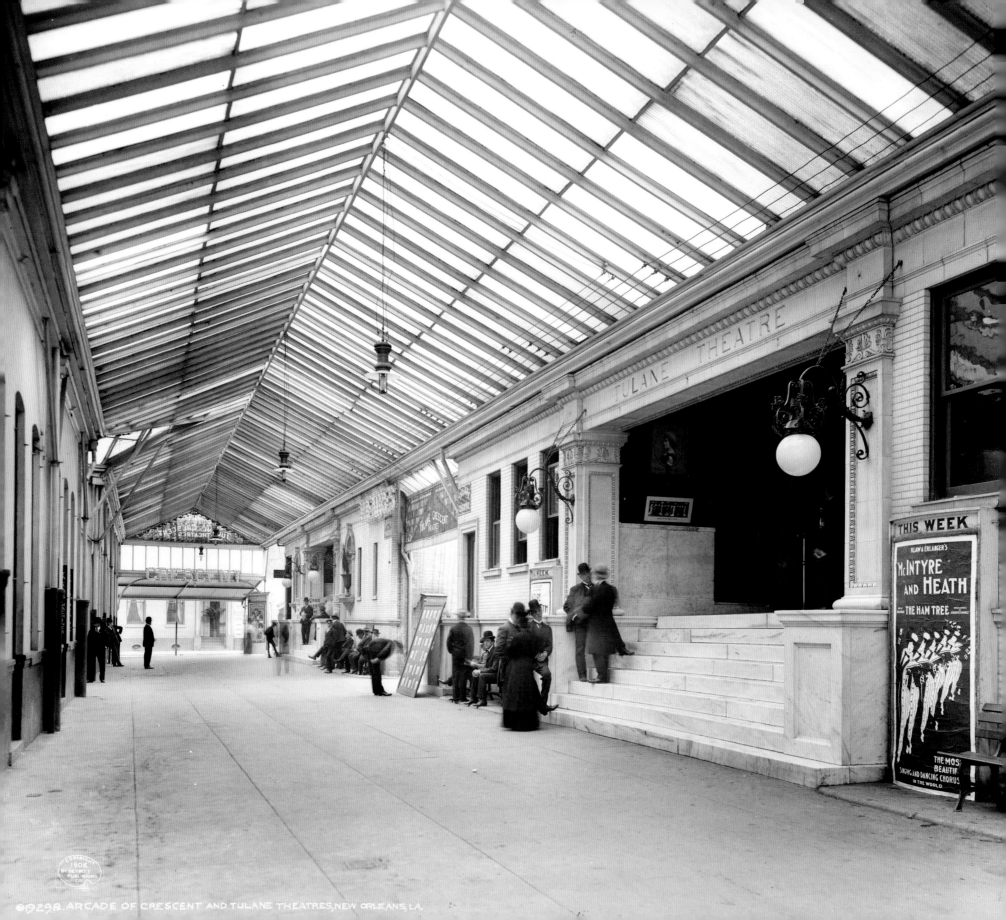

TULANE THEATRE

THIS WEEK

KLAW & ERLANGER'S

McINTYRE
AND HEATH

THE HAM TREE

THE MOST
BEAUTIFUL
SINGING AND DANCING CHORUS
IN THE WORLD

9298. ARCADE OF CRESCENT AND TULANE THEATRES, NEW ORLEANS, LA.

Performance Theaters DECLINED 1960s–1970s

Theaters covered the spectrum in New Orleans. There were high-, mid-, and low-brow venues; there were houses for opera and plays, for orchestras and balls; for "concert saloons" with rollicking piano and can-can dancing, and for vaudeville and moving pictures. They were on the French and American sides of town, for white and black, and for speakers of every major tongue. By the late 19th century, theaters formed a glamorous district around Canal Street's intersection with Basin Street, and by 1915, 11 of New Orleans' 80 picture theaters had an address on Canal. Why such popularity? Theaters were the radio, television, and Internet of the pre-modern era. They provided the social experience of a night out and an escape from the tedium of daily life. By 1930 New Orleans counted at least 65 venues presenting live performances of one type or another, as well as 63 chartered dance halls and 56 motion-picture theaters.

Seen here are four venues typical of the era. The Grand Opera House (originally Third Varieties Theater, opened 1872) had a deceptively modest entrance on 900 Canal, next to the original Maison Blanche. It accessed a hallway leading to the main performance space on Iberville Street, where some of the best-known actors of the day appeared. The expansion of a department store led to the Grand Opera House's demolition in 1906.

The Orpheum replaced the famed St. Charles Theater at present-day 430–438 St. Charles Avenue near Poydras, which dated to 1835, burned in 1842, was promptly rebuilt, and burned again in 1899. The new house, built in a fireproof design by George K. Pratt for $150,000 and known as the St. Charles Orpheum, opened in 1902 and hosted vaudeville performances until its owners decided to build a more modern facility in 1918 on University Place. Two years prior, another theater, the Liberty, opened next door to the St. Charles Orpheum, and both houses would show movies for decades. They were demolished in 1967 and replaced by the Pan American Life Center in 1980. The 1918 Orpheum on University Place operated until the Hurricane Katrina deluge of 2005 flooded its lower floor; it is currently undergoing restoration.

The Crescent and Tulane (1898), built on Tulane University's original campus, were separate twin theaters united by two steel-and-glass arcades opening onto three adjacent streets. Designed by Thomas Sully and erected for $200,000, the unique plan enticed pedestrians to become patrons while doubling their show options. "Over 1,000 electric lights illuminate these theaters," said a *Picayune* guide, "and the effect on gala nights is surpassingly brilliant." The twin theaters were demolished for parking space in the mid-1930s and the famous glass arcade followed in 1937. Tulane University owns the property to this day.

Downtown theaters declined in inverse proportion to the rise of television and the flight to the suburbs.

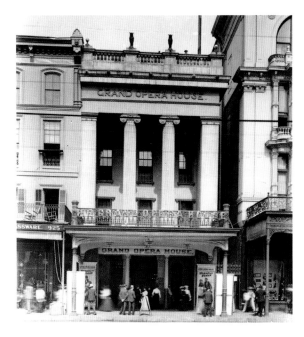

ABOVE *The Grand Opera House had an entrance on famous Canal Street, seen here in 1902, but its main performance venue was on the much cheaper real estate of Customhouse (Iberville) Street. (Photo by John N. Teunisson, courtesy of Visual Materials Collection, Southeastern Architectural Archive, Special Collections Division, Tulane University Libraries)*

ABOVE LEFT *The Liberty Theater, seen here in 1936, opened next to the St. Charles Orpheum and showed movies for decades. This photograph by Walker Evans was taken in 1936.* **LEFT** *This is not the extant Orpheum Theater on University Place but its predecessor on St. Charles Avenue near Poydras, opened in 1901.* **OPPOSITE** *The Tulane and Crescent theaters were twin venues unified by a glass arcade and built on the former downtown campus of Tulane University. The theaters are long gone, but Tulane owns the property to this day. (Courtesy of Library of Congress)*

"Mom and Pop" Shops, Laundries, and Grocers DECLINED 1960s–1970s

"Mom and pop" retailers still may be found throughout New Orleans neighborhoods, so much so that arteries such as Magazine, Carrollton, Broad, St. Claude, and Royal are often upheld by urbanists as exemplars of localism. But such businesses once numbered many more than they do today, appearing on practically every other intersection in every neighborhood, or clustered by the score around municipal markets or along commercial avenues.

Two types of neighbor businesses ranked among the most common citywide during the heyday of local enterprise; both had a distinct ethnic background, a particular geography, an important role in ethnic assimilation, and, unfortunately, a precipitous decline in the 1960s–1970s. They were Chinese laundries and Italian grocers.

Chinese domination of hand-laundering was foreseen as early as 1871, when Chinese first began to settle here in significant numbers. "The peculiar *forte* of the Chinaman," wrote the *New Orleans Times*,

is that of laundryman… In San Francisco, where Chinamen abound, there are hundreds of laundries, which, through the extreme neatness and scientific attainments of that race, have almost exclusive control of the washing trade of the city…. It would not surprise us to soon see [Chinese laundries] in New Orleans….

The journalist was right. Laundering required little capital outlay and no costly equipment, and could almost always count on steady business. The entire family could share in the labor and save on rent by living in the back. While the 1876 City Directory recorded two laundries with Chinese names, 13 were listed in the 1882 directory, 57 in 1886, 73 in 1892 directory, and 198 in 1898. Most were scattered citywide, and for good reason: each had to be located within convenient walking distance of its clientele, but not too close to incite competition. Chinese laundries were truly ubiquitous in the historical cityscape of New Orleans.

Corner groceries were to the Italians what laundries were to the Chinese. Overwhelmingly Sicilian, these immigrants generally arrived at New Orleans a few years after the Chinese, and for similar reasons, as recruits to replace formerly enslaved agricultural labor. But their numbers were about 10 times higher than the Chinese and, settled as they were around the French Market, they soon came to control much of the food processing, wholesaling and retailing industries. What drove them to spread their corner grocery stores citywide was the same geographical factors behind the distribution of laundries: to maximize convenience while minimizing competition. Ice manufacturing, refrigeration, and electricity also aided their success, as they enabled the widespread availability of perishables and cold drinks. Corner grocers put the city at a disadvantage because they drew customers away from its own municipal markets; the city fought back in 1901 with an ordinance prohibiting groceries to open within nine blocks of a municipal market. But soon automobiles and later supermarkets undercut the advantage of both corner grocers and municipal markets. Most markets closed by the early 1960s and most Italian grocers were gone by the 1980s.

As for Chinese laundries, they too have largely disappeared, victims of wash-and-wear fabrics and changing tastes in apparel. Many laundry families reinvested in dry-cleaning enterprises and the restaurant business, and carry on successfully today in the suburbs.

During the 1980s to 2000s, other locally owned businesses, from famed department stores to beloved restaurants, duly closed in large numbers, as unhelpful land-use zoning, national chains' economies of scale, upward flows of investment capital from smaller to larger enterprises, and the outward flow of middle-class money all conspired to hollow out the local business sector. Today local and regional businesses remain more visible and greater in number in New Orleans compared to other American cities, but pale in comparison to a century ago.

RIGHT *Canal Street from North Front to North Peters, seen here in a photo by Walker Evans from December 1935, was home to a number of local independent shops, among them one of scores of Chinese launderers throughout the city. This particular business assured customers it was not part of a price-fixing trust. All buildings in the right half of this photo were bulldozed in the 1970s for the Canal Place complex.* **BELOW LEFT** *Decatur Street by the French Market, photographed by Walker Evans in December 1935.* **BELOW** *Hymel's Hemstitching, 201 Bourbon Street, photographed by Marion Post Wolcott in January 1941. The place is now a daiquiri bar. (Courtesy of Library of Congress)*

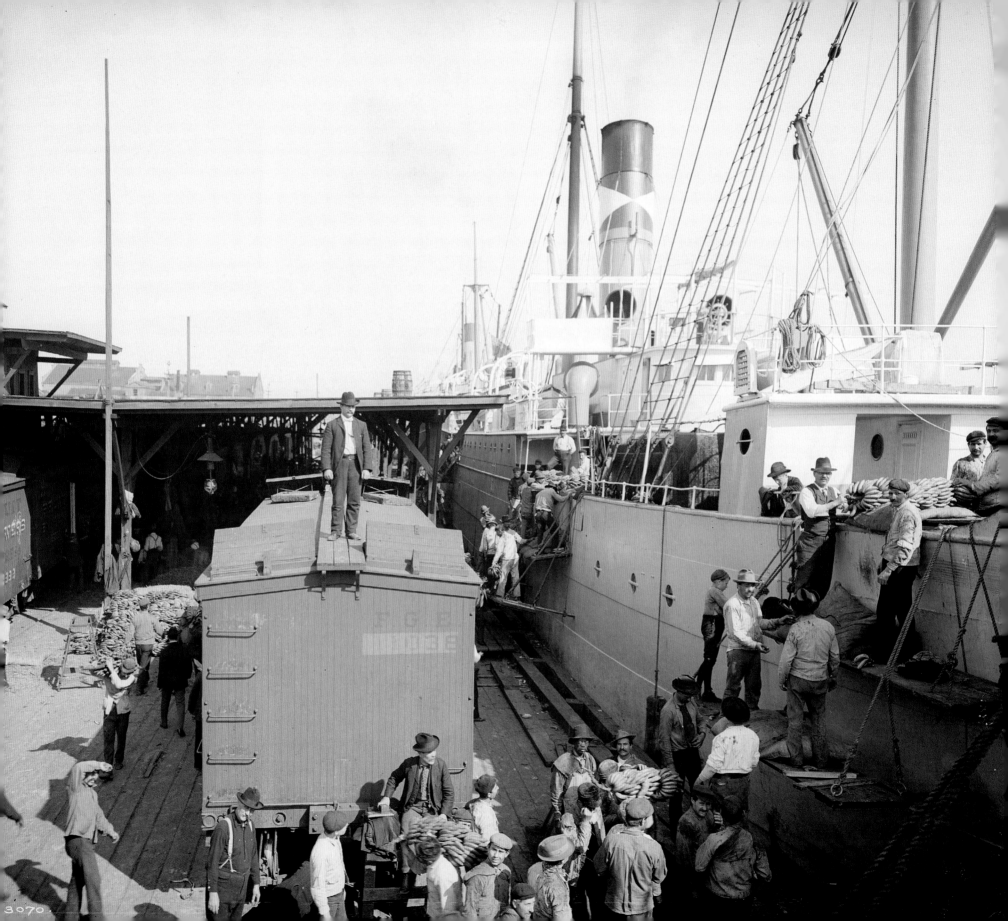

Banana Wharf REPURPOSED AFTER 1973

Whereas the French Quarter riverfront monopolized the sugar and rice trade, the wharves along the present-day Warehouse District served as the tropical fruit landing, where a wide range of citrus, mangoes, pineapple, coconuts and, most importantly, bananas were deposited by steamers arriving from throughout the Caribbean.

Since antebellum days the Port of New Orleans commanded a sizeable Caribbean and Mediterranean fruit industry, courtesy of direct shipping lines to places like Havana, Tampico, and Palermo. Lower Louisiana's own subtropical climate also allowed for seasonal production of certain citrus and bananas, though in fewer varieties and oftentimes inferior quality. Bananas, for example, were generally reddish in color and dense and sour in texture, usually requiring cooking before consumption. This was true for imports as well, until a mutant strain producing a sweet yellow fruit was

discovered and selectively bred in Jamaica. After the Civil War, American shippers started importing the sweet strain into Eastern and Southern ports, including New Orleans and Mobile, and created something of a banana craze among Americans, who viewed the tasty, filling and incredibly convenient fruit as an exotic and exclusive treat.

Working on the docks in Mobile in the 1890s, a young Russian immigrant named Samuel Zemurray observed to his surprise that any slightly blemished or overripe fruit would be thoughtlessly discarded. Sensing an opportunity, Zemurray instead bought the stressed bananas at rock-bottom prices and moved them swiftly via rail to local and regional markets at prices that made his customers happy— and him rich. Now settled in New Orleans, Zemurray in short time invested in steamships, infrastructure, vast acreages along the Cuyamel River in Honduras, and friends in high places.

His tactics tracked those of three immigrant brothers from Sicily, the Vacarros, who starting in 1899 established steam lines based in New Orleans and acquired land holdings near La Ceiba, Honduras, for tropical fruit production and importation. The Vacarros would come into control of all the ice houses in New Orleans, critical for the refrigeration of imports, and expanded their fleet by purchasing surplus vessels left over from World War I. In the 1920s, Vacarros Brothers would become the Standard Fruit and Steamship Company.

Zemurray, meanwhile, sold his Cuyamel Fruit Company at great profit to Boston-based rival United Fruit in 1930, only to buy it back a few years later and make United Fruit, now also New Orleans-based, even more profitable. The rival immigrants and their two companies, Standard and United, would for decades exhort disproportionate influence over the political destiny of the so-called "banana republics" of Central America, and make the Port of New Orleans, namely the wharves seen here, the unquestioned center of the American banana trade.

At the turn of the century, when a steamer inbound from Honduras approached the wharf, a stevedore would contract with the ship's company and hire laborers, called longshoremen, to do the unloading. Rope-connected wooden planks would be draped over the sides of the vessel, and longshoremen, usually of Italian, African American, or Hispanic ancestry, positioned themselves bucket-brigade style to extract bunches from the darkened hold to the deck, down the stairs and

OPPOSITE *Although steamers arrived from Honduras to wharves from the First Ward to the Ninth Ward, the Port of New Orleans' main banana wharf was located where the cotton wharf used to be, along the present-day Central Business District and Warehouse District riverfront. This scene dates from 1903–1905.* **LEFT** *In the days before conveyors, longshoremen of all races hand-unloaded "bunches" of bananas down a rope staircase into sheds for inspection, and into refrigerated ripening rooms or rail cars bound for market. (Courtesy of Library of Congress)*

onto the sun-drenched wharf. The ripest bounty was separated and sold immediately at the lowest prices, Zemurray-style, such that local markets abounded in fresh fruits and New Orleanians enjoyed some of the cheapest tropical produce in the nation. The rest was carried over the shoulder and loaded into refrigerated ripening rooms or insulated box cars. Steamers would line up bow to stern along the river bank, and three to four longshoremen brigades would work each ship, transferring the cargo to freight trains which would then chug off for transshipment points throughout the interior South and as far as Chicago, ultimately to the breakfast tables and lunch pails of millions of Americans.

Technology would change the labor needs of New Orleans' banana trade, and both technology and labor would eventually bring it to an end. By the 1910s, hand-unloading was replaced by mechanized conveyors, which used motorized "stairs" to unload stalks at a pace of 10 thousand bunches per hour and transfer them to long shed-covered conveyor belts parallel to the river, where men sorted them and filled entire box cars in all of five minutes. For decades, these pyramid-shaped conveyors lined the banana wharf like boxy Easter

Island statues; neighborhood children would come to watch them and seek the huge tropical spiders that would fall from the bunches. The Port handled some 23 million bunches per year around 1940, and despite the mechanization, thousands of longshoremen were still needed in the process, and many lived a short distance from the banana wharves.

This changed with the advent of containerization technology in the 1960s. The new approach used two standard-sized shipping containers specially designed to be handled by gantries and loaders with minimal human labor. Shipping boxed bananas in refrigerated containers meant containers would be loaded and unloaded only once, at their origin and destination and not at their transshipment point, and could be swiftly and efficiently moved from ship to truck to train. First, however, the Port of New Orleans would have to build new wharves equipped with the new technology. It eyed the area to the east, where a brand-new intermodal "Centroport" could exploit the new Interstate 10, multiple railroad lines, and the newly excavated Mississippi River-Gulf Outlet Canal.

But New Orleans by this time was growing increasingly unattractive to its two main banana

customers, Dole (formerly Standard Fruit) and Chiquita (formerly United). Local unions and their labor demands had managers seeking cheaper manpower elsewhere, and smaller up-and-coming ports were able to mechanize faster and cheaper, and offer better lease deals, than could a complicated old port like New Orleans. Coastal cities in neighboring states boasted direct access to the Gulf of Mexico without the need to come 95 miles up the Mississippi, and also benefitted from interstates, railroads, and non-unionized, lower-cost labor. Dole departed New Orleans in 1967 and Chiquita in 1973 for Gulfport a hundred miles to the east in the state of Mississippi. For decades, Gulfport would become the South's premier banana port, handing up to three-quarters of a million tons of bananas and second nationally only to Wilmington, Delaware. Miles of New Orleans' riverfront wharves were rendered surplus by containerization, and during the late 1970s and early 1980s, the old banana wharf was transformed into facilities for the 1984 World's Fair and later the Riverwalk Festival Marketplace, the Cruise Ship Terminal, and headquarters of the Port of New Orleans. Working-class families who had lived for generations near the wharves for its job opportunities now had to seek employ elsewhere, and if they found it at all, it was usually in the lower-paying service jobs of tourism.

In May 2014, after a decade of secret negotiations and to nearly everyone's surprise, port officials succeeded in luring Chiquita back to the banks of the Mississippi. What convinced company officials was a state subsidy of $18.55 per container, subject to performance metrics and capped at $11 million, to offset higher local shipping and handling costs, plus another $4.2 million for infrastructure upgrades and a new ripening and distribution facility. By the late 2010s, after an absence of over 40 years, bananas should once again be arriving to the Port of New Orleans.

LEFT *The United Fruit wharf (lower center) in the late 1950s. (Photo by J. R. St. Julien, courtesy of Visual Materials Collection, Southeastern Architectural Archive, Special Collections Division, Tulane University Libraries)*

RIGHT *By the 1910s, conveyors with motorized "stairs" replaced hand-unloading, extracting bunches at a pace of 10 thousand per hour and transferring them to long sheds, where workers sorted and transferred them to box cars. (Courtesy of Library of Congress)*

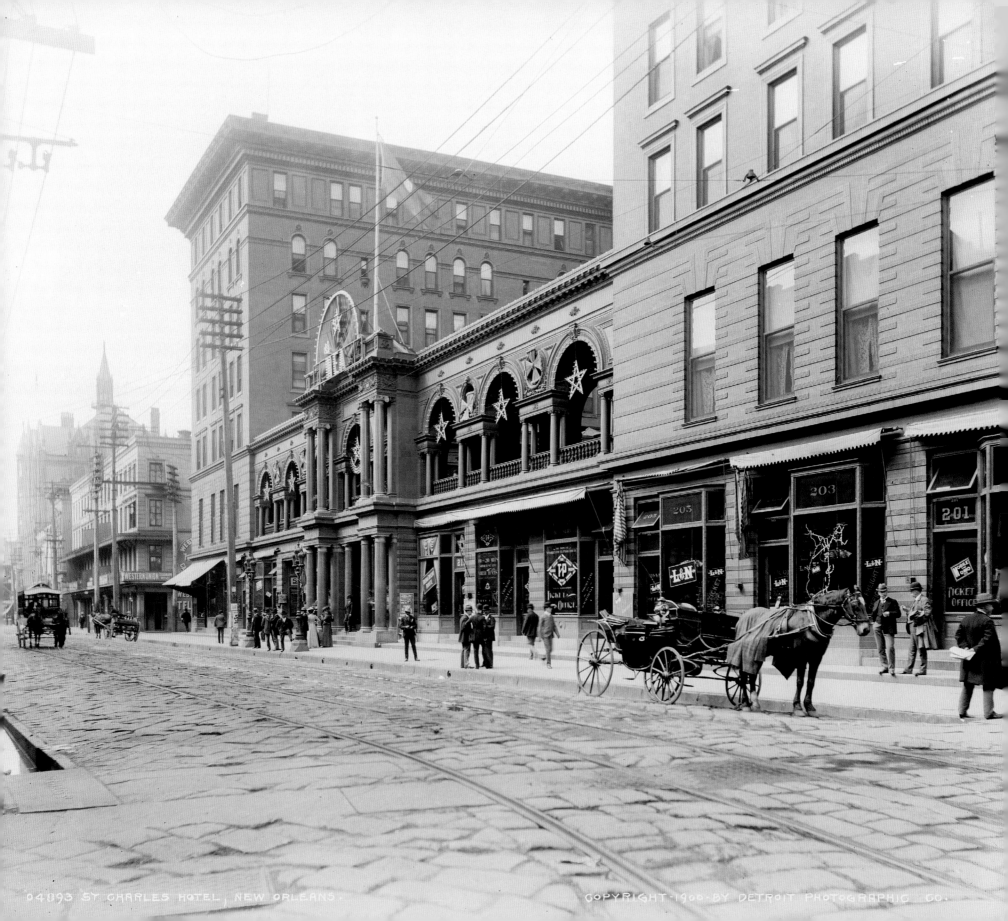

St. Charles Hotels BURNED 1851 AND 1894; RAZED 1974

For 137 years, three hotels of great significance, all bearing the name St. Charles, sequentially occupied this second block of St. Charles Avenue.

The original St. Charles Exchange Hotel, one of the most splendid structures in the nation, was designed by James Gallier, Sr. and (probably) Charles Dakin and completed in 1837. Under its 185-foot dome and cupola were elegant accommodations and financial services (hence the term "exchange") catering to a mostly American clientele doing business in Faubourg St. Mary. Its counterpart on the French-speaking side of the city was the St. Louis Exchange, and like its rival, the St. Charles offered a wide range of services—lodging, dining, banking, congregating, auctioning, leisure—for extended-stay guests. It was a cultural and economic nerve center in a powerful city.

In these days before gas and electric service, a proliferation of candles and oil lamps made hotels a dreaded fire risk. Before noon on January 18, 1851, a blaze broke out below the St. Charles' north eaves and spread. A *Daily Picayune* journalist described "a scene of confusion that baffles description…with boarders…busy packing up, carrying out trunks, running here and there, husbands looking for their wives, and wives…in agony." Winds shifted the flames southward and timber swept them upward. "At 1 o'clock the dome fell in with a tremendous crash," and "the pride of our city gradually [became] a mass of ruins."

Attesting to its commercial success, the hotel was promptly rebuilt and reopened in January 1853, with, according to the *Daily Picayune*, "the same imposing architectural display that delighted every beholder of the old one"—only this time without the front steps and costly dome. Like the predecessor, the hotel served as a focal point for Americans in St. Mary in the so-called Golden Age of the 1850s, and it bore silent witness to the subsequent Civil War, occupation, and Reconstruction eras. But fire remained a risk. At 11 p.m. on April 28, 1894, flames erupted in the kitchen, spread, and sent deadly smoke upward toward slumbering guests. Shortly after midnight sections of the building began caving in, and by dawn only the massive columns and pediment remained. It was a harrowing sight, and the toll of four lives could have been much higher.

Once again, investors endeavored to rebuild, but wanted to account for the new technologies and higher standards of the new age. They sent architect Thomas Sully on a tour of comparable hotels nationwide, and, finding particular inspiration in the Planters' Hotel in St. Louis, Sully designed what the *Daily Picayune* described as "a hotel containing all [the] latest modern conveniences, built especially for light, comfort and ventilation." The third St. Charles Hotel, with an Italian Renaissance aesthetic, opened on February 1, 1896 and for the next eight decades, its reddish brick, rooftop garden, 500 guestrooms, and arcade of street-level shops formed the veritable heart of the Central Business District. It was sold in 1959 to Sheraton for $5 million and continued in service as the Sheraton-St. Charles.

By the 1970s, two factors put pressure on the aging hotel. One was the rise of new skyscraper hotels; the other was the petroleum industry, which exerted pressure for office space. In 1973, a local businessman partnered with an Italian financier to replace the third St. Charles Hotel with what would have been a fourth lodge, 52 stories high, with 1,080 guestrooms as well as office space. With the land title in their hands and zero preservation rules holding them back, they razed the old hotel in 1974.

The lot remained empty for years until the Place St. Charles skyscraper, designed by Moriyama and Teshima Architects, was completed in 1984. Postmodern in style, Place St. Charles has a spacious, triple-level veranda overlooking the avenue, and boasts more stories (53) than any other building in the city. Initial plans for lodging within the new high-rise fell by the wayside, and today Place St. Charles is home to finance, banking, legal, and energy offices. Thus ended the long history of lodging on this site.

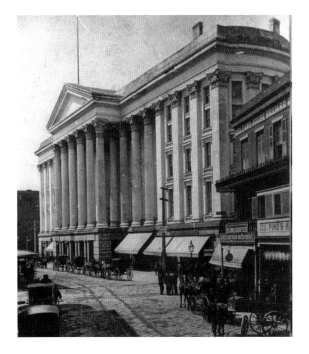

ABOVE *The dome of the original St. Charles Hotel (1837) may be seen in this detail of a lithograph by D. W. Moody. By the time it was released in 1852, the hotel had been destroyed by fire.* **LEFT** *The second St. Charles Hotel, built in 1853 and seen here in 1869, met the same fiery fate as the original, in 1894.* **OPPOSITE** *In 1896, the third St. Charles arose on the ashes of the first two. This view, looking up St. Charles Avenue circa 1900, captures the Masonic Lodge in the distance. (Courtesy of Library of Congress)*

The French Market

RENOVATED LATE 1930s; CONVERTED MID-1970s

New Orleanians in colonial times wholesaled and retailed food wherever supply and demand could negotiate a deal, and that usually meant on levees, plazas, and streets. Spanish administrators struggled to inspect and regulate such scattered spots, and so in 1780 erected the city's first public market to centralize the food trade. The 60-by-22-foot wooden pavilion, used mostly for meat, was replaced by a sturdier covered structure in 1782 and expanded in 1784, according to Cabildo (Spanish City Hall) records,

> to have all the retailers in one place, as their number has increased…. This public market will be large enough to receive the merchandise and accommodate the peddlers and will protect them from the bad weather and excessive heat, heavy rains and extreme cold weather…

After this complex was destroyed by the Good Friday Fire of 1788, the city replaced it during 1790–1792 with an open-air market later remodeled into an enclosed stall market where St. Ann Street met the levee. Tradition holds this milestone (specifically 1791) as the foundation of the French Market, although antecedents date back to 1780.

The market grew in 1799 to accommodate a section for fish and later veal, pork, and lamb. Colloquially called the "Creole market," "Latin market," and finally the "French Market," New Orleans' first municipal market expanded sectionally over the next 140 years. The original meat market at St. Ann was destroyed by a hurricane in 1812 and replaced by the extant Roman-style arcade; a vegetable market arose at the St. Philip intersection in the 1820s, followed by a fish and game market (1840), a fruit market, and a bazaar market (1870) for dry goods. During this era, the larger municipal market system also expanded, starting with the St. Mary, Poydras, and Washington markets in adjacent faubourgs, and continuing with the Tremé, Dryades, and dozens of other units into the early 20th century.

The French Market gained widespread fame in the antebellum era thanks to the steady stream of visitors who wrote about the spectacle. Most waxed—with varying degrees of eloquence—on the market's incredible ethnic diversity ("all nations under the sun have here vomited forth their specimens of human cattle"), or on the dizzying linguistic soundscape ("…a confusion of languages various as at Babel…"). A visitor from Edinburgh in 1828 noted that "the fishermen were talking Spanish," possibly Canary Islanders (Isleños) from St. Bernard Parish, "while amongst the rest…was a pretty equal distribution of French and English." His inventory of produce informs on the city's food culture at the time:

> cabbages, peas, beet-roots, artichokes, French beans, radishes, and a great variety of spotted seeds, and caravansas [a type of bean]; potatoes both of the sweet and Irish kind; tomatoes, rice, Indian corn, ginger, blackberries, roses and violets, oranges, bananas, apples; fowls tied in threes by the leg, quails, gingerbread, beer in bottles, and salt fish….

Swedish traveler Fredrika Bremer, who visited New Orleans in January 1851, found the market "in full bloom on Sunday morning each week," reflecting, she thought, the difference between French and Anglo

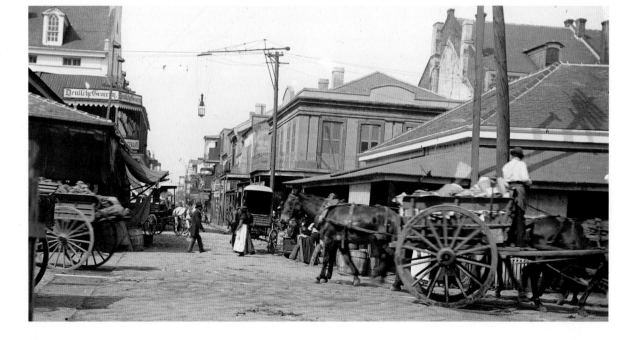

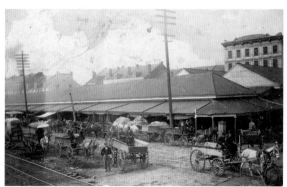

LEFT *Looking up St. Philip Street from the heart of the French Market in the 1890s, a time when the neighborhood and the market were dominated by Sicilian immigrants. (Photo by William Henry Jackson, courtesy of Library of Congress)*

RIGHT & BELOW *Scenes of the lower units of the French Market, 1900s–1910s. (Right, courtesy of Library of Congress; below, courtesy of the author's collection)*

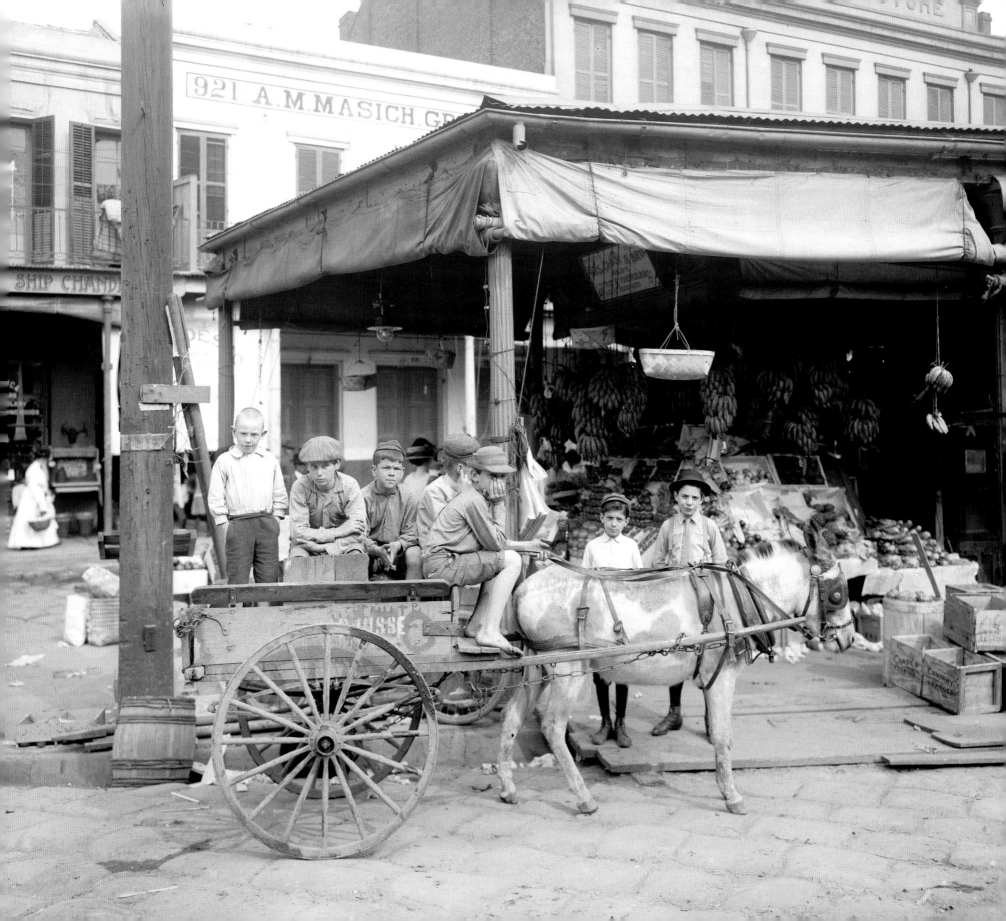

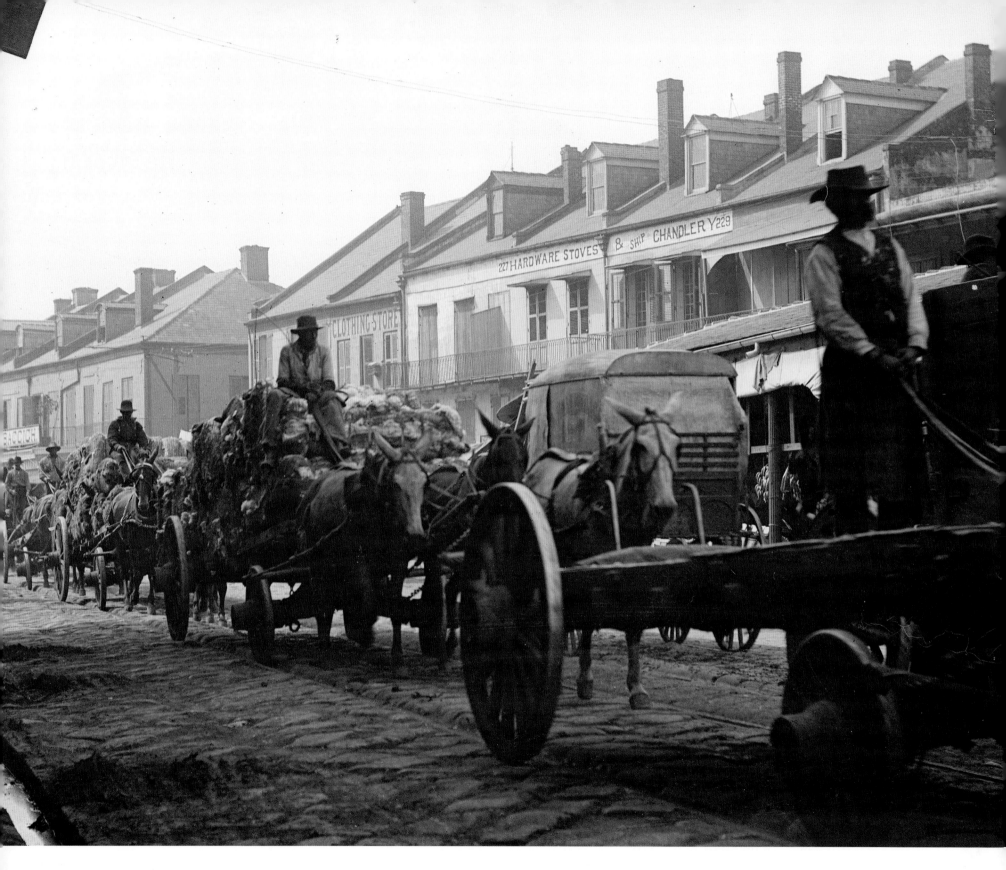

observance of the Sabbath. "The French Market is one of the most lively and picturesque scenes of New Orleans," wrote Bremer,

One feels as if transported at once to a great Paris *marché* [except] that one here meets with various races of people, hears many different languages spoken, and sees the productions of various zones. Here are English, Irish, Germans, French, Spanish, Mexicans… negroes and Indians. Most [who sell] are black Creoles, or natives, who have the French animation and gayety, who speak French fluently…

New Orleans' municipal market system enjoyed its heyday at the turn of the 20th century. What thwarted its domination were the increasingly ubiquitous corner grocery stores, many of which were established by Sicilians and other immigrants who got their start in the French Market. The city fought back with a 1901 ordinance which prohibited groceries to open within nine blocks of a market, and in 1911, the system expanded to its 34th unit, double the number from 1880.

That number would gradually decline with the rise of automobiles, supermarkets, and suburbanization. Most markets closed by the late 1950s, their structures either demolished or retrofit for other uses. Yet their geography survives: a number of modern-day commercial clusters, along corridors such as Magazine, Prytania, Decatur, and Claiborne, mark the old market locations.

The French Market managed to survive, in part for its fame and in part because of adaptation. In the late 1930s, the Works Progress Administration gutted most market buildings and modernized them, putting an end to the picturesque but unsanitary conditions seen in the circa-1900 photographs here. The WPA also demolished the buildings on the river side of old Gallatin Street and replaced them with an open farmer's market pavilion. Forty years later, with the decline of the French Quarter residential population and the rise of tourism, the city adapted to the changing circumstances by allowing tenants to reorient their businesses to the desires and demands of millions of visitors. Ever since, the French Market has functioned essentially as a festival marketplace.

Many local historians, unable to see past the T-shirts and souvenirs, generally disdain the modern French Market and loudly lament the days of old. In fact, at least in the Flea Market portion of the complex, stall-based vendors still create an open marketplace ambience which loosely matches the descriptions recorded in historical journals. More significantly, the vendors, most of them immigrants, continue the French Market's ancient legacy as a place of extraordinary ethnic diversity where working-class newcomers can launch low-capital businesses and determine their own destiny.

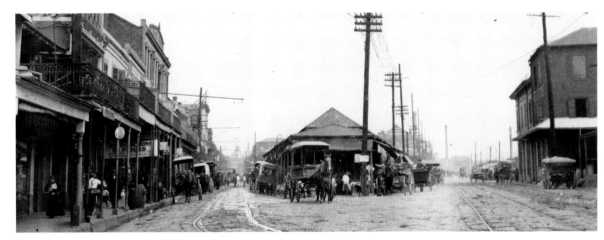

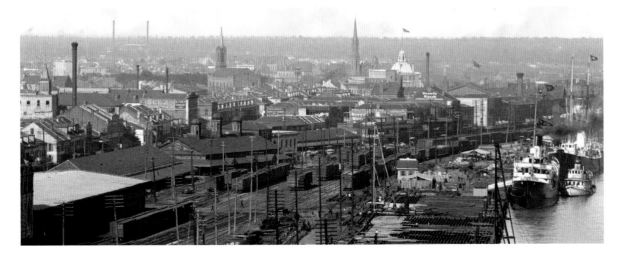

TOP *This market scene photograph from 1936 by Carl Mydans is picturesque if not particularly tidy, which can be said about New Orleans generally.* **ABOVE** *The lower units of the French Market occupied the sliver between Decatur and North Peter streets, seen here in this 1890s photographs by William Henry Jackson.* **LEFT** *This detail of a bird's eye view taken from the opposite end of the French Quarter captures the various pavilions of the French Market (center left) as they formed an interface between the lower French Quarter and riverfront wharfs.* **OPPOSITE** *Mule teams hauling produce down North Peters Street, 1890s, taken by William Henry Jackson. Most of the buildings lining Decatur Street in the background still stand, but the market ceased functioning as a food retailer in the early 1970s. (Courtesy of Library of Congress)*

Seven Oaks DEMOLISHED 1977

Seven Oaks, located in what is now Westwego on the "right" (west) bank of the Mississippi River, was the largest and most spectacular plantation house in the greater New Orleans area. Built around 1840, this Greek Revival mansion belonged to sugar planter Camille Zeringue and pertained to a plantation traceable to earliest colonial times (1719) when the land called *Petit Desert* was conceded by the Company of the Indies to its first French owners. A dozen tenure changes later, the parcel, in 1794,

came into the hands of the family Zeringue, a Gallicized version of the Bavarian *Zehringer*, who would run it for the next century.

During its late-antebellum zenith, Camille Zeringue's plantation was the largest land-holding near New Orleans, and his circa-1840 house, with its 18 rooms and 26 Doric columns, four symmetrical chimneys, and signature rooftop deck and balustrade (replaced around the time of the Civil War by a belvedere) could be seen from miles around, particularly by steamboat passengers. Seven Oaks' size, grandeur, and exuberant Classicism reflected the wealth and spirit of Louisiana's sugar aristocracy, and that its main doorway faced the Mississippi River spoke to the importance of that artery as the sustenance of the region's prosperity. The plantation also benefitted from Gulf access, as its eastern flanks bordered a manmade canal connecting to the upper Barataria Bay and its rich estuarine resources.

The Civil War reversed the fortunes of most lower-coast sugar planters, but Zeringue managed to hang on, and Seven Oaks continued as the family residence and agricultural headquarters. After his death, however, the house entered into an all-too-familiar track of shifting tenure and absentee ownership which occasioned the demise of so many of its neighbors. In 1891 the plantation was sliced up among heirs and Seven Oaks was sold via sheriff's deed to Citizens Bank, which the next year sold the house to one Pablo Sala, who died and left it to his widow Maria in 1895, who sold it to Narcisso Durall in 1898, who sold it to Alphonee A. Lelong, who sold it to Charles T. Soniat in 1906. Some owners had tried repurposing the old mansion as a recreational resort, "Columbia Gardens," but probably for its distance across the river from New Orleans, it did not prove viable. In 1912, Soniat sold Seven Oaks to the Missouri Pacific Railroad Company, which naturally prioritized for transportation assets and industrial development more so than the liability of an aging manor. Troops were said to occupy the building during their transit through New Orleans to World War I in Europe, and some, along with local vandals, made off with interior details. At times Seven Oaks' rooms were rented to residents, giving the company just enough incentive to keep the mansion from decaying.

The opening of the Huey P. Long Bridge in 1935 put Seven Oaks within a short drive from New Orleans, raising its potential for use as a historic attraction or a resort. Oak Alley, located 50 miles upriver in Vacherie and the next-largest antebellum home in the region, exemplified what could be done, culturally and economically, with a restored plantation house. But the ownership of Seven Oaks expressed no interest in such a costly undertaking, and after the last occupants departed in 1954, the mansion fell into a ruin, inviting vagrants, looters, and Hurricane Betsy's winds in 1965.

By the 1970s, Seven Oaks' roof had partially collapsed, its dormers and belvedere had sunken into the attic, and some columns, entwined in vegetation, stood free of the house: a part-Roman, part-Mayan ruin on the Mississippi. Some of the eponymous live oaks still stood, but they were outnumbered by the storage tanks and other industrial apparatus. Preservationists pleaded with authorities and current owner Texas Pacific-Missouri Pacific Railroad Company to stabilize what remained. The state was willing but the parish dragged its feet, and indifferent company officials itched to unburden themselves of the controversy and the liability. On August 27, 1977, they had the ruins bulldozed.

RIGHT *In the late antebellum era, Camille Zeringue's plantation was the largest land-holding near New Orleans, and his Seven Oaks mansion, built around 1840, could be seen from miles around. Frances Benjamin Johnston captured this photograph in 1938 for the Historic American Building Survey.* **TOP LEFT** *Arnold Genthe took this shot of Seven Oaks' imposing Doric columns in 1928. Located in Westwego directly across the Mississippi River from Audubon Park, Seven Oaks' surroundings at the time remained all but rural.* **LEFT** *Nothing hastens the demise of a historic structure like a hole in the roof. These, likely a result of Hurricane Betsy in 1965, let rainwater inside, while vandals and vagrants made off with interior components. By the mid-1970s Seven Oaks looked like a Mayan ruin. (Courtesy of Library of Congress)*

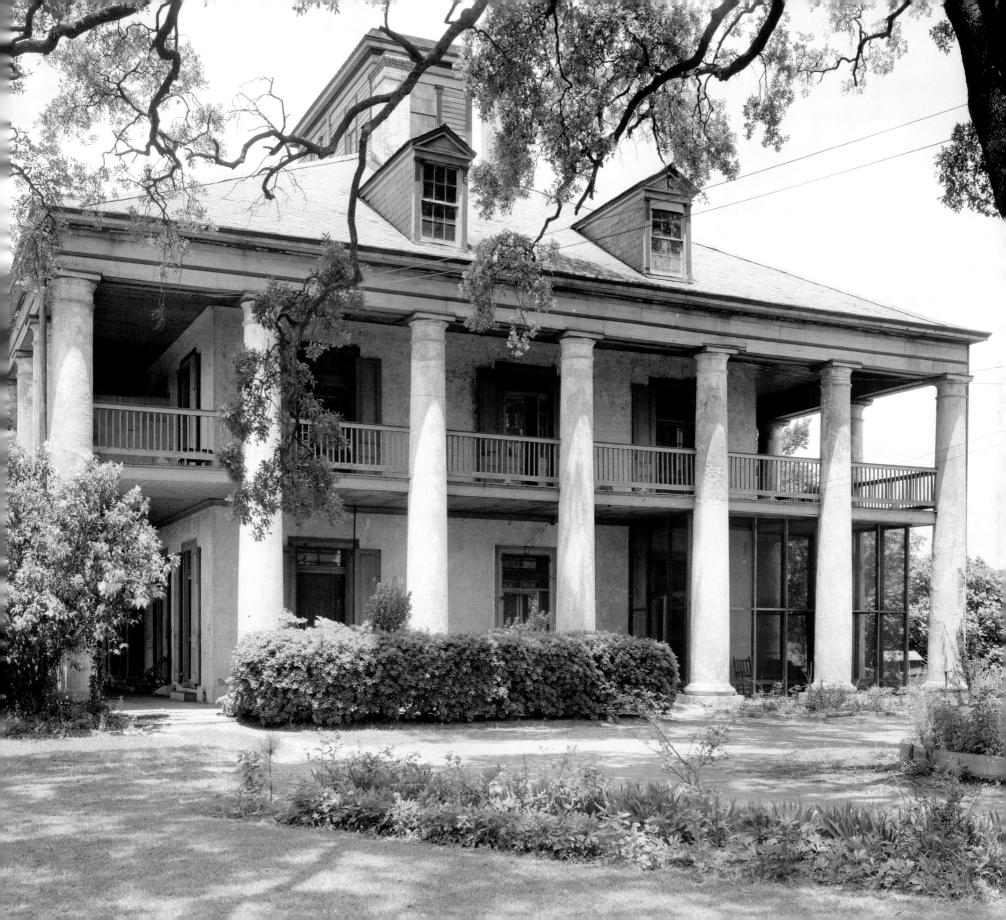

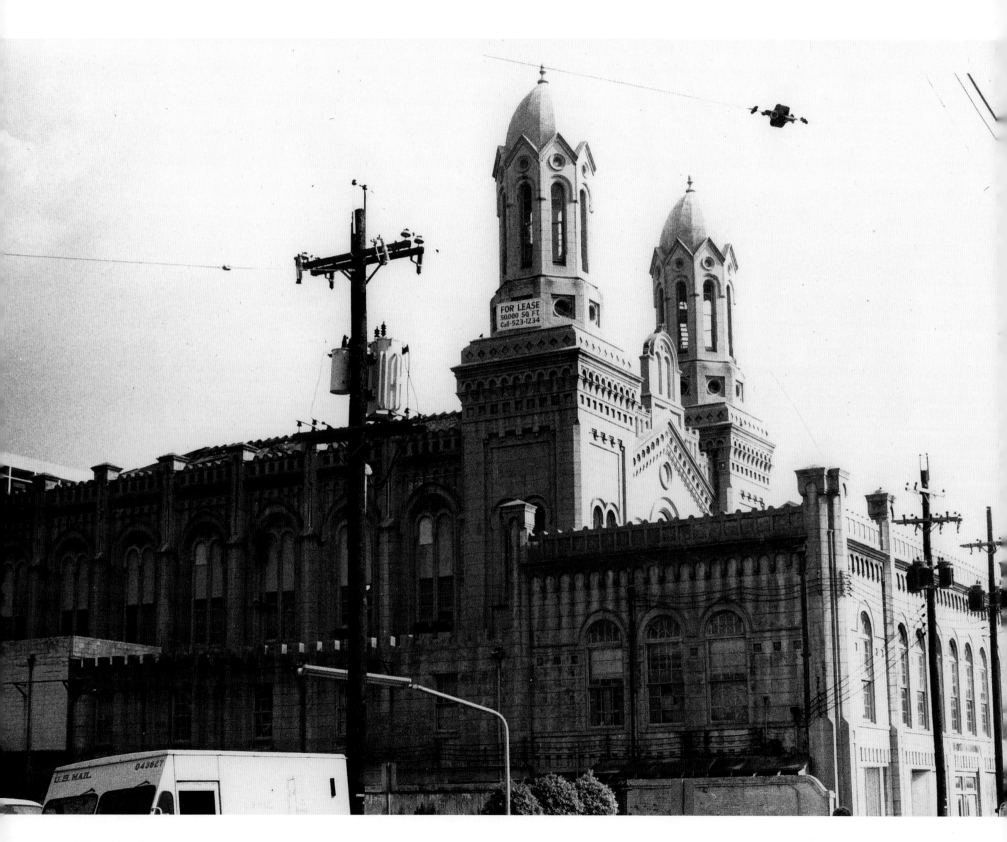

Temple Sinai DEMOLISHED 1977

Around the time of the Civil War, a split developed within New Orleans' Jewish population reflecting an international Reformist movement appealing to German Jews elsewhere in America. The Reverend James Koppel Gutheim, spiritual leader of the city's Gates of Mercy congregation in the early 1850s, founded the first local Reform congregation, Temple Sinai (1870) for many former Gates of Mercy members. With the "cultivation and spread of enlightened religious sentiment" as its mission, the congregation in 1871 bought a lot on Carondelet Street at Calliope near Lee Circle and had the magnificent new temple, seen here, erected upon it. Designed by Charles Lewis Hillger and built by Peter Middlemiss, Temple Sinai cost $104,000, seated 1,500 people, boasted a $6,000 organ and 1,000 gas jets for illumination, and broke the skyline with twin 115-foot-high towers of the Roman-Byzantine order and a unique two-tone striped coloration. When it was completed in 1872, Temple Sinai was the most prominent Jewish landmark the mostly Catholic city had ever seen. Practically every photograph of the Lee Circle area from the 1870s to the 1970s could not help but include its distinctive profile.

The late 19th century was also the era when Orthodox Jews from Eastern Europe started to arrive at New Orleans, as they did in much larger numbers at New York. Far more traditional in their observance of Judaic law and culturally and linguistically isolated from the wealthier, older Reform population, Orthodox Jews settled along working-class Dryades Street, geographically apart from their brethren. By 1890, roughly 550 Orthodox Jewish communicants worshipped in seven small congregations with a total property value of $20,000, while 2,200 Reformists worshipped in two large congregations, Temple Sinai and Touro Synagogue, valued at $215,000. With their considerable wealth, Reformists were doing in this era what other well-off New Orleanians were doing: moving out of the inner city and into attractive new uptown residential neighborhoods.

Their institutions followed. Touro Synagogue moved from their antebellum synagogue at Carondelet near Julia to a new Byzantine-style building at 4200 St. Charles Avenue on January 1, 1909. Gates of Prayer, the Lafayette-based Ashkenazic congregation formed during the German immigration era, relocated from its antebellum site on

Jackson Avenue to the comfortable new environs of 1139 Napoleon in 1920. In 1925, Temple Sinai continued the uptown trend: it held its last service in the Street Carondelet temple in 1926, started building a new Byzantine-style synagogue at 6227 St. Charles Avenue in 1927, and moved into it in 1928.

For decades, a chasm persisted between the wealthier, older, more Germanic, totally assimilated, and highly influential "St. Charles Avenue Jews" of the uptown Reform congregations, and the working-class, eastern-European "Dryades Street Jews" of the downtown Orthodox congregations. In this regard, the geography of Jewish New Orleans mimicked that of New York City, where wealthier German Jews resided in the affluent Upper East Side, far from the lower-class Russian Jewish immigrants amassed in the Lower East Side.

The former Temple Sinai on Carondelet Street, meanwhile, had been sold in 1929 and subsequently fitted with an ungainly front addition covering the cast-iron doorway and marble steps. Since then, the former holy place had been used for offices, storage, as a theater, and as an advertising studio. The landmark was narrowly missed by the right-of-way clearance for the Pontchartrain Expressway to the Mississippi River Bridge (1958), and survived the transformation of the Central Business District into a modern skyscraper downtown. But the need for parking space exerted constant economic pressure on this and other large historic buildings, particularly those with high maintenance costs that were difficult to adapt for reuse.

One day in July 1977, preservationists noticed the old temple's roof being dismantled and began a frantic last-minute effort to save it. By late July, the city had approved the demolition permit, and, lacking any legal protection, the 105-year-old landmark became a parking lot.

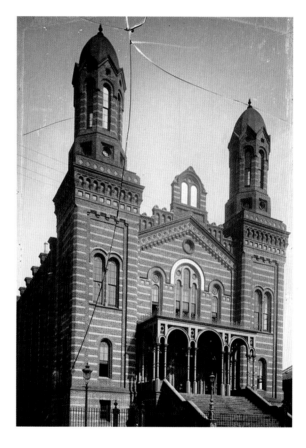

ABOVE *Temple Sinai, built in 1872 and seen here in the 1890s, broke the skyline with twin 115-foot-high towers of Roman-Byzantine style and two-tone striped coloration. (Courtesy of Visual Materials Collection, Southeastern Architectural Archive, Special Collections Division, Tulane University Libraries)*

OPPOSITE & ABOVE LEFT *Temple Sinai in early 1977 (opposite) and mid-demolition (above left) later the same year. (Historic New Orleans Collection)*

Tulane Stadium DEMOLISHED 1979–1980

For over half a century, a coliseum of startling proportions dominated the uptown campus of Tulane University. At the time, Tulane Stadium was arguably ground-zero for Southern collegiate football and later professional football at the national scale.

It took 60 years for the institution eventually known as Tulane to arrive at this campus, and another 30 to construct this stadium. Founded downtown in 1834 as the Medical College of Louisiana and privatized and renamed in 1884 for its benefactor, Tulane University in 1894 moved its main campus to a section of the old Foucher tract, the only colonial-era uptown plantation that was never urbanized. French surveying traditions had given this and adjacent parcels narrow, wedge-like shapes, to which future occupants had to conform. Tulane's resulting elongated campus thus had a "front" by St. Charles Avenue, which became its iconic face and home to its main academic building, and a "rear," lakeside of Freret, which generally remained open and became a perfect place for its "Green Wave" athletics teams to play. A viewing stand seating 10,000 was built here in 1909, followed by a larger grandstand in 1917.

As popular interest in spectator sports burgeoned during the heady 1920s, citizens contributed $300,000 to build for Tulane the city's first modern, national-level football stadium. The enthusiastic response—the fund-raising campaign's slogan was "We WANT, we WANT, we WANT A SEAT" and later "Greenbacks for the Greenbacks"—reflected an era in which this private institution of higher learning mostly served local families and reflected regional Southern society, including its insatiable craving for the game of football. It was the children of New Orleans' middle and upper class who attended Tulane University—men to Tulane College, women to Newcomb College; whites only until 1963—and their families and neighbors embraced the school as their own and cheered its sports teams. Testimony to the enthusiasm, the completed stadium, designed by Emil Weil, opened only 11 months after the November 1925 fund-raiser and readily attracted capacity crowds of 35,000. Because of the historical geography of the campus, the enormous arena, no matter where it was viewed from, appeared to be oversized for its lot, pressing against its confines like an egg dropped hard into a cone.

It would press ever tighter with four subsequent expansions, from the 1930s to the 1970s, during which time Tulane Stadium hosted 41 Sugar Bowls and three Superbowls, not to mention the New Orleans Saints' first eight seasons, countless high school football games, and special events ranging from revivals to rock concerts. Dearth of parking created something of a carnival atmosphere in the adjacent neighborhoods, as residents rented out their lawns for autos and fans perambulated by the tens of thousands from streetcars and bus lines. The larger the events got—crowds sometimes exceeded 80,000—the more authorities sensed that modern needs had outgrown Tulane Stadium's cramped confines.

Others felt that Tulane University had outgrown New Orleans. The school had become increasingly prestigious, expensive, and non-local in both student enrollment and faculty; less and less did it reflect local society or seem to care about its host city. New Orleanians returned the favor by shifting their loyalties to Tulane's archrival LSU or to their wildly popular new professional team, the New

Orleans Saints (1967). When the Louisiana Superdome opened in 1975, all the action that formerly transpired in Tulane Stadium shifted downtown, including Green Wave games, and the old coliseum remained in use only for practice and high school games. It was demolished during late 1979 and 1980 and replaced by dormitories and smaller sports facilities.

In 2012, university officials announced plans for a new on-campus football stadium, to be located directly behind the site of the old structure. Unlike 1926, however, this time neighbors reacted with ambivalence, some with nostalgia for the old stadium but others troubled over matters of zoning, noise and congestion. The university prevailed, and the stadium, called Yulman for its major donor (no citizens fund-raising campaign this time), opened in September 2014.

RIGHT *Tulane Stadium, arguably the premier football venue in the South, fit snugly onto Tulane University's elongated campus, and reflected a time when the institution was more local and regional in its enrollment and institutional culture. (Courtesy of the author's collection)*

LEFT & BELOW *Tulane Stadium hosted 41 Sugar Bowls and three Super Bowls from the 1930s to the 1970s, not to mention thousands of college, high school, and Saints games. (Courtesy of Corbis)*

1984 Louisiana World Exposition DISMANTLED 1985

One day in autumn 1974, New Orleanians learned of an intriguing idea. Edward Stagg, Executive Director of the Council for a Better Louisiana, proposed to the Louisiana Tourism Development Commission to hold a world's fair, bigger and better than the one held that summer in Spokane, right here in New Orleans. Targeted for the year 1980, Stagg's vision aimed to revitalize downtown's old warehouses and wharves while diversifying the New Orleans economy and promoting the state in the process.

The idea gained momentum and got a longer gestation period when 1980 proved too soon and 1982 got taken by Knoxville's world fair. Organizers settled on 1984, and with little more than moral support from City Hall, the state of Louisiana, and the federal government, private investors aimed to pull off what they hoped to be a win for everyone.

Stagg teamed with tourism sage Lester Kabacoff and hired Petr Spurney, who oversaw Spokane's 1974 fair and the Lake Placid Winter Olympics in 1980, as President and Chief Executive Officer of the "Louisiana World Exposition." With $85 million raised through a bond issue, officials hired architects and proceeded to negotiate leases with land owners in the eight-acre footprint. In exchange for the lease of their property for 184 days—May 12 to November 11, 1984—owners would benefit from improvements and see their property values rise as a result.

To hear New Orleanians tell it today, there were two Louisiana World Expositions held that memorable summer. One was a cultural triumph, starting with lavish opening ceremonies and thrilling a mostly local crowd 12 hours a day for half a year—part festival, part museum, and part amusement park, with a little bit of Bourbon Street, a little bit of the bayou, and a whole lot of music, food, and fun.

Amusements? There was a 200-foot-high Ferris wheel, a water-splash rollercoaster, a boat tour through the Louisiana landscape inside the Great Hall, the "Wonder Wall," a water garden for children, and most astonishing of all, a hair-raising gondola high above the Mississippi.

Museums? There was the refined Vatican Exhibit with its priceless treasures, including sculptures, tapestries, and master paintings such as Caravaggio's *Entombment of Christ*, along with pavilions from various states and countries and regional institutions such as the Army Corps of Engineers.

Entertainment? Schedulers programmed nine stages for 12 hours per day, seven days a week, with the biggest acts playing at a Frank Gehry-designed amphitheater overlooking the Mississippi.

Food and Fun? There was the German Beer Garden and its Bavarian bands, a replica of a Venetian neighborhood with Italian food stands, neon nightspots in the Federal Fiber Mills, traditional jazz in Pete Fountain's Reunion Hall, and Cajun music and rural crafts in the Louisiana Folklife Pavilion.

Locals loved every inch and every day of the Louisiana World Exposition, and to this day anyone old enough to remember 1984 waxes nostalgic on the fair.

To organizers and investors, however, the event was a financial nightmare. Trouble started when the U.S. government, which was in a contractive phase in this era, declined to provide federal support, jacking up the local cost burden while demoralizing international participation. Organizers were forced to make up for the shortfall through private financing, which banks handed over all too readily based on overly optimistic projections of fair attendance. In fact, Americans contemplating vacations could plan on a 1982 world's fair in Knoxville, the 1984 Olympics in Los Angeles, and a 1986 fair in Vancouver, Canada, all of which made any one event seem less special. When fewer than 60 percent of predicted visitors actually bought tickets, acts had to be cancelled and employees laid off, even as the city froze the fair's bank accounts over a tax dispute. Bankruptcy was declared while the fair still operated. Private donations had to pay for the closing ceremonies in November, and most features were dismantled immediately afterwards, with the Great Hall left to be transformed into what is now the Morial Convention Center.

The fiscal fiasco will forever be a bitter footnote to the 1984 Louisiana World Exposition. But the main text will tell of its cultural accomplishments and its role in catalyzing the redevelopment of the Warehouse District and diversification of the tourism sector at exactly the time when the petroleum industry collapsed and the port no longer ranked as the major source of employment. Most of all, the 1984 Louisiana World Exposition was a triumph for the people of New Orleans, and if it did not make millions of dollars, it made many more memories.

OPPOSITE *At the heart of the 1984 World's Fair was the area between Julia and Girod, featuring a lake surrounded by attractions and encircled with a monorail. At extreme left in this scene appears the Great Hall which later became the Morial Convention Center.* **BELOW** *Patrons walk along the Wonderwall (right) down what is now Convention Center Boulevard. (Courtesy of Corbis)*

Rivergate Exhibition Hall DEMOLISHED 1995

Second only to the Louisiana Superdome in terms of bold design and sheer size, the Rivergate Exhibition Hall presents a story of mid-century optimism, progressive planning, and architectural daring. That it is now a part of lost New Orleans tells a very different story.

New Orleans aggressively modernized its infrastructure in the years after World War II, building new bridges, unifying rail lines, widening arteries and separating grade crossings, and constructing a new Civic Center replete with Brasilia-inspired architecture. By the 1960s, in the midst of a petroleum boom, the renewal effort became framed as a competition with Houston, which was fast rising as the center of the oil universe and threatened to supplant New Orleans

as the premier city of the Gulf South. Private and public leaders in the Crescent City struggled to match the Bayou City with projects such as the development of Poydras Street into a corporate skyscraper corridor starting in 1966, and the building of the Louisiana Superdome (envisioned 1968, opened 1975) to answer the Houston Astrodome. They also sought to lure big industries, for conventions as well as for permanent offices, by putting New Orleans on the map as a "World Trade Center," which entailed the building of a complex of structures dedicated to international visitation and commerce.

With these goals in mind, the City of New Orleans and the Port of New Orleans eyed the most valuable land in town, the vertex of Canal and

Poydras Street at the Mississippi River, for an office skyscraper paired with an exhibition hall. Slated for six parallelogram-shaped city blocks on a former *batture* (a sandy river deposit created after the city's founding, which was later enveloped with levees and urbanized), the hall was intended not as a convention center but as floor space for the big trade shows that usually accompany professional and industrial gatherings. Convoluted land titles led to an arrangement in which the Port would own the lion's share of the facility, and the city the remainder—but the Port alone would bear the costs of operation.

The clearing in 1964 of the area bounded by Canal, South Peters, Poydras, and Delta streets left a vast acreage of upturned soil in the heart of the historic cityscape. Even a tunnel was dug, in expectation of the planned Riverfront Expressway as it was supposed to go below grade in its approach to the Mississippi River Bridge. Pilings were driven, foundations were laid, and during 1965, workers erected Edward Durell Stone's International Trade Mart as one of New Orleans' two first truly modern skyscrapers. (The other, the Plaza Tower, went up simultaneously in the hope of attracting other high-rises along Loyola Avenue. It didn't.)

What arose on the main site would stun New Orleanians, many of whom had grown up appreciating only pedestrian-scale historical architecture. They got quite the opposite: an

RIGHT *Unlike any other building New Orleans had ever seen, the stunning Rivergate Exhibition Hall was part of a massive push in the 1960s to modernize the city into a "world trade center" and ensure Houston would not eclipse it as the leading metropolis of the Gulf South. (Photograph by Frank Lotz Miller, circa 1967, courtesy of Curtis and Davis Office Records, Southeastern Architectural Archive, Special Collections Division, Tulane University Libraries)*

LEFT *The roof of the Rivergate, when viewed from above, appeared as a rectangular grid, exactly the opposite of the curvaceous, freeform shape it presented from the ground. This photo pair from 1952 and 1989 show how radically transformed lower Canal Street had been during 1965–1968. (Courtesy of the author's collection)*

enormous pavilion of sweeping freeform arches and vaulted ceilings recalling Eero Saarinen's recently opened Gateway Arch in St. Louis and reflecting a rebirth of Expressionist architecture within the context of Modernism. Officially known as the Port of New Orleans Rivergate Exhibition Hall, the space was designed for floor shows as well as Carnival events, such that trucks and floats could drive directly inside, and because of its affiliation with the International Trade Mart overlooking the Mississippi, the hall faced not the city but the river. The design was the work of the stellar local architectural firm of Nathaniel Curtis and Arthur Q. Davis, and the construction took over three years, delayed a bit by the tunnel dig. The Rivergate and Trade Mart, known together as the International Center, got an elaborate dedication ceremony on April 30, 1968, themed to the city's 250th anniversary and coordinated with dual conferences by the Organization of American States and the Alliance for Progress.

Conferences and conventions like those got the Rivergate off to a good start. By one estimate reported by Wilbur Meneray, it generated $170 million for public coffers during its first five years. The next decade would see the completion of the Louisiana Superdome (1975), also a Curtis and Davis design, and the Louisiana World Exposition (1984), whose Great Hall would afterwards become a full-service conference center complete with exhibition floors, food facilities, and theater. The convention business prospered as a result, but the new venues came at the expense of the Rivergate, diverting potential customers and making it seem small, ill-equipped and outdated by comparison. Worse, from the perspective of pedestrians downtown, the Rivergate's looming block-long flanks and river-facing orientation made it appear inaccessible and overwhelming, quite the opposite of the pedestrian-scale intimacy of the historic French Quarter. It did not help that architects in this era were casting their eyes toward something called Postmodernism, while preservationists remained enamored with, well, pre-Modernism. As the Rivergate lost fans, it also lost clients; its revenues declined, and, stuck as it was with the cost of operations, the Port looked to get out of the exhibition hall business.

Economically, the city in this era suffered the worst oil bust in memory, costing the state vital tax revenue and wiping out blue-collar jobs regionally as well as white-collar jobs on Poydras Street. Leaders looked for new ways to fill the gap, and legalized gambling topped the list. Promoters in

New Orleans sought not the tacky barges masquerading as riverboats that were popping up on riverfronts across the nation, but rather a big Vegas-style land-based casino, which, they pointed out, would stem dollars from flowing to the Mississippi Gulf Coast. As for the impact it would have on downtown New Orleans, well, this *was* The City Care Forgot, right? Millions of tourists came annually, and they all sought a good time. Gambling fit right in.

What ensued in the early 1990s was a complex caper involving chicanery on the part of promoters and politicians and a gross overestimation of just how successful a downtown casino might be. What got sacrificed was the Rivergate Exhibition Hall, whose prime location and ample size had the casino people salivating. The architectural community spoke passionately of the building's remarkable design and argued for adaptive reuse, but they failed to inspire many rank-and-file preservationists who, in this past-oriented city, had never warmed to Modernism. Sadly, the battle to save the Rivergate marked the last chapter in the six-decade-long career of the father of architectural history and preservation in New Orleans, Samuel Wilson Jr., who died shortly before testifying to the City Council to save the Rivergate.

In January 1995, demolition began on the barely 27-year-old building to make way for Harrah's new casino. Construction dragged on for over four years because an interim casino in the Municipal Auditorium had filed for bankruptcy and cast doubt on the viability of the entire project. It nevertheless proceeded tenuously, and Harrah's Casino finally opened in October 1999.

Gambling has since come to occupy a modest niche in the city's economy, well short of circa-1990 expectations but in all likelihood here to stay. Meanwhile, the Rivergate's partner project, the former International Trade Mart, now known as the World Trade Center, sits empty, threatened occasionally with demolition proposals and awaiting an adaptive reuse.

ABOVE LEFT & ABOVE *The soaring columns, vaulted ceilings, and smooth portals of the newly completed Rivergate, whose opening coincided with the 250th anniversary of the foundation of New Orleans, 1718–1968. (Photographs by Frank Lotz Miller, courtesy of Curtis and Davis Office Records, Southeastern Architectural Archive, Special Collections Division, Tulane University Libraries)*

OPPOSITE *The Rivergate was not a convention center but an exhibition hall, and despite its futuristic look, it was soon eclipsed by the Superdome and Convention Center in terms of size and services. Amid great controversy, it was demolished in 1995 for a casino. (Undated publicity photograph, courtesy of Curtis and Davis Office Records, Southeastern Architectural Archive, Special Collections Division, Tulane University Libraries)*

Maison Blanche

ORIGINAL BUILDING DEMOLISHED 1907–1908; STORE CLOSED 1998

One of New Orleans' most famous department stores, Maison Blanche operated on the corner of Canal and Dauphine from late Victorian times to the Internet age. This area in the 1700s marked the periphery of the original city, but by the early 1800s Canal Street developed into a fashionable residential address, and in 1847 the Gothic-style Christ Church, designed by James Gallier for the Episcopal congregation, was built on the site of the future store.

Commerce would subsequently reign on Canal, and the old church fell for the domed Victorian-style Mercier Building, an 1887 project of the local capitalist and philanthropist John Anselmo Mercier. Mercier's main tenant was the Fellman & Co. Department Store, which according to an 1890 advertisement, offered its "immense stock of foreign and domestic dry goods and fancy goods" in a "grand emporium" unequalled "this side of Mason and Dixon's Line."

In fact, Canal Street had a number of such businesses, among them Schwartz's Dry Goods on the corner of Bourbon Street. Late on the evening of February 16, 1892, amid what the *Daily Picayune* described as "a ceaseless procession of merry, happy" people patronizing "saloons, restaurants, and other places," a fire started at Schwartz's. It soon "crossed [Bourbon] street in a bound" and eventually destroyed nearly 20 buildings. With $2 million in damages and two blocks in ruins, the 1892 blaze ranks as one of the last great downtown conflagrations in the city's history.

As often happens, the disaster opened up opportunities. Schwartz's son Simon aimed to reopen the family business and found space in the Mercier Building, where it thrived for four years and begged for expansion. With financing from his famous father-in-law, investor and philanthropist Isidore Newman, Schwartz and Newman renovated the Mercier Building in 1897 (forcing Fellman's to move to Canal at Carondelet) and created within it a full-scale department store named Maison Blanche.

Booming business motivated the owners to expand further. In 1905 they announced plans for a specially designed 12-story building so big (275,000 square feet of floor space, with retail below and offices above) that the cobbling-together of properties constituted what the *Daily Picayune* described as "the largest single real estate transaction ever carried through this city." Demolition and construction in 1907 was staggered so that business could continue, and for a time, the old domed Mercier Building remained in operation on the Canal Street side while a gigantic modern steel frame arose on the Iberville Street side. In 1908, inventory was moved into the newly completed Iberville side, the Mercier was demolished, and new construction proceeded toward Canal.

The full building opened in 1909, and for decades, the pearl-white Beaux-Arts behemoth rivaled Godchaux's and D. H. Holmes as the South's premier shopping emporium—the type of place women donned white gloves to visit. Generations of New Orleanians to this day speak of charmed memories of Maison Blanche, particularly at Christmas, when its "Mr. Bingle" snowman mascot was mounted above the entrance and animated window displays drew crowds. Recalled Del Hall, who grew up in the Iberville Projects in the 1940s, "I remember the elevator doors opening like a curtain, unveiling the toy department on the third floor." (Visiting the store's Santa Claus, he asked him, "'What happens when you stop believing in Santa Claus?' He answered, 'You stop getting presents.' I never mentioned it again.") Until the late 1960s such memories were for whites only: "Jim Crow" segregation prevented black patronage of Maison Blanche and most other fancy Canal Street department stores; if African Americans were admitted at all, they were strictly prohibited from trying on clothing.

Like other downtown businesses, Maison Blanche's fortunes rested on the economic vibrancy of the inner city and the retail habitats of its population. When predominantly white middle-class populations shifted to the suburbs, and when impoverished people and tourists (who either had little money or little interest to shop at a traditional department store) took their place on Canal Street, old downtown institutions closed in rapid sequence: Godchaux's Department Store and Maylie's Restaurant in 1986, D. H. Holmes in 1989, Kolbs Restaurant in 1994, and Krauss Department Store in 1997. Finally, after various bankruptcies and consolidations ongoing since 1979 and even a closure of the flagship store during 1982–1984, Maison Blanche got subsumed within the mall-based Dillard department store chain, and its Canal Street location closed permanently in 1998. Reflective of the shift to tourism, an elegant Ritz-Carlton opened within its walls in 2000, and after having flooded during Hurricane Katrina, the 1909 building has since become a major part of the high-end downtown lodging industry.

RIGHT *The domed Mercier Building, built 1887 in a high Victorian style, was home to the original Maison Blanche department store. The elaborate structure was demolished in 1907–1908 for a larger modern building. (Courtesy of Corbis)*

LEFT *The second Maison Blanche building, a Beaux-Arts behemoth on Canal Street, photographed shortly after it opened in 1909. (Courtesy of Library of Congress)*

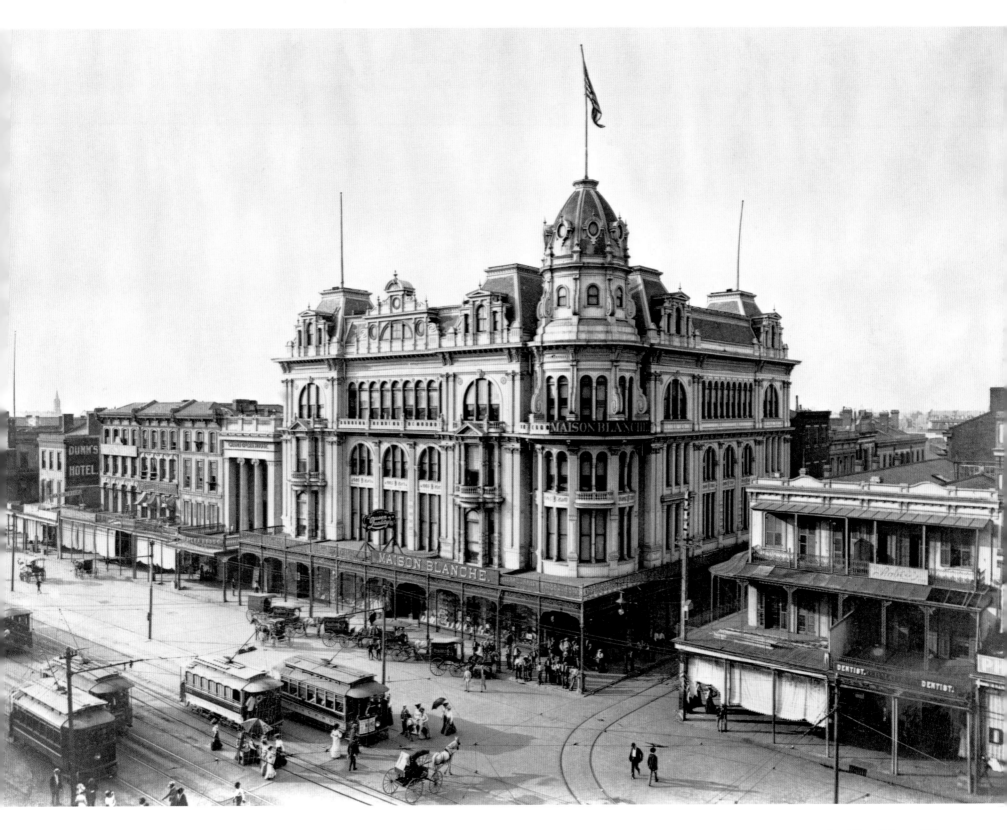

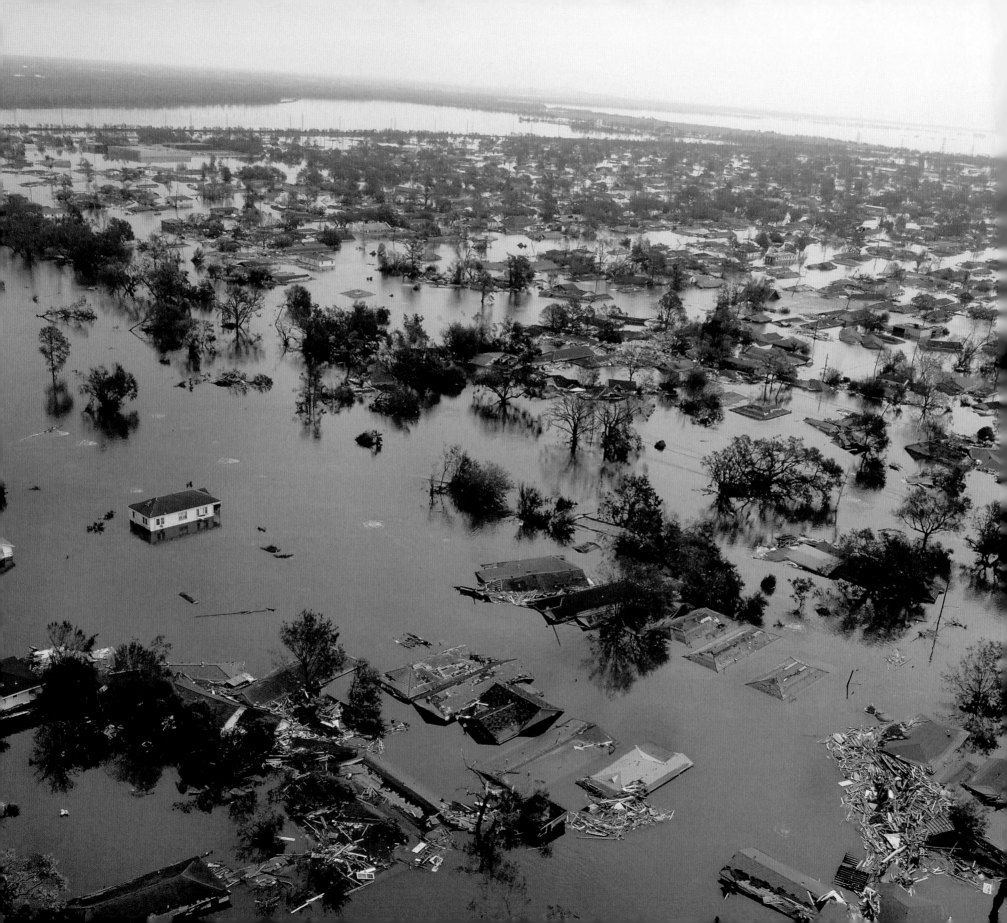

Lower Ninth Ward SEVERELY FLOODED 2005

The Lower Ninth Ward the world came to know after Hurricane Katrina in 2005 bore neither that name nor that form during its first two centuries. A sequence of human interventions—some gradual, some swift—transformed this deltaic landscape into the cityscape of today.

As New Orleans expanded downriver in the early 1800s, working-class Creoles, Irish and German immigrants, and other groups settled into what would become the Third Municipality, the poorest of the city's districts. To some, these were the "Creole faubourgs;" to others, they were the "old Third," the "dirty Third," or the "poor Third." After 1852, the city adopted a new municipal jurisdiction, wards, and areas below Press Street became the Ninth Ward.

Most Ninth Ward residents in the mid-19th century were clustered in its upriver end, an area now called Bywater. Slowly they spread downriver, enough to warrant the establishment of St. Maurice Catholic Church in 1857. Fourteen years later, the Brothers of the Holy Cross created an orphanage which would later become Holy Cross Catholic High School. Mule-drawn streetcar service arrived at the area in 1872, and by 1880, it had been subdivided up to Urquhart Street.

The single most influential transformation of the Ninth Ward came in 1918 with the excavation of the Inner Harbor Navigation ("Industrial") Canal. When the waterway opened in 1923, it invigorated port activity, but it also severed the lowermost portion of the city from the urban core (hence "Lower" Ninth Ward). Worse, it brought gulf water within city limits, even as the newly installed drainage system dried out the backswamp and allowed it to sink below sea level. New Orleans' topography began to assume the shape of a bowl—or rather, a series of bowls, of which the Lower Ninth Ward was one.

Settlement patterns reflected topography. Those settling on higher ground closer to the river, in Holy Cross, were predominantly white, usually of Irish, German, Sicilian, French, Creole, or Hispanic stock. Those who settled in the back-of-town (north of St. Claude and Claiborne avenues) were mostly African American and either poor or working class. After the Intracoastal Waterway was dug during World War II, the 11,556 residents of the subsiding Lower Ninth Ward, detached from 97.7 percent of the city's population by the Industrial Canal, were now surrounded on three sides by water.

The 1960s brought more turmoil. Resistance to school integration led to the wholesale departure of whites into St. Bernard Parish. At the same time, excavation commenced on the Mississippi River-Gulf Outlet Canal, connecting the other man-made waterways with the Gulf of Mexico. The MR-GO promised jobs and economic dividends; instead, it delivered environmental degradation and urban hazard, as demonstrated when Hurricane Betsy struck in September 1965 and inundated four "bowls" including the Lower Ninth Ward.

The next 35 years saw the Lower Ninth Ward's population dwindle from a 1960 peak of over 33,000 to under 19,500 by century's end. Once racially mixed, the neighborhood in 2000 was over 95 percent black and working class or poor. The isolated rear sections of the neighborhood seemed like a world unto itself—cherished by its residents, avoided by everyone else, and highly vulnerable to trauma.

Trauma came on August 29, 2005, when Hurricane Katrina's surge penetrated the metropolis via the aforementioned canals, causing flimsy levees and floodwalls to collapse. Salt water rushed in, eventually flooding 80 percent of the urbanized area of Orleans Parish's East Bank—plus some of Jefferson, half of Plaquemine, and all of St. Bernard parishes—by anywhere from two to 12 feet. By the end of September, 1,500 Louisianians had perished.

What distinguished the Lower Ninth Ward's Katrina experience was the severity of the destruction. The neighborhood witnessed the two largest breaches and suffered the deepest, highest-velocity, and longest-lasting deluge. Its rear section saw near-total obliteration, and became the only area where, in the aftermath, most flooded homeowners decided to sell their properties to the state rather than rebuild.

The Lower Ninth Ward has since become a cause célèbre for architectural sustainability and urban resilience advocates, and a favored location for progressive nonprofit activity. The older, higher section (Holy Cross) has recovered over half its pre-Katrina population, and it is currently experiencing a revival with hints of gentrification. But the rear section has barely recovered a quarter of its residents, and save for actor Brad Pitt's Make It Right project and a few other bright spots, empty fields with overgrown vegetation now dominate where families once lived.

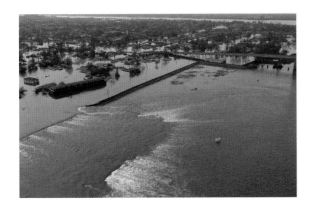

OPPOSITE *New Orleans at its darkest moment: peak flooding in the rear of the Lower Ninth Ward, looking toward Bayou Bienvenue, one day after Hurricane Katrina's August 29, 2005 landfall.* **FAR LEFT** *The 900-foot-long breach (left) in the floodwall of the Industrial Canal was the worst of at least three major sources of floodwaters inundating the Lower Ninth Ward and upper St. Bernard Parish. (Photos by Jocelyn Augustino, courtesy of FEMA)*

LEFT *This is what high-velocity salt water does to a bowl-shaped neighborhood after sitting there, up to 12 feet deep, for over two weeks. (Photo by Andrea Booher, September 18, 2005, courtesy of FEMA)*

St. Francis Cabrini Catholic Church

DEMOLISHED 2007

Gentilly in the 1950s had a burgeoning middle-class population with an abundance of young families, and with them came a need for new services, schools, and in this religious city, churches. In 1953 local Roman Catholics had a new parish carved out of an older, larger jurisdiction, and erected a Quonset hut for Masses and meetings. By 1960, parishioners had arranged with the Archdiocese for a permanent home befitting their congregation, an effort that became all the more pressing when the Quonset hut burned down in 1961. Church authorities selected the up-and-coming local architectural firm Curtis and Davis for the design, and the soaring Modernist creation it would devise for St. Francis Cabrini Church at 5500 Paris Avenue would foretell the eminence the firm would later achieve. Nathaniel Curtis had written in his diary the "considerations that influenced the design" of St. Francis Cabrini,

> The strongest, of course, was…Vatican II…. The priest would no longer have his back to the congregation; there would be a sense of more participation, with the pews being placed in a semi-circle as close to the altar as possible….

St. Francis Cabrini was funded by parishioners and built by Keller Construction in 1962, at the same time Pope John XXIII convened the Second Vatican Council in Rome. The ensuing changes in Catholicism inspired the architects to redesign St. Francis Cabrini's interior to reflect the liberalization brought about by Vatican II. The parish prospered even when the neighborhood did not, as middle-class families departed in droves for the suburbs in subsequent years and Gentilly became less affluent. When Hurricane Katrina struck in 2005, breaches in the London Avenue Canal flooded St. Francis Cabrini and all the surrounding neighborhood.

As bad as the damage was, it was even worse four miles away in the Lower Ninth Ward. Among the victims in that hard-hit area was Holy Cross School, a fixture in the neighborhood since the 1870s. In 2006, with both neighborhoods barely beginning to recover and the Archdiocese prioritizing for the reopening of schools, Holy Cross' leaders offered to buy St. Francis Cabrini's land and move their campus to Gentilly.

The news disheartened residents of the Lower Ninth Ward but thrilled those in Gentilly, who viewed the arrival of a high-quality private school as just the sort of recovery catalyst their neighborhood needed, even if it meant the demolition of St. Francis Cabrini. Architects and preservationists saw things differently: here was an important example of Modernist architecture which embodied the transformative changes of Vatican II, and it could easily be adapted into the design of the school. Street protests to save the building were met with counterdemonstrations in favor of Holy Cross' plan. As if to reflect the chasm between the two sides, designs for the new school aimed to capture the historical style of the beloved circa-1880s building in the Lower Ninth Ward, the very backward-looking nostalgia that riles Modernists.

The architects had a good case—but a bad time to make it. Many, probably most, of those seeking to preserve the church lived outside Gentilly, and, as residents emphatically pointed out, were not personal stakeholders in the recovery of the neighborhood, the church, or the school. The architects found themselves bringing an abstract argument to an all-too-real situation—of wrecked homes, stressed families, population loss, lowered property values, and inadequate education options. Saving St. Francis Cabrini didn't have a prayer.

Demolition commenced in June 2007, and the new Holy Cross Middle and High School for Boys opened in 2010. By all accounts, it has delivered on expectations. As for the parish, a diminished population, lack of priests, and declining church attendance forced the Archdiocese, amid more controversy in 2008, to close a number of old churches and combine their congregations. Catholics in this area now go to the Transfiguration of the Lord Church at 2212 Prentiss Avenue, representing a merger of the former parishes of St. Francis Cabrini, St. Raphael the Archangel, and St. Thomas the Apostle.

RIGHT *Cabrini's interior was designed to reflect Vatican II changes to the liturgy and the relationship between priest and flock.* **BELOW** *Wrote architect Nathaniel Curtis on his Modernist design, "The spire, or steeple…was placed directly over the altar…as if pointing toward God…" Curtis modeled the roof in "the shape of the Quonset hut" which had been the previous home of the growing congregation. (Photographs by Frank Lotz Miller, 1963, courtesy of Curtis and Davis Office Records, Southeastern Architectural Archive, Special Collections Division, Tulane University Libraries)*

Le Beau House TORCHED BY ARSONISTS 2013

This stately if dilapidated mansion was among the very last great antebellum plantation houses in the region, much less the metropolis, to have evaded destruction but also miss out on restoration. Built by Francois Barthelemy Le Beau during 1854–1857 in the upper reaches of St. Bernard Parish, the house oversaw a mix of enterprises, from light agriculture and orchards to ranching and brickmaking. According to St. Bernard Parish historian William de Marigny Hyland, the Le Beau House "represents a hybrid of Creole vernacular design principles [namely its brick-between-post interior walls, a rarity by the 1850s] and very bold, simple Greek Revival architectural details," with its center hallway American in its origins. Thus the Le Beau House may be viewed as an architectural expression of the 19th-century transformation of Louisiana from Creole to American culture.

Never a quintessential slave-based commodity plantation, the Le Beau property had an intermittent history of owners, uses, and environs. Le Beau's widow Sylvanie Fuselier de la Claire lived in the house until 1879 and willed it to her children, who sold it in 1905. The next year, Arabi was subdivided adjacently, and with stockyards and a slaughterhouse on one side and the Chalmette Sugar Refinery (1912) on the other, the aging mansion increasingly found itself a relic of a lost era amid industrializing and urbanizing surroundings. New owner Friscoville Realty Company converted the house into a resort and illicit gambling casino, an activity that found a lucrative home here immediately outside New Orleans city limits because it dodged vice raids while remaining convenient to urban patrons. As late as 2013, one could see interior corner niches covered by steel plates with peepholes, said to be the perches for armed watchmen eyeing the casino floor.

Local real estate tycoon Joseph Maumus Meraux purchased Le Beau in 1967, and for the next 20 years the house had a number of odd uses and tenants, not to mention a reputation among parish youth as a "haunted house" and a destination for teenage hijinks. It survived decades of heavy-handed use and abuse, larcenous relic-hunters, the winds of Hurricane Betsy, and an intentionally set fire in June 1986 which destroyed its roof and signature cupola. A $1 million effort in 2004 funded by its current titleholder, the Arlene and Joseph Meraux Charitable Foundation, and executed by Robert J. Cangelosi of Koch and Wilson Architects, stabilized the building just in time for the winds and floodwaters of Hurricane Katrina in 2005. Incredibly, the Le Beau House beat the odds, and despite its weathered appearance, seemed to be on the brink of a major renovation. The author would often bring his Tulane University architecture students to inspect the house inside and out, and historian William de Marigny Hyland and restoration architect Gene Cizek would lead the class up the precarious staircase to the attic, roof, and rebuilt cupola. Students proposed viable plans to convert the mansion into an interpretative center and museum for St. Bernard Parish.

The Le Beau House had survived every conceivable threat for 159 years, from war to wind to water to fire, from creeping urbanization and vandalizing creeps. But it could not survive stupidity. One night in November 2013, seven ne'er-do-well broke into the inadequately secured building and, in a stupor of drugs and alcohol, tried and failed to conjure up ghosts. Frustrated, they set the landmark ablaze. By next morning, the mansion was reduced to four chimneys and a pile of ashes. These scenes, taken during two class visits earlier in 2013, are among the last interior and rooftop photographs of this major element of lost New Orleans.

LEFT *A student makes her way down the Le Beau House's precarious staircase, February 2013.* **FAR LEFT** *The Le Beau House six weeks after it was blown and flooded by Hurricane Katrina in 2005.* **OPPOSITE** *The author's students gather at the circa-1854 Le Beau House in the Arabi neighborhood of St. Bernard Parish, October 2012. (Courtesy of the author's collection)*

INDEX

Abraham, Wilson P. 104
Algiers 12, 41, 84
Algiers Ferry 26
Ambrose, Stephen 59
Ames, William 72
Anderson, Tom 55
Andrew Higgins Place 88
Annunciation Street 88
Arabi 37, 107, 143
Armstrong, Louis 63
Audubon Park 20, 124
Audubon Zoological Gardens 20
Baker, Bryant 9
Banana Wharf 114–117
Bank Place 25, 56
Banks, Nathanial 79
Barnett, A. L. 96
Barnett, John 87
Baronne Street 47, 52, 60
Basin Street 42, 55, 63, 83, 111
Baton Rouge 29, 34
Baton Rouge Advocate 25
Battle of Liberty Place 96, 99
Bayou Gentilly 79
Bayou Metairie 78–79
Bayou Road 48
Bayou St. John 12, 48, 59, 68, 79
Bayou St. John Canal 26
Bayou Sauvage 79
Beer Building 47
Behrman, Martin 55
benevolent institutions 38–41
Bienville Street 36, 52, 103
Blackmar, K. K. 16
Blessing, S. T. 33
Bolivar, Simon 83
Boudousquié, Charles 23
Bourbon Street 23, 47, 60, 68, 91, 94–95, 104, 112, 136
Bremer, Fredrika 120, 123
Broad Street 64
Brokers' Charm Saloon 103
Bucktown 68
Burnham, Daniel 83
Burnside, John 80
Bywater 67, 139
Calliope Street 30, 84, 127
Camp Street 24–25, 30, 38, 56, 80, 84, 87, 88
Camp Street Female Orphans Asylum 38, 39, 41
Canal Street 9, 14, 15, 45, 47, 52, 60, 68, 71, 83, 88, 96–99, 108, 111, 112, 132, 136
Canal Street Presbyterian Church 45
Cangelosi, Robert J. 143
Capablanca, José 47
Carondelet Canal 9, 48–49, 83
Carondelet Street 29, 60, 72, 127, 136
Carondelet Walk 48
Carrollton Railroad Depot 30
Carrollton Water Works Plant 12
Cavaroc House 107
Central Business District 9, 29
Central Congregational (Fourth Presbyterian) Church 44–45
Centroport 116
Chalmette Battlefield 107
Chalmette Refinery 37, 107, 143
Charity Hospital 38, 47, 52–53
Chartres Street 16, 19, 25, 52, 67, 88, 108
Chef Menteur Highway 104
Chess, Checkers, and Whist Club 46–47, 60
Chestnut Street 80
Children's Home of the Protestant Episcopal Church 38, 40
Chippewa Street 40
Christ Church 136
cisterns 12–13
City Park 59, 79
Civic Center 9
Cizek, Gene 143
Claiborne Avenue 16, 51, 139
Clapp, Theodore 51
Clay, Henry 8, 9
Clay Statue 8–9, 96
Cleveland Avenue 45
Coliseum Place Baptist Church 87
Coliseum Square 87

Commercial Exchange 30
Commercial Hotel 71
Common Street 9, 52, 60, 63
Constance Street 33
Conti Street 34, 96, 103
Convention Center Boulevard 131
Cosmopolitan Hotel 47
Cotton Wharf 14–15
Crescent City Connection 84
Crescent and Tulane Theaters 111
Curtis, Nathaniel 140
Curtis and Davis 140
Customhouse Street 55, 71, 91, 100
D. H. Holmes Store 108, 136
Dabney, Thomas 25
Daily Picayune 19, 23, 25, 30, 42, 51, 56, 68, 80, 83, 87, 92, 108, 119, 136
Dakin, Charles 119
Danneel Street 38, 41
Darcantel & Diasselliss 108
Dauphine Street 16, 136
Davis, Jefferson 100
de la Claire, Sylvanie Fuselier 143
De Lue, Donald 9
de Pouilly, J. N. B. 19, 33
Decatur Street 96, 112, 123
Deitel, Albert 72
Delgado, Isaac 40
Delgado Memorial Clinic 52, 53
Delord-Sarpy House 88
Delord Street 88
Delta Street 132
Desire Street 71
Desire Streetcar Line 71
Diboll, Owen, and Goldstein 91
Dryades Market 42
Dryades Street 42, 43, 127
Duplantier 88
Duplessis, Francois 88
Dymond, John 103
East Bank 11, 84, 139
Ecclesiastic Square 33
Edwards, Jay Dearborn 80
Elkin's Exchange 19
Elysian Fields 71
Evans, Walker 112
Exposition Hall 72
F. Edward Hebert Federal Building 51
Farnsworth, R. P. 52
Faubourg St. Mary 25, 29, 42, 52, 119
Feibleman, Leopold 60
Feibleman, Max 60
Fellman, Leon 60
Fellman's/Feibleman's Clothing Store 60–61, 136
Ferry Building 96
Ferry House 14, 15
Filter House 37
Fine Arts Hall 72
Fink, John 40
First Presbyterian Church 50–1
Fish, Stuyvesant 11
Fisk, Abijah 91
Fisk, Alvarez 91
Fleitas, Francis B. 34, 103
Forman, B. R. 68
Fourth Presbyterian Church 44–45
France Street 67
Franklin, Benjamin 9
French House 23
French Market 26, 56, 108, 112, 120–123
French Quarter 9, 12, 13, 19, 25, 26, 34, 37, 71, 95, 100, 123
Freret 128
Freret, James 30, 103
Gaienne Street 84
Gallatin Street 123
Gallier, James 30, 119, 136
Gallier and Esterbrook 23
Garden District 12, 33
Garrison, Jim 95
Gasquet Street 45
General Meyer Avenue 41
Genthe, Arnold 88, 107, 124
Gentilly 79, 80, 140
Girod, Nicholas 38
Girod House 88
Girod Street 72, 131
Godchaux, Leon 108
Godchaux Building 60, 108–109, 136
Gov. Nicholls Street Wharf Shed 26
Grand, Theodore 87

Grand Opera House 111
Gravier Street 25, 29, 30, 51, 63
Gurlie and Guillot 16
Gus Mayer Company 60
Gutheim, James Koppel 127
Hall, Del 29, 75, 136
Harbor Station 96
Harrah's Casino 135
Harrod, Benjamin F. 79
Hart, Joel Tanner 9
Harvey, H. J. 68, 107
Haughery, Margaret 38, 41
Hector, Francisco Luis 48
Henderson, Steven 38
Hewlett's Exchange 19
Higgins, Andrew Jackson 59
Higgins Industries 58–59
Hillger, Charles Lewis 127
Holy Cross Catholic High School 139, 140
Holy Family Convent and School 104–105
Horseshoe Lake 79
Horticultural Hall 20–21
Hotel Grunewald 47
Hotel Royal 19
Hotel Victor 71
Howard, Henry 34, 51, 67
Howard Avenue 25, 42, 52, 76
Howard-Tilton Library 91
Huey P. Long Bridge 84, 124
Hunter, Thomas 20
Hyland, William de Marigny 143
Iberville Housing Project 55, 136
Iberville Street 9, 71, 100, 111
Importers Bonded Warehouse 34
Industrial Canal 11, 58, 59, 138
Inner Harbor Navigation Canal 11, 16, 139
International Center 134
International Trade Mart 99, 132, 134
Interstate 10 116
Intracoastal Waterway 139
Irish Channel 12, 33
Jackson, William Henry 15, 42, 123
Jackson Avenue 33, 40, 127
Jackson Square 37
Jamison, Samuel 45
Jefferson 33, 68, 79, 84, 139
Jefferson Avenue 41, 51
Jefferson & Lake Pontchartrain Railroad 68
Jewish Community Center 41
Jewish Orphan and Widows Home 38, 40
Jewish Orphans' Home 41
John Hancock Building 91
Johnston, Frances Benjamin 124
Joseph Street 38, 41
Josephine Street 37
Julia Street 72, 96, 127, 131
Kabacoff, Lester 131
Kellogg, W. P. 96
King, Nina 33
Kohlmeyer Jr., Herman S. 29
Laclotte, Jean Hyacinthe 88
Lafayette 33, 80
Lafayette Square 9, 25, 40, 51, 91
Lafitte Street 48
Lafon, Barthelemy 88
Lafourche 26
Lake Pontchartrain 16, 26, 42, 48, 68
Lake Prospect 79
Landrieu, Moon 95
Larned, Sylvester 51
LaSalle Street 52
Latrobe, Benjamin H. B. 12, 56
Laurel Street 33
Laussat, Pierre Clément de 79
Le Beau, Francois Barthelemy 143
Le Beau House 142–143
Lee, Russell 26
Lee Circle 30, 91, 127
Levee Street 96
Levy, Neville 84
Lewis, Thomas 87
Liberty Place Monument 96, 97, 99
Liberty Theater 111
Lincoln, Abraham 51
Lloyd Wright, Frank 76
London Avenue 68
London Avenue Canal 140
Long, Alecia 55
Long, Huey P. 41, 67, 84
Louisiana Avenue 11, 100
Louisiana State House 47

Louisiana Sugar Refinery 37
Louisiana Superdome 128, 132, 134
Louisiana World Exposition (1984) 130–131, 134
Louisville & Nashville (L & N) Station 96
Lower Garden District 12, 87, 88
Lower Ninth Ward 138–139, 140
Loyola Avenue 63, 64, 91, 132
LSU Medical Building 52
Lugger Landing 26–27
Macheca Building 108
Madison Street 56
Magazine Street 41
Maison Blanche 47, 60, 108, 111, 136–137
Manual Street 16
Marine Gallery 11
Mariott Hotel 108
Mart and Hall 99
Maspero's Exchange 19
Masson Costa, Mildred 23
Maybin School 84
Mazant Street 67
McDonogh, John 40, 41
McDonogh Boys High School No. 1 84
McDonogh Public School #14 40, 41
McIntosh, James 45
Melpomene Street 88
Meraux, Joseph Maumus 143
Merchants' Exchange 71
Mercier, John Anselmo 136
Mercier Building 60, 136
Mercy Hospital 88
Metairie Cemetery 79
Metairie Race Course 79
Metairie Ridge 79
Metairie Road 79
Michoud 59
Middlemiss, Peter 127
Miller, Frank Lotz 132, 140
Milne, Alexander 38
Milneburg 79
Mississippi River 9, 11, 12, 16, 29, 34, 75, 79, 84, 88, 98, 99, 107, 124, 132, 134
Mississippi River Bridge 87, 88, 91, 127, 132
Mississippi River Bridge Right-of-Way 84–85
Mississippi River-Gulf Outlet Canal 116, 139
Mississippi Valley 29
Mister B's Bistro 100
Monteleone, Antonio 71
Moody, D. W. 119
Moriyama and Teshima Architects 119
Morphy, Paul 47
Morrison, Chep 64, 76, 79, 83, 84
Muir, Alexander 37
mule drayage 74–75
Mulla, Brittany 75
Mydan, Carl 123
Napoleon Avenue 11
Napoleon Avenue Container Terminal 15
Nashville Avenue 38, 41
Natchez Street 25
National World War II Museum 59, 88
New Basin Canal 26, 42, 48, 68, 76, 84
New Lake End 68
New Orleans Cotton Exchange 28–29
New Orleans Public Library 9, 90–91
"Newspaper Row" 24–25, 56
Newman, Isidore 136
Ninth Ward 11, 16, 138–139, 140
North Front Street 37, 103, 112
North Peter Street 34, 123
North Rampart Street 71
Notre Dame Church 32–33
Oak Alley 124
Oakey Hall, A. 56
Octavia Street 51
Ogden Museum 91
O'Keefe Street 42
Old Basin Canal 26, 48–49, 83
Old French Opera House 22–23, 95
Old Lake End 68
Old Masonic Temple 30–31
Old Orleans Ballroom 104–105
Olivier, Antoine David 67

Olivier Plantation House 66–67
Orleans Parish Criminal Courts Building 62–65
Orleans Street 68, 104
Orpheum Theater 111
Palmer, Benjamin Morgan 51
Pan American Life Center 111
Paris Avenue 140
Parish Prison 9
Parkard, Herman 45
Parker, Dr. 51
Paxton, John Adems 48
Penn Street 42
Performance Theaters 110–111
Perdido Street 30
Perry House 47
Persac, Marie Adrien 23
Peyroux, Sylvain 107
Picayune Pier 25
Picayune Place 25
Pickwick Club 60
Pilie Market 42
Pitot, James 48
Place St. Charles 119
Planters Refinery 37
Plaquemine 26, 107, 139
Plaza Tower 132
Poland Avenue 84
Polymnia Street 88
Pontchartrain Beach 68
Pontchartrain Expressway 84, 91, 127
Pontchartrain Railroad 68
Port of New Orleans 11
Poydras, Julian 40
Poydras Market 42–43
Poydras Street 15, 25, 42, 96, 100, 111, 132, 134
Poydras Street Wharf 11
Prentiss Avenue 140
Public Belt Railroad 11, 26
Purves, George 51
Race Street 41
Richard Milliken Memorial Hospital for Children 52, 53
Richardson, Henry Hobson 91
Richardson Memorial Hospital 52
Rivergate Exhibition Hall 99, 132–135
Robb, James 80
Robb Mansion 80–81
Robertson Street 55
Roosevelt Hotel 47
Roxas, Don Andres Almonaster y 52
Royal Orleans Hotel 104
Royal Street 9, 19, 70–71, 100
St. Alphonsus Church 33
St. Ann Street 104, 120
St. Bernard 26, 37, 107, 120, 139, 143
St. Charles Armory 72
St. Charles Avenue 9, 30, 41, 42, 51, 71, 72, 75, 100, 111, 118–119, 127, 128
St. Charles Avenue Presbyterian Church 51
St. Charles Exchange Hotel 119
St. Charles Hotels 51, 118–119
St. Charles Orpheum 111
St. Charles Streetcar Line 33
St. Charles Theater 111
St. Claude Avenue 139
St. Francis Cabrini Catholic Church 140–141
St. John Berchman's Orphan Asylum 104
St. Julien, J. R. 116
St. Louis Cathedral 104
St. Louis Exchange 119
St. Louis Hotel and Exchange 18–19
St. Louis Street 19, 34, 55, 83
St. Mary's Academy 104
St. Mary's Assumption Church 33
St. Mary's Orphan Asylum 67
St. Maurice Catholic Church 139
St. Patrick's Church 30
St. Patrick's Hall 91
St. Paul's Episcopal Church 86–87, 88
St. Philip Street 120
St. Teresa of Avila Catholic Church 87
St. Ursula Chapel 16
St. Vincent's Infant Asylum 41
Santa Maria 9
Sara Mayo Hospital 38, 40
Saulet 88

Saulet House 88
Schwartz, Simon 136
Scottish Rite Cathedral 30
Sears Store 60
Seven Oaks 124–125
17th Street 60
Sheraton-St. Charles Hotel 119
Sickles, Simon 40
Simon Bolivar Boulevard 84
Sister Street 16
Skidmore, Owings & Merrill 91
Solari, Angelo 100
Solari, Joseph. B. 71, 100
Solari's Delicatessen 71, 100–101
Sophie Newcomb College 80–81, 128
South Liberty Street 45
South Peters Street 132
South Rampart Street 42, 75, 76
Southern Yacht Club 68
Spanish Fort 68
Spokane 131
Spurney, Petr 131
Stagg, Edward 131
State Street 16, 51
Stone, Edward Durell 132
Stone Bros. 30
stoop sitting 92–93
Story, Sidney 55
Storyville 52, 54–55
street peddlers 56–57
Stuyvesant Docks and Elevators 10–11
Suburbio Santa Maria 30
Sugar District 34–7, 103
Sugar and Rice Exchange 102–103
Sullivan, Louis Henry 76
Sully, Thomas 40, 41, 71, 111, 119
Sully & Stone 108
Tango Belt 55
Temple Sinai 126–127
Tenth Ward 33
Terminal (Southern Railway) Station 82–83
Teunisson, John N. 111
Thalia Street 88
Théâtre d'Orléans 23, 104
Third Varieties Theater 111
Three Oaks 106–107
Times-Picayune 25, 63, 64
Tivoli Circle 87
Toledano and Wogan 71
Toulouse Street 23
Touro, Judah 38, 40, 41
Touro-Shakespeare Alms House 39, 41
Tremoulet's Exchange 19
Tulane Avenue 52, 63, 64, 91
Tulane Stadium 128–129
Tulane University 80, 111, 128
Tulane University Medical Center 45, 52
Tullis, Eli 29
Tureck, Joseph R. 103
Union Bank 71
Union Passenger Terminal 76
Union Railroad Depot 76–77
University Place 52, 111
Upper City Park 20
Upper St. Bernard 107
uptown mansions 88–89
Urquhart Street 139
Ursuline Convent Complex 16–17
Ursuline Street 12, 26
Villere Street 52
Warehouse District 88, 115
Washington, George 9
Washington Artillery Hall 72–73
Washington Avenue 80
Water Works Building 96
Weiss, Dreyfous and Seiferth 52
Wells Street 34, 103
West Bank 11, 84, 88
West End 68–69
Westwego 11, 124
Williams, Thomas "Tennessee" 71
Wilson, Samuel 45, 135
Wilson Jr., Samuel 88
Wolcott, Marion Post 112
World Trade Center 99, 132
World's Industrial and Cotton Centennial Exposition 20
Yulman Stadium 128
Zacharie, James S. 9
Zemurray, Samuel 115
Zeringue, Camille 124

OTHER TITLES IN THE SERIES

ISBN 9781862059344

ISBN 9781862059924

ISBN 9781862059931

ISBN 9781909108714

ISBN 9781909815032

ISBN 9781909108448

ISBN 9781909108431

ISBN 9781909108639

ISBN 9781862059351